WOMAN BETWEEN TWO KINGDOMS

Woman between Two Kingdoms

Dara Rasami and the Making of Modern Thailand

Leslie Castro-Woodhouse

SOUTHEAST ASIA PROGRAM PUBLICATIONS

AN IMPRINT OF CORNELL UNIVERSITY PRESS

ITHACA AND LONDON

Segments of chapter 4 have been excerpted from "A Very 'Modern' Matron:
Phra Rachaya Dara Rasami as Promoter and Preserver of Lan Na Culture
in Early Twentieth-Century Siam," in *Women, Gender and Art in Asia, c. 1500–1900*,
ed. Melia Belli Bose (London: Ashgate, 2016), pp. 91–121. Copyright © 2016.

First published 2020 by Cornell University Press

Library of Congress Cataloging-in-Publication Data
Names: Castro-Woodhouse, Leslie, 1968– author.
Title: Woman between two kingdoms: Dara Rasami and the making of modern
 Thailand / Leslie Castro-Woodhouse.
Description: Ithaca [New York]: Cornell University Press, 2020. | Includes
 bibliographical references and index.
Identifiers: LCCN 2020029372 (print) | LCCN 2020029373 (ebook) |
 ISBN 9781501755507 (paperback) | ISBN 9781501755514 (epub) |
 ISBN 9781501755521 (pdf)
Subjects: LCSH: Sex role—Political aspects—Thailand—History—19th century.
 | Sex role—Political aspects—Thailand—History—20th century. | Polygyny—
 Thailand—History—19th century. | Polygyny—Thailand—History—20th
 century. | Ethnicity—Thailand—History—19th century. | Ethnicity—Thailand—
 History—20th century.
Classification: LCC HQ1075.5.T5 C37 2020 (print) | LCC HQ1075.5.T5 (ebook) |
 DDC 305.309593—dc23
LC record available at https://lccn.loc.gov/2020029372
LC ebook record available at https://lccn.loc.gov/2020029373

S|H **The Sustainable History Monograph Pilot**
M|P Opening up the Past, Publishing for the Future

This book is published as part of the Sustainable History
Monograph Pilot. With the generous support of the
Andrew W. Mellon Foundation, the Pilot uses cutting-edge
publishing technology to produce open access digital editions
of high-quality, peer-reviewed monographs from leading
university presses. Free digital editions can be downloaded
from: Books at JSTOR, EBSCO, Hathi Trust, Internet
Archive, OAPEN, Project MUSE, and many other open
repositories.

When you cite the book, please include the following
URL for its Digital Object Identifier (DOI):
https://doi.org/10.7298/pq1f-t958

We are eager to learn more about how you discovered this
title and how you are using it. We hope you will spend a few
minutes answering a couple of questions at this url:
https://www.longleafservices.org/shmp-survey/

More information about the Sustainable History Monograph
Pilot can be found at https://www.longleafservices.org.

CONTENTS

ACKNOWLEDGMENTS

This book is a product of more than a decade of research, thinking, and writing, which would not have been possible without the support of a host of people and institutions. There are a number of people to whom I owe special thanks for their collegial and moral support over the years. First and foremost, I would like to thank my former academic advisers, Peter Zinoman and Penny Edwards, without whose advice, feedback, and support I might never have successfully navigated the circuitous process that ultimately allowed me to complete the research that formed the basis of this book.

I also owe a debt of deep gratitude to a host of colleagues around the world who were instrumental in helping me move this project from dissertation to book. Firstly I owe thanks to Katherine Bowie for her unflagging support of my research, as well as Thongchai Winichakul for both his personal support of my work and for connecting me with Warunee Osatharom, my longtime mentor at Thammasat University's Thai Khadi Institute, to whom I also owe a great debt of gratitude. Among my Thai colleagues, I particularly appreciate the support and feedback I've received from Wongsak and Chanida na Chiang Mai, Ratana (Jaeng) Pakdeekul, Plai-Auw Thongsuwat, Aroonrut Wichienkieow, Ratanaporn Sethakul, Phichet Tanthinamchai, Jirachat Santayot, and Kreuk Akornchinaret of Chiang Mai. From Bangkok (and beyond), I have Ake (Thweep) Rittinapakorn, Lupt Utama, Supatra Chowchuvech, Pat Chiraprawati, and Narisa Chakrabongse to thank for their kind assistance, encouragement, and collegiality.

Among my Western colleagues whose friendship and feedback have also been invaluable to my work: Taylor Easum, Rebecca Hall, Julia Cassaniti, Bonnie Brereton, Kanjana Hubik Thepboriruk, Joel Sawat Selway, Andrew Turton, Volker Grabowsky, and Hillary Disch. My deepest thanks for sharing so generously from your own experience and research on Lan Na/northern Thai culture and history.

Lastly, I thank the friends and family who have provided such tremendous emotional and moral support over the lengthy time it took to turn this research into a readable book—the last five years of which saw me through a career

change, several moves, a separation and divorce, and a remarriage. I am especially grateful for the friendship and support of my uncle John and aunt Carol Woodhouse and my uncle David and aunt Ann Cunningham, as well as close friends Laurie Margot Ross, Marady Hill, Robin Sackett-Smith, and Karri Donahue, without whom I could not have survived these past few challenging years. Lastly, my deepest thanks and gratitude go to my husband Edo, without whom I would truly be adrift. Your love and support have been invaluable—thank you from the bottom of my heart.

Introducing Lan Na, Siam, and the Inland Constellation

THE 1880S WERE A remarkable decade, witnessing the passing away of an old world and the birth of a new one. The time needed to move people and communications across long distances shrunk rapidly with the advent of the Suez Canal, the steam ship, the telephone, and transoceanic telegraph lines. European nations raced to expand their empires around the globe, from the British Raj in India to French Indochina and Dutch Indonesia. This competition imparted a particular urgency to the wild rumor that swept Bangkok in 1882: that Queen Victoria planned to adopt a young princess named Dara Rasami from Lan Na, a small kingdom roughly three hundred miles north of Bangkok, one of Siam's principal tributary states. The threat of such a move greatly alarmed Siam's King Chulalongkorn, as the annexation of Siam's old enemy and neighbor Burma was well underway by the British. And they were not the only European threat: the French were also pressing in on Siam's eastern peripheries from Cambodia and Laos. If such an adoption took place, it would expand England's colonial reach uncomfortably close to Siam's doorstep.

It was nearly unheard of for the Siamese king to reach out to individual families in asking for their daughter's hand, as young women were usually "gifted" to the Siamese palace as consorts (literally in the hundreds at times). But this rumor sparked quite a different response: the king acted quickly, sending a gift of jewels and a letter of engagement to secure Dara Rasami as his royal consort in 1883. Princess Dara Rasami, the only surviving daughter of the ruling line of Lan Na's hundred-year-old Chao Chet Ton dynasty, was at that time nine years old.

Dara's story highlights the intense anxiety and uncertainty that European imperial encroachment in the region caused Siam's rulership in that era. It also illustrates the collision between two very different views of how nation-states defined and controlled their territory. On the one hand, the rumor at the heart of the story reflects a localized awareness of the long reach of European imperialism. The idea of the adoption mirrors that of the young Punjabi Maharaja Duleep Singh, whom Queen Victoria really did bring to England from India and

"raise" as an English gentleman.[1] The Siamese response to the rumor, however, reaffirmed the regional practice of marital alliances between kingdoms, which was firmly rooted in modes of traditional statecraft that had been practiced in Southeast Asia for millennia.

On the other hand, the story disrupts the dominant narrative of Siam as a sovereign kingdom that successfully avoided colonization by adapting to the "modern" political practices of European nations. Not only does it highlight that what is now northern Thailand was until only a century ago a separate and sovereign kingdom in its own right; it also demonstrates how central polygamous practices still were to Thai statecraft during this era. And yet, royal polygyny remains largely untouched by Western historians in their survey of this period of Thai history. Dara Rasami's story raises for us a number of questions that the existing historical scholarship has not bothered to answer: When did the practice of royal concubinage in Siam begin, and when did it end? How did the system of royal queens and concubines work, exactly? Who were the women who became royal consorts, and where did they come from? While we are dimly aware of the fact that polygyny was practiced by the kings of Siam (as well as many other places) until a few decades ago, these questions remain unanswered outside of Thai-language scholarship. Which leads to the critical question: Why?

Tracing the Place of Women in Thai Historiography

Modern Thai historiography was constructed by Siam's royal elites on the nineteenth-century model of European histories, which celebrated the nation-state. In this type of modern history, as Hong Lysa succinctly puts it, "The male-associated activities of building and defending the country against hostile neighbors and colonial threats dominated the historical narrative, in which women hardly featured at all."[2] Ironically, many of these narratives can be traced to the "father of Siamese history," Prince Damrong Rajanubhab, who was himself both a product and a practitioner of polygyny.[3] Though Damrong himself wrote important historical accounts of Siam the nation, the practice of royal polygyny is notably absent from them.

Western historians have perpetuated the disappearance of polygyny from Siam's political history in twentieth-century scholarship. The seminal English-language political histories of late nineteenth-and early twentieth-century Siam emphasize the activities of its "modernizing" monarchs: King Mongkut (Rama IV, r. 1855–68), his son Chulalongkorn (Rama V, r. 1868–1910), and grandson Vajiravudh (Rama VI, r. 1910–25).[4] The scholarship focusing on King

Chulalongkorn depicts his reign as an era of rapid—and successful—modernization, viewing it in terms of the systemic administrative changes undertaken by Chulalongkorn and his team of half-brother ministers. On the rare occasions royal women or consorts are mentioned in these works, it is in passing. If, as Joan Wallach Scott puts it, "political history has . . . been enacted on the field of gender," then these ostensibly political histories obscure the roles of women in their assumption that Siamese statecraft was by default driven exclusively by men.[5]

Historians of that generation may well have been made suspicious of the topic of palace women by the efforts of a lone forerunner in the field: Anna Leonowens. Her 1870 book, *The English Governess at the Siamese Court: Being Recollections of Six Years in the Royal Palace at Bangkok*, brought her literary fame in both England and the United States, although her claims to both Englishness and her status as a governess have been largely debunked.[6] Leonowens continued to capitalize on her unique experience in exotic, erotic Siam in her second book, *The Romance of the Harem* (1872). In both texts, Leonowens plays up slavery, the hot button issue of the day, to align her portrayal of the women of the Inner Palace, the walled palace-within-the-palace where the king's consorts and female relatives lived, with those of the decadent harems of India and Ottoman Turkey—already a well-established and marketable literary genre by the 1870s.[7] In Leonowens's Siamese harem, every woman was enslaved, subject to the whims of a tyrannical and capricious king. The Thai objections to these works and their subsequent adaptations into film and musical forms have resulted in their being banned in Thailand.[8] Whether out of distaste for Anna's titillating treatments of the subject, or for the perceived political illegitimacy of the Siamese harem, historians have avoided tracing Anna's footsteps into Siam's Inner Palace for nearly 150 years since her departure from Siam.

Finding Lost Palace Women: Materials, Methods, and Approaches

The absence of palace women in the scholarship is due in some part to the challenges that face any researcher in Thai history. The archival records of the Inner Palace are sparse, and the documents that do exist offer slender but deep pockets of data on a very limited number of aspects of royal life (legal cases and medical care, in particular).[9] The habit of keeping personal diaries and daily journals, so common among Western royal figures in the same era, was not practiced by Siamese royals. There are several possible reasons for this absence: while illiteracy or inconvenience could be the culprit, I suspect that Thai

cultural presentism—which privileges staying up-to-date with current trends over adherence to past tradition—devalued the act of recording the minutiae of daily life. Given the high status of the inhabitants of the Inner Palace, however, such personal accounts could actually have been dangerous for palace women to keep, due to their royal subject matter. It simply may have been safer to keep one's secrets, critiques, and complaints to oneself, rather than risk written words falling into the wrong hands. This is where rumors become especially important to the narrative: as anonymous reservoirs of memory that could circulate freely without consequence to their originators.

To construct a comprehensive picture of the social world of King Chulalongkorn's Inner Palace, the scholar must draw from a broader range of source materials, many of which can be found only outside the traditional archive. Many details of life in the Inner Palace can be gleaned from the memoirs of women who lived and worked there, or in works of historical fiction (such as Kukrit Pramoj's *Four Reigns*). Cremation volumes, which are biographical memorial volumes published in conjunction with an individual's funeral events, make up another significant source of accounts of life inside the palace. Another important source is oral history: interviews with surviving palace ladies and other royal descendants, like *Mom Chao* Jong Jitra Thanom Diskul, a daughter of Prince Damrong and niece of King Chulalongkorn, who was interviewed in later life by prominent Thai scholar and social critic Sulak Sivaraksa.[10] Last but not least, museum collections, textiles, and photographs (of which there are many for the Fifth Reign) provide a tremendous trove of data for the cultural historian of this era. Thus the research for this book has drawn on a broader notion of the archive, pulling from written, oral, visual, and material "documents" to construct a picture of the lives of the Lan Na women who lived within King Chulalongkorn's palace.

In keeping with my use of a broader cultural archive, I also attempt to include as many visual images as possible to aid the reader in imagining the space and environment of the Siamese palace afresh. Thus each chapter is accompanied by illustrations and images to complement the written narrative.

Chapter Themes and Arguments

My next section begins by familiarizing the reader with the geography and early history of Dara Rasami's homeland, Lan Na. I situate the kingdom as part of a greater Inland Constellation of city-states between Burma and Laos. I intend this model to decenter the notion of Lan Na (and its neighboring polities) as

"northern," as it is only so from a Bangkok-centric view of the region. The cultural, geographic, and economic background I discuss in this chapter demonstrates Lan Na's distinctiveness in contrast to Siam and sets the scene for the events of the mid-to late nineteenth century. At that time, Lan Na's loyalties to Siam came into question as Britain consolidated its colonial presence in Burma, and British-Burmese loggers increasingly conflicted with Lan Na's rulers. Rumors that the Queen of England wanted to adopt young princess Dara Rasami played on Bangkok's colonial anxieties in that moment, prompting the Siamese king to extend an offer of engagement to Dara's family. The resulting marital alliance of Dara Rasami and King Chulalongkorn, intended to cement the political relationship between Lan Na and Siam, illustrates the contingency of the historical moment produced by European colonial encroachment in the region.

Chapter 2 examines Dara Rasami's career in the world of Siam's Inner Palace. This female-only environment, which was off-limits to the male Westerners of the time, has long been incorrectly assumed to be a harem in the same sense as Ottoman Turkey or Mughal India. The Inner Palace, considered an oriental seraglio, obscured from Western eyes the real political power relationships created and expressed there. Nonetheless, the Inner Palace represented the embodiment of the monarch's political reach: a microcosm of the Siamese polity, where the peripheries were represented quite literally by women's bodies.

To analyze Siamese royal polygyny, I depend on a notion of the "circulation of bodies" adapted form Marx's theory of money, wherein value accrues through circulation and movement (or the restriction thereof). This notion illuminates the idea that premodern Thai statecraft depended on a currency of human bodies—particularly those of palace women—as an important part of its political economy. This metaphor also speaks to the "geo-body" described by Thongchai Winichakul in *Siam Mapped* and the mapping technologies by which Siam's political landscape was reshaped during King Chulalongkorn's reign.[11] I challenge Thongchai's characterization by showing that the bodies of palace women—and Dara Rasami in particular—continued to function as political currency throughout the Fifth Reign era.

In chapter 2, I explore the notions of circulation and social currency that governed the seclusion of elite women and the idea that high status equated to invisibility in the traditional Siamese worldview. As the highest stratum of Siamese elite society, the Inner Palace represented a cultural crucible within which Siamese culture was produced and reproduced. Here I also consider Dara Rasami's social and political significance in terms of space and proximity to the king himself. I also consider the various ways in which her life (and that of her

ladies-in-waiting) in the palace was shaped by the distinctly Siamese customs that informed the culture of the Inner Palace. Dara Rasami's early palace career reflects the politically central role played by provincial consorts like herself, and how their lives in the palace—as hostages for their family's loyalty—ultimately depended on Siam's king himself.

Chapter 3 explores the ways in which Dara Rasami performed her ethnic difference from the Siamese within the palace in her later career: in particular, through her hairstyle, dress, her participation in dance-drama productions, and through different gestural forms. Even as her value as a political pawn declined toward the end of the nineteenth century, Dara exemplified how palace women's roles took on new significance in creating and expressing notions of *siwilai*—the Siamese hierarchy of civilizations—in the early twentieth century. A new cultural hierarchy was formulated through the presence of Dara Rasami (and other cultural outsiders) as "Others within" Siamese elite society, in cultural expressions like the Siamese adaptation of *Madame Butterfly*—titled *Sao Khrua Fa*—and other dramatic works.[12] As the Siamese aspired to incorporate modern notions of the hierarchy of civilizations—or siwilai—into their worldview, Dara Rasami provided an immediately accessible, elite yet non-Siamese Other. At the same time, Dara retained enough agency to push back against the Siamese definition of her as a "Lao lady." Using the notion of strategic essentialism—deploying an essentialized version of a minority's identity to resist domination by a hegemonic majority—Dara consciously reshaped the discourse around Lan Na identity, ultimately improving both her own status and Siamese perceptions of her homeland and its people.[13]

Strategic essentialism also helps us understand the events of Dara's later life, which I trace in chapter 4. This chapter examines the final phase of Dara Rasami's life following King Chulalongkorn's death in 1910 and the nearly twenty years between her retirement to Chiang Mai in 1914 and her death in 1933. Looking at Dara's later life and activities in her hometown reveals her ongoing interest in cultivating certain elements of Lan Na's cultural and economic uniqueness, and her efforts to promote the educational and agricultural interests of Chiang Mai's people. This chapter also discusses how Dara Rasami's memory has figured in Chiang Mai over the decades since her death. While one would imagine that Dara would be considered an elite insider as a member of Chiang Mai's old royalty, the many years she spent in Bangkok turned her into a cultural outsider by the time of her return in 1914. Comparing her with Lan Na contemporary, rebel monk Khruba Srivichai, reveals that Dara's memory has evolved into a touchstone for the conservative royalist faction of the local elites, while Khruba

Srivichai's memory is evoked by groups at the more populist end of the political spectrum (including the Red Shirt movement that backed former Thai prime ministers Thaksin and Yingluck Shinawatra). The ongoing tension between these two political poles affects how Dara Rasami's memory has been maintained and expressed in contemporary Chiang Mai.

The political fortunes of Siam's elite women were subject to a similarly ambiguous fate, which I explore in the final chapter. In the space of a single generation after King Chulalongkorn's death, royal polygyny fell out of vogue with Siam's monarchs (beginning with Rama VII, King Prajadhiphok, r. 1925–33). After 1932, when Siam became a constitutional monarchy, the new political system provided no equivalent spaces for women's participation. As the consorts of Dara's generation lived out their days secluded in their luxurious residences, palace women faded from Siam's political and cultural center. With the expansion of Bangkok's bureaucratic middle class in the early twentieth century, the debate about the moral and social implications of polygyny moved to the public sphere, where the practice of keeping multiple wives was criticized as a mark of elite decadence and corruption. Ultimately, Thai marriage law was written to recognize only a man's first wife and their children, without outlawing additional marriages, though subsequent spouses and their offspring were deprived of rights in the case of inheritance and divorce. Though royal polygyny fell out of favor after the reign of King Vajiravudh (r. 1910–25), its recent resurgence reminds us of the fact that it was never formally forbidden under palatine law.[14] Its contemporary usage, however, reflects a totally different view of the political roles embodied by royal concubines in the current Thai state.

This analysis of Dara Rasami's political and cultural roles as a consort during Siam's Fifth Reign provides fresh historical perspective on the regional history of Southeast Asia, Siam's political history, and the role of the Inner Palace as a crucial intersection of the two.

Lan Na and Siam: Stars in a Shifting Constellation

To most people residing outside Thailand, the term Lan Na has little significance. Even for most modern Thais, Lan Na brings to mind a kingdom from Thailand's ancient past, whose relationship to Thai history they only vaguely understand. But Lan Na's history and cultural orientation is quite distinct from Siam's, and it is this distinctiveness that deeply informed Dara Rasami's worldview, making her an outsider to Siamese culture when she arrived in Bangkok to marry the king of Siam in 1883. Her role in bridging the great cultural and

political differences between her homeland and Siam are what make her story both historically significant and personally compelling.

Lan Na was once a kingdom on par with Siam or Burma, with a distinct language, social structure, and cultural traditions of its own. However, these differences have been largely obscured by the dominant historical narratives of the Thai nation-state, which minimize the extent of Siam's expansion of control over neighboring city-states by describing it as "bringing them under the protection of the Siamese [royal] umbrella." To combat this act of historical erasure, we must reorient our view of Lan Na's role in the regional economy and politics. This move, in turn, will demonstrate the significance of Dara Rasami's alliance with the Siamese king in the late nineteenth century.

Lan Na's historical territory comprises what are today Thailand's eight northernmost provinces: Chiang Mai, Lamphun, Lampang, Chiang Rai, Phayao, Phrae, Nan, and Mae Hong Son.[15] At one time or another, Lan Na has included parts of what is today upper Burma, Sipsòng Panna in China's Yunnan province, Thailand's northern and northeastern regions, and northern Laos. As this region is northern only in terms of how it is viewed from Bangkok, I prefer to reframe it as an Inland Constellation. This term both denotes the polities' landlocked inland location and references Stanley Jeyaraja Tambiah's notion of the "galactic polity."[16] Reframing the region in this way also helps account for the constantly shifting group of city-states—*muang*—whose peripheries often overlapped, fluctuating with the waxing and waning of the political strength of capital cities at their centers, and the pull of neighboring states. These muang and the satellite polities under their control were linked by commonalities of geography and economy that created shared elements of culture and religion.[17] Whether or not geography is destiny, the particular political and environmental challenges posed by this physical landscape produced a cohesive cultural environment in Lan Na that was highly distinct from (though sometimes influenced by) those of Burma, China, and Siam.[18]

The physical characteristics of the Inland Constellation's terrain are markedly different from those of central Thailand. Starting north of today's city of Phitsanulok, the terrain rises sharply to high, thickly forested mountain ranges separating many narrow, flat river valleys. These mountain ranges, which run mostly from north to south, are extensions of the Yunnan mountain ranges of southern China and the eastern Himalayas. The snowmelt waters winding through these ranges flow into the Mekong River to the east, the Salween in the west, and Chiang Mai's Mae Ping River, into a host of tributaries that feed the Chao Phraya River in the central Thai plains, facilitating trade, travel, and communications

in the region.[19] The mountainous terrain provided rich resources for both hunter-gatherers and small-scale agriculturists. However, it also made overland travel difficult and slow going, and even movement on the waterways was largely limited to the rainiest months of the year (typically July through November). These geographic factors made it essential for settlers to choose sites that could remain largely self-sufficient for much of the year.

The narrow riverine highlands and valleys, while resource rich, were sparsely populated compared to the wide, flat lowlands of Siam. Due to the steep, mountainous terrain separating them, Lan Na's small river valley communities had limited farmland, necessitating periodic interaction with other communities for continued survival. Thus the much-vaunted self-sufficiency of northern villages was largely mythical.[20] In reality, most Lan Na village economies depended on their ability to trade local crops and goods with larger towns in exchange for supplemental rice and necessities like salt. Additional trade came from seasonal visits from overland caravans traveling between Burma and China. A number of such caravans linked in turn to the tea trade route even further north called the Tea Horse Road, which stretched between Sipsòng Panna and Tibet.[21] At the same time, rivers also served as trade routes running north and south through the steep valleys, giving overland routes connections to entrepôts with oceanic access, such as Phitsanulok in the west and Luang Prabang in the east.[22] Traders brought a continuous flow of cultural and religious elements to the towns of the Inland Constellation, from crafts and textiles to religious concepts and practices. Another characteristic shared by the people of Lan Na and the rest of the Inland Constellation was a preference for glutinous (sticky) rice, versus the long-grain rice grown in Siam's low-lying Chao Phraya River basin.[23] Such trade flows gave Lan Na's cultural and economic exchanges a markedly inland orientation, in contrast to the distinctly oceanic orientation of the Siamese entrepôt kingdoms of Ayutthaya and Bangkok (which we could think of as part of a Maritime Constellation, á la Anthony Reid's formulation).[24]

Enduring Patterns: Lan Na, Burma, and the *Khon* Muang

Informed by these geographic and physical constraints, Lan Na's rulers favored a style of rulership that depended on familial connection, in which women played a key role. Thirteenth-century King Mangrai, for example, not only arranged marriages with a number of local women to consolidate his political authority, but also arranged his sons' marital alliances with the daughters of neighboring kings in order to align the loyalties of the satellite cities with the capital

at Chiang Mai.[25] This pattern of "daughter-in-law" succession he established, which granted local women important roles in localizing the rule of invading rulers, persisted as the dominant political pattern in Lan Na until the late nineteenth century. The practice was distinct enough from those of its neighbors to warrant special mention in Ming dynasty chronicles, where Lan Na was described as "the land of 800 daughters-in-law."[26]

By the mid-sixteenth century, Lan Na became desirable to the Burmese as a northern base for their incursions into central Siam. In the 1560s, the Burmese took advantage of political instability in Lan Na to take control of the region, marking the start of a period of indirect colonial rule and cultural continuity. The potential for rebellions was quelled by deporting most of Lan Na's noble families to Burma; whatever relatives remained were forbidden to intermarry, effectively disrupting the old networks of marital and kinship ties between the constellation's muang and allowing the Burmese to divide and rule. The long-term Burmese presence in Lan Na imparted certain influences to local foodways, dress, and language.[27] Nonetheless, Burmese control was strongest in Chiang Mai and Chiang Saen, while it was much looser in the farther-flung muang of Nan, Phrae, and Lampang.

By the eighteenth century, Burma's efforts to impose changes in Lan Na were felt to be increasingly oppressive, and sporadic rebellions erupted on the peripheries. After a Chinese invasion in 1771 weakened Burmese control, Lan Na's remaining nobles were able to oust the colonial official from Chiang Mai. When the rebels got word to the Siamese General Taksin at Bangkok, he rapidly sent troops to assist them in Chiang Mai and Lampang.[28] As Siam's Chakri dynasty began in 1782, Kawila was crowned king of the refounded Lan Na kingdom. However, the capital he inherited was nearly desolate, having suffered decades of warfare and wholesale deportation of its populace. According to a chronicle of the era:

> At that time Chiang Mai was depopulated and had become a jungle overgrown by climbing plants, it turned into a place where rhinoceroses, elephants, tigers and bears were living. There were few people [left], only enough for building houses to live in and roads to facilitate communication with each other. Thus, there were no opportunities for clearing [the jungle].[29]

Before the king could take up residence in Chiang Mai once again, the capital needed to be rebuilt. The new king then embarked on a process of repopulation and resettlement called "putting people into cities as vegetables into baskets."[30]

The first step was persuading several groups who had fled the area to return: some were residents who had fled to Mae Hong Son in the 1760s and from Tak and Lampang to Siam some twenty years before. Though this process met with some success, "the severe losses of population caused by war, famine, and epidemics could . . . hardly be compensated for" by voluntary migration.[31] Consequently, Kawila embarked on a long-term campaign to resettle Lan Na's cities in three waves: the first from 1783 to 1786, the second from 1798 to 1804, and the final wave lasting from 1808 to 1813.[32] Though some of these efforts began with rulers sending gifts to the local elites to entice them to relocate their villages, more often than not they ended with military forces rounding up people and forcibly moving them to Chiang Mai[33]—a process which often cost many lives.[34] To the east, the regional center of Nan, which had also sworn allegiance to Siam but was unconnected with Chiang Mai's ruling elites, similarly repopulated their villages with people from Sipsòng Panna.[35]

These campaigns resulted in an ethnically diverse population, including the Lüe of Sipsòng Panna, the Khoen of the Chiang Tung area, and the Tai Yai from the muang of Sat, Pan, and Phu.[36] These resettled peoples "were seen by the Yuan not at all as *khon tang chat* [foreigners], but were viewed as people belonging to a greater Lan Na cultural zone," since they spoke mutually intelligible dialects and utilized a similar writing system.[37] There were also numbers of Karen, Lawa, and other upland peoples among the war captives. Following preexisting patterns of cooperative upland–lowland relationships, these peoples were seen as semicivilized, and thus appropriate for urban resettlement. These groups were allocated land in the outlying areas surrounding the walled center of the capital city and their populations scattered across multiple communities to prevent uprisings. In and around contemporary Chiang Mai, a number of these communities still bear place names that reflect the origins of these resettled peoples, who often named them for their home villages.[38]

From this ethnic diversity sprung the khon muang identity (literally "people of the muang," a muang being a village, town, or city) in Lan Na. This supraethnic category was forged by Lan Na's rulers—themselves ethnically Yuan—as a coherent identity for the peoples recently resettled from the hinterlands.[39] As a multilayered identity, which allowed relocated highland peoples to retain elements of their ethnic difference, khon muang came to denote blended Lan Na lowland city and village dwellers over decades of intermarriage and exchange. While resettled groups' linguistic and ethnic heritage was never erased, it was subsumed by khon muang identity, distinguishing Lan Na city dwellers from their upland counterparts.

To the central plains Siamese, however, the definition of khon muang depended on the situation: sometimes individual ethnicities were names (as in the Yuan, in particular, as that was the ethnicity of the ruling elites); however, the Siamese most often referred to khon muang as Lao, which was more a reference to their shared language than either geography or ethnicity. This may be confusing to present-day observers familiar only with the nation-state of Laos. What is important here is that the territory of Lao speakers then encompassed the territory from Phitsanulok in the south to Chiang Rai in the north, and from Burma in the west to Luang Prabang in the east. Thus, when the term Lao is used in this text, it should be understood as the exonym for the khon muang of Lan Na as perceived by the Siamese.

Shifting Economies, Shifting Allegiances: Lan Na in the 1850s

Lan Na scarcely had time to enjoy its newfound peace and prosperity before global events destabilized the balance of power in the region once again. In faraway England, the dispensations of the 1824 Treaty of London gave Britain control of the trade ports of Ceylon (India), Malacca (Indonesia), Singapore, and Penang (Malaysia). British rule in northeastern India culminated in the first Anglo-Burmese War (1823–26), forcing the Burmese to sign exploitive treaties that financially devastated the kingdom. The defeat of Burma—an old enemy of both Lan Na and Siam—made Great Britain the dominant European power in the region. Even more worrisome, however, was British control of the territory of Tenasserim, which shared the common boundary of the Salween River with Chiang Mai. For the first time, Lan Na and Siam were confronted with a Western colonial power as an immediate neighbor.[40]

At the same time, Siam was experiencing problems on its eastern frontiers as well. Possibly influenced by news of the British victory in Burma, the king of Vientiane (Laos), *Chao* Anouwongse, launched a military offensive southward toward Bangkok in 1827. This incursion has been interpreted differently by Siamese and Lao historians. Was it an attempt to reestablish the ancient kingdom of Lan Xang, an effort to "liberate" thousands of Lao who had been resettled by the Siamese in Nakhon Ratchasima in the 1770s, or a preemptive strike against "Thai aggression" aiming to dismantle Lao independence entirely?[41] In either case, Chao Anou's campaign was seen as a sign of aggression by the Siamese, who responded quickly and ruthlessly. In addition to destroying Chao Anou's capital city of Vientiane, the Siamese deported its entire population (estimated conservatively at one hundred thousand people)

from the east bank of the Mekong River westward to the interior of Siam's Khorat Plateau. After Chao Anou's capture in 1828, he was taken to Bangkok and imprisoned publicly in a cage, where he died after several days of direct exposure to the punishing forces of both the blistering sun and the derision of the Siamese populace.[42]

Why did the Siamese treat a former vassal so brutally? The open rebellion of one of its tributary rulers—particularly a Buddhist one—was perceived as undermining the dharmic authority of the Siamese king. As European pressure increased on both Siam's eastern and western frontiers, a harsh response signaled Siam's intolerance of internal challenges to their monarch's increasingly centralized power. For Lan Na, whose nobles' loyalties were somewhat divided over the episode, Siam's message was clear as to the fate awaiting any vassals foolish enough to openly display disloyalty to Bangkok.[43]

Meanwhile, in Lan Na, the increasing British presence in the region did not appear to threaten the local rulership—quite the contrary. On the conclusion of the First Anglo-Burmese War (1825), Lan Na's king sent a number of letters to the British at Moulmein (Burma) requesting formal contact, presumably to establish trade relations.[44] The British development of Moulmein into an inland trade center increased the flow of trade between Chiang Mai and Burma, and initiated two new industries that would quickly become major revenue streams for Lan Na's nobles: cattle and teak.

Starting in 1826, British troops stationed at the Moulmein garrison required a steady supply of beef, as standard rations for British soldiers included a pound of fresh beef per soldier per day. When the garrison was smaller, the average demand was about seven hundred head of cattle per year; by the later 1830s, demand had grown to 2,500–3,000 head per year.[45] The "Shan bullocks," as they were called, were considered higher quality beef than either buffalo meat or the flesh of cows from Madras or Bengal, and their worth was accordingly higher. In 1841, for example, around two hundred Moulmein traders were said to be waiting to buy cattle in Chiang Mai with one hundred thousand rupees—a sum that could purchase up to five thousand head.[46] Cattle remained the most profitable export from Lan Na until the mid-1850s, then only surpassed by the value of teak in the 1860s as the forests were depleted.[47]

As cattle and teak became the most profitable export products, the Lan Na economy's center of gravity shifted westward to British Burma. However, it was not until Siam's attempts to extend their political control over Lan Na in the 1850s that the relationship between the two *mandalas* became strained nearly to the breaking point.

Turning Point: The Chiang Tung Wars, 1848–54

Following a succession crisis in 1848, the Lan Na muang of Chiang Rung requested Siamese military assistance in quelling civil unrest. During this crisis some of the city's nobles fled to (now British-Burmese) Chiang Tung, where they sought the support of local Burmese nobles, highlighting the fluid relationship that still existed among the Burma–Lan Na muang of the old constellation.[48] The Siamese chronicle of the time quotes Siam's King Rama III as stating, "If we can subdue Chiang Tung, Chiang Rung will be ours."[49] To this end, the Siamese king authorized Chiang Mai to conscript a total of 7,500 men to attack Chiang Tung, but the expedition was ultimately a failure.[50]

When Siam's King Mongkut (Rama IV) inherited this enterprise from his older brother in 1852, Chiang Rung had requested assistance once again—but this time, the Siamese felt Siam's reputation was at stake. This time, the conscripts from cities throughout Lan Na, plus troops sent from Bangkok, totaled thirty thousand.[51] Though King Mongkut sent his own brother, Prince Wongsa Thirat, to head up the new offensive on Chiang Tung, the effort was plagued by both tactical and supply problems; food supplies ran out due to a bad harvest in Chiang Mai that year.[52] By the time the troops from Bangkok arrived to relieve Lan Na forces, they heard that the Burmese were sending reinforcements and withdrew, ending the offensive.

Meanwhile in Burma, since Britain's victory in the Second Anglo-Burmese War of 1853, its trade monopoly in Burma's rice-rich delta region was solidified, forcing Burmese King Mindon (r. 1853–78) to seek out new sources of state income. King Mindon was described by Western observers as a forward-looking, modernizing" monarch (in much the same vein as his Siamese contemporary, King Mongkut). As the British export of most of Burma's rice production depleted Burma's economy, the monarch hastened to find new ways to generate income. Mindon's strategy was twofold: he established industrial factories at Mandalay and encouraged trade with southern China, the Shan States, Lower Burma, India, and Europe to offset the loss of agricultural revenues to the royal coffers.[53] These efforts increased the level of trade (and the number of Burmese traders) flowing between upper Burma and Chiang Tung and into southern China in the 1850s.

Siam made one last attempt to retake Chiang Tung in 1854, but it was also unsuccessful. Though King Mongkut and his ministers wanted more than ever to take the outpost once and for all, it proved impossible to gather the thirty to forty thousand additional soldiers that the Siamese needed. Many local

conscripts fled, leaving the commanders with fewer than ten thousand troops. The timing of the new offensive also coincided with the start of the rainy season, making overland travel difficult and oxcart transportation of provisions all but impossible. By all accounts, Lan Na's heart just was not in it: the lack of support by the local nobles and abysmal troop morale were the main reasons why the campaign was finally abandoned.[54]

In material terms, however, the losses suffered by Siam in the offensive were paltry compared to those endured by Lan Na. Not only had Siam ignored Chiang Mai's requests to delay the final attack, but it was Lan Na—not Siam—whose cities had borne the loss of the humanpower expended in the offensive. Siam, as Lan Na's supposed protector, had failed them, and at a high cost. Additionally, Lan Na still had both family and economic links with Chiang Tung, now a rapidly growing trade center that Lan Na could ill afford to alienate. The period following the Chiang Tung Wars of the mid-1850s found Lan Na scrambling to recover from the significant human losses it suffered through Siam's failed military campaign, and to repair its relationship with an important trade partner in the region. As for Siam, they had lost face to both Burma and Lan Na and gained nothing on their northern frontier. If anything, the necessity of King Mongkut's intervention in matters of Lan Na's succession in 1855 highlighted Siam's lack of control over their peripheries in Lan Na and the increasing contingency of the regional situation of the British presence in Burma.

Testing Lan Na's Loyalties to Siam

In the 1840s, Burmese loggers, now British legal subjects, began making their way into Lan Na's forests in increasing numbers, cutting teak logs to send to Moulmein for processing and sale. Heretofore Lan Na's forests had been considered the property of the royal family: they were traditionally viewed as a local building resource, rather than a source of commercial income. At first, there were no fixed fees for cutting trees in Lan Na; individual loggers negotiated a per-tree price, which was collected by officials and divided three ways between the forest owner, the collecting official, and finally the ruler himself.[55] During the 1850s, however, the policy changed as the forest trade rapidly expanded. Fees were revised and separated into three categories, depending on the size of the tree cut. For example, a tree measuring eight-to ten-hands' breadth cost one rupee; eleven to thirteen hands cost two rupees, and fourteen to sixteen hands cost three rupees. These fees went up over time, presumably as the forests of

upper Burma were depleted; by 1896 (when Siam established its Department of Forestry) the fee had risen to twelve rupees per tree.[56]

The rising value of teak forest leases led to a corresponding rise in the number of disputes with the nobles of Chiang Mai. King Kawilorot (r. 1854–70) was involved in a number of legal disputes with British-Burmese parties in Chiang Mai, for which he was summoned to Bangkok to defend himself in court. Though he ultimately won his case, the handling of the matter by the Siamese resulted in the northern chao leaving Bangkok resentful and with hurt pride.[57] Absent any other means of controlling Kawilorot, Siam's King Mongkut decided to adopt a policy of appeasement toward the Lan Na rulership.

In 1856, rumors about the loyalties of Chiang Mai's king began to circulate. Apparently King Kawilorot found the anti-Western attitude of the Burmese elite more appealing than the conciliatory stance of the Thai.[58] After a round of correspondence with the Burmese king at Ava, King Kawilorot allegedly ordered the execution of his Burmese translator, so that no one could divulge the nature of their communications. Kawilorot's exchange of elephants with the Burmese king was reported to Bangkok by two members of a rival faction in the Chiang Mai court. Unfortunately for them, when Kawilorot was called to make his case to King Mongkut in Bangkok, he managed to convince Mongkut that his activities were innocent, and he carried the day. Kawilorot's rivals, in turn, were held in Bangkok where their questionable loyalties could be more closely monitored.[59]

This episode demonstrates Kawilorot's dissatisfaction with Lan Na's place in Siam's tributary scheme and his consideration of a plan to realign Lan Na with a powerful old neighbor who had had its own recent troubles with Western interests. Though Kawilorot's original scheme to align himself with a northern Burmese king may ultimately have failed, his brilliant—if duplicitous—performance in Bangkok resulted in both his vindication in the eyes of the Siamese and the elimination of his political rivals in Chiang Mai.

This episode provided an instructive example to Lan Na's nobility as to how they should best manage their role in the region's shifting political balance of power. First, they learned the power of rumor, by which threats could be made indirectly to the Siamese while maintaining plausible deniability. Second—and perhaps more importantly—Lan Na had learned the advantage of playing Burma and Siam against each other. These lessons were passed down to the next generation of Lan Na's rulership: Kawilorot's daughter Thipkraisorn (figure 1) and her husband, Inthanon, who became the next rulers of Chiang Mai in 1870.

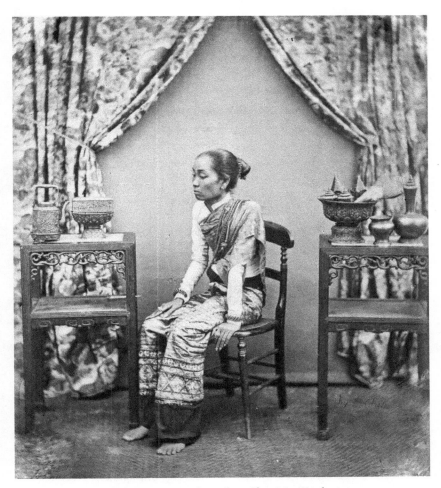

FIGURE I. Dara Rasami's mother, *Chao Mae* Thipkraisorn (ca. 1880). Wikimedia Commons/public domain.

The 1874 Chiang Mai Treaty: Undermining Lan Na's Autonomy

In 1873, the year of Princess Dara Rasami's birth, two other major political events occurred in the region. First, the young Siamese king, Chulalongkorn, was finally crowned, having spent five years under a regent following the death of his father, Mongkut, in 1868. Second, in Lan Na, Dara's father Inthanon was officially recognized by Chulalongkorn as successor to the throne of Chiang Mai. On Inthanon's annual visit to Bangkok that year, he received the title of

chao luang (high king) of Chiang Mai and was given the enhanced reign name of Inthawichyanon. However, his visit was not entirely triumphant: not only did he not receive the higher title he was hoping for on this occasion, but he was also saddled with fines from legal cases left over from the prior king's reign. These fines, totaling 466,000 rupees, were too much for the new king to pay at one time, so a seven-year period was granted for repayment.

This fine reflects the increased importance of the teak trade in Lan Na—but also the increasing concerns of the Siamese over the dealings of the Lan Na nobility in teak-related disputes with British-Burmese loggers. By 1851, the annual income to the Chiang Mai nobility from timber leases had spiraled to nearly 150,000 rupees, plus nearly as much in bribes and fees charged by nobles.[60] British officer Thomas Lowndes, sent from upper Burma in 1871 to survey the situation in Chiang Mai, described frequently overlapping forest tract leases and cases of outright double-leasing by local nobles.[61] Conflicts over these problematic leases, thefts, and unresolved lawsuits resulted in British demands for Siamese intervention. By 1873, the British government in India was actively campaigning in Bangkok for an agreement that would guarantee their subjects greater protection in their timber dealings in Lan Na.

The Chiang Mai Treaty was concluded rather hastily in 1874 between the British Indian government in Calcutta and the Siamese in Bangkok.[62] The treaty's name is ironic, as in reality Chiang Mai rulership played no part in drafting the document. Though the British requested that Chiang Mai's king be included in the negotiations, the Siamese demurred, claiming that his involvement would lengthen the already-long negotiation process by at least four months, to allow for the necessary travel time between Chiang Mai and Bangkok—a delay that the British rejected. Thus the Siamese and British excluded Lan Na's rulers from drawing up a treaty that would affect the local economy, judicial practices, and ultimately Lan Na's sovereignty itself.

The 1874 Chiang Mai Treaty included several provisions that directly affected Chiang Mai's governance. First, a system of dual government was established, with a full-time resident Siamese *kha luang* (royal servant) or commissioner stationed in Chiang Mai. The second provision established a permanent police force to monitor posts along the Salween River to prevent thefts and banditry on loggers traveling through the area. Third, new regulations were put in place to control the leasing of teak forests. Last, a new system of taxes and monopolies was introduced that greatly impacted Chiang Mai's economy and society.

Under the new dual government, the Siamese kha luang investigated and adjudicated all legal cases brought by British subjects against Lan Na or Siamese

subjects in Chiang Mai's international court.[63] These cases, which consisted mainly of disputes involving timber leases between British-Burmese loggers and local forest holders, were to be heard by both the Siamese commissioner and the British consul (who visited only periodically). Those charged with regular criminal offenses were to be tried in the Siamese courts regardless of their nationality, and if a British subject was unhappy with the Chiang Mai court's decision, the case could be sent to the British officer in Burma for review.[64] This gave Burmese-British subjects a differential level of legal protections in Siam, as they could demand the application of British law rather than Siamese law to their cases—which greatly increased their chances of defeating Lan Na defendants, who were usually forest-leasing nobles.

The new tax farms and monopolies created by the treaty also undermined the authority of Chiang Mai's nobility, even while filling their coffers. The new tax farms were licenses auctioned off to the highest bidder that granted holders the right to collect specified taxes from the populace on behalf of the government. As these auctions required substantial up-front investment, accessible to few common folks in either Siam or Lan Na, licenses were usually won by members of the Chinese merchant class, which had access to larger cash reserves. Monopolies on the sales of commodities like sticklac, betel nut, and cloth—worth several thousand British pounds annually—had in the past been the province of the local nobility. Under the new structure, they were bought up mainly by Chinese tax farmers "hitherto unknown in the state."[65] While Chinese immigrants had freely flowed into provincial Siam and Lan Na via both Bangkok and Yunnan since the 1850s, the new tax farming system prompted a new influx. As part of the new tax system, the Siamese commissioner also created new tax monopolies on guns and ammunition, tobacco, ivory, pork, and rice whisky.[66] Due to Chinese tax collectors' "social and spatial distance from the local people," they did not feel obliged to trade as fairly with local people as Lan Na's nobility.[67] Additionally, these new tax collectors insisted on payments in cash rather than goods-in-kind—a practice that became increasingly burdensome on the common populace of Lan Na.

The Siamese commissioner also profited personally, setting up a number of tax farms and monopolies that benefitted both himself and the Siamese king. He persuaded the Chiang Mai king to divide the new tax and monopoly incomes into three parts, with one third paying for the administrative expenses of the kha luang himself.[68]

As for the rest of the new tax income, however, most went into the pockets of the highest-ranking Lan Na nobles. Besides the income from teak, the monies

brought in by monopolies on gambling and cloth increased the Chiang Mai ruler's income to roughly 280,000 rupees a year—a lavish sum in the 1870s.[69] To understand the impact of this income on the lifestyles of Chiang Mai's elites, we can compare the accounts of two Western travelers to Chiang Mai both before and after the establishment of the new tax system. An 1871 account describes the houses of Chiang Mai's king and his next-in-command as "merely substantial, but rather plain, wooden houses with tile roofing."[70] In 1876, only a year after the implementation of the new tax farming system, Lowndes reports that the houses had become built up like "enormous edifices, broken up into gables and separate roofs that give them the appearance of small villages. The houses of the other chiefs are large, rambling structures, but considerably smaller than the above."[71]

The Chiang Mai Treaty of 1874 effectively increased the incomes of the ruling elites through extractive tax measures imposed on the common people. Yet the actors most closely identified with the exploitative taxes and monopolies were not the nobles themselves, but the new Chinese tax collectors. By utilizing outsiders to implement the unpleasant new measures, Lan Na's chao insulated themselves from criticism by their subjects, even as they profited from their complicity with the Siamese administration. At the same time, the Siamese government mollified Lan Na's rulership by increasing the level of income derived from the new tax system, effectively buying off Lan Na's senior chao to distract them from the very real loss of their political autonomy.[72]

Thus the Chiang Mai Treaty of 1874 set in motion a number of policies that began to undermine the traditional social and economic ties between the Lan Na *nai* (elites) and *phrai* (commoners). It also marks the beginning of Lan Na's long transition to a cash economy. But the treaty's ultimate failure to enforce British claims in Lan Na eventually resulted in an even more intrusive agreement in 1883: the second Chiang Mai Treaty.

What Went Wrong: Or, Why a New Chiang Mai Treaty Was Necessary

Under the first Chiang Mai Treaty of 1874, the British were empowered to periodically send an official from Burma to Chiang Mai to judge cases that had not been satisfactorily settled in the Siamese court. The first of these officers, A. H. Hildebrand, was dispatched to Chiang Mai in early 1875 to settle several legal cases in tandem with the new Siamese commissioner. However, after only three months in the city, Hildebrand left in frustration at his inability to get satisfactory responses from the commissioner.[73] Due primarily to indecision by

the British colonial office at Calcutta as to how best to proceed after that, there was no new British official visit to Chiang Mai until 1879, which "virtually spelt the epitaph of the 1874 Treaty arrangements," as there had been no British representative present to ensure that new cases were settled to the satisfaction of the British subjects involved.[74]

While the Siamese commissioner's mission in Chiang Mai may have failed in the eyes of the British, his main objectives from the Siamese point of view were quite different. The 1874 treaty—and his presence in Chiang Mai—satisfied their two major goals: first, it kept problematic Chiang Tung in check, and second, it ensured the repayment of Chao Inthanon's considerable debts (fines from the various teak logging lawsuits levied in 1874) to the Siamese.

On the first count, the Siamese still feared that the Lan Na rulership's relationship with the Burmese through Chiang Tung was too cozy. Chiang Mai's nobles had become friendly with the Shan resettling the deserted city of Chiang Saen. Word reached the Siamese that Lan Na's king had sent a "friendly mission" to Mandalay in January of 1874.[75] And in early 1875, Siamese officials learned of "a number of amicably-worded letters passed between Chieng Tung and Nai on the one hand, and [Chiang Mai's King] Inthanon on the other," further fueling Siam's anxieties.[76]

King Inthanon's debts also figured into Siam's new presence in Chiang Mai. In the past, the only regular payment that Chiang Mai had made to Bangkok was a triennial tribute payment. But after Inthanon was fined more than 466,000 rupees in 1873,[77] it became part of the Siamese commissioner's responsibilities to ensure the collection on the loan. This payment plan, coupled with a new forest registration framework that prevented overlapping and duplicate forest leases, completely altered the financial situation of the Chiang Mai nobility, whose massive holdings of teak forests were their major source of income. So it is unsurprising that when the new Siamese commissioner suggested in 1873 that the Chiang Mai king grant a host of lucrative new monopolies, he was more than amenable.

Despite a host of restrictions intended to prevent corruption, Siamese administrators to Chiang Mai were not immune to the temptations of their high posts. One early appointee *Phra* Narin was accused of "... systematically robbing this country and prostituting his office," taking in between twenty and thirty thousand dollars annually on the side by 1879.[78] Subsequent replacements' success in "reforming" the practices of the Chiang Mai rulership met with varying levels of resistance and cooperation, with local villagers' interests often caught in the middle.

Despite optimism following the enactment of the 1874 treaty, the British were ultimately disappointed in the progress of legal procedures in Chiang Mai and lobbied the Siamese government for a new agreement in 1882. As the teak industry had grown exponentially in the region, bringing further conflicts between British loggers and Lan Na forest owners, the British felt the timing was right for a new treaty, as they had finally found the funds to station a vice-consul permanently in Chiang Mai. At the same time, the Siamese began to feel increasing territorial pressure from both Britain in the west and France in the east, which prompted a reevaluation of their tributary relationship with Lan Na. Ultimately, the setup of the international court in 1883 under the second Chiang Mai Treaty became the "model for the Siamese modern court system."[79]

Needless to say, the new treaty and courts were not popular with the Chiang Mai rulership. Losses of timber-related legal cases drained the coffers of Lan Na's noble families, and the Siamese—not the British—were perceived as being to blame. As new tensions arose between King Inthanon and Siamese commissioners, so did a renewed awareness of the potential benefits of playing the British-Burmese and the Siamese against each other. It is here that Lan Na's traditional patterns of family rule—and women's roles in creating political alliances—enter again into the story.

Lan Na Women and Rulership

As mentioned earlier in this chapter, women played roles of particular prominence in political and social life in the Inland Constellation. Lan Na society, as in the Lao and Isaan regions, was matriarchal and matrilocal.[80] From early times, marrying a local chief's daughter was an important element of Lan Na statecraft, resulting in the Chinese chroniclers' nickname for the area, "land of 800 daughters-in-law."[81] In the Lan Na city of Lamphun (located about sixteen miles south of Chiang Mai), Queen Chamathewi, founder of the seventh-century Mon Buddhist kingdom of Hariphunchai, remains a prominent figure in Lan Na mythology and historical thought.

Lan Na's political patterns reflected women's prominence as well. In the Lan Na pattern of royal succession, the throne devolved not to the king's eldest son, but rather to his eldest daughter's husband. While it contrasts greatly with the European practice of male primogeniture, this pattern of succession is consistent with practices in earlier Lan Na history. The local historical exemplar of these practices is thirteenth-century King Mangrai, the first ruler to unite a

true Lan Na empire. Mangrai married his sons out to the daughters of noble families in neighboring Lan Na towns as a means of integrating political control. It appears that this mode of rule also shaped the unique pattern of royal succession that emerged during the latter part of the Chao Chet Ton (Seven Lords) dynasty. This pattern, identified by the anthropologist Gehan Wijeyewardene as "son-in-law succession," flowed from father to son-in-law through the women of the family.[82] This pattern was practiced by both royal and common families within La Na and evolved over the first hundred years of the Chao Chet Ton dynasty.[83] From 1840 onward, royal succession in Chiang Mai adhered to the same pattern, in which the successor was married to the daughter of the prior king. For example, King Kawilorot (r. 1854–1970) was married to *Chao Mae* Utsah, the daughter of his predecessor, King Mahotraprathet (r. 1847–54). (See figure 2.)

On King Kawilorot's death in 1870, the Lan Na throne passed not to his son, but rather to his eldest daughter Thipkraisorn's husband. Thus succession flowed from Kawilorot through his daughter, to be held (at least nominally) by her husband. According to contemporary sources, Thipkraisorn was allowed to choose her own husband, giving her unprecedented influence over the succession process.[84] Though her chosen spouse, Inthanon, had already been married (several times, to boot), Thipkraisorn forced him to give up his previously acquired wives.[85] In 1884, visiting explorer Carl Bock wrote:

> He looked—as he had the reputation of being—a kindly-disposed man, but weak. He was, it appeared, quite overruled by his wife [Thipkraisorn], who seemed to be quite a sufficiently strong-minded individual to make up for his weakness. She was his third wife, and when he married her she compelled him not only to enter the priesthood, but to put away all his concubines. He did not wear the yellow cloth long—only seven days—but that was considered long enough to cleanse him.[86]

Though Inthanon's lineage was traceable to another of Kawila's brothers, he held a relatively minor rank among the royals; his marriage to Thipkraisorn raised his status considerably. In this case, the custom of son-in-law succession linked two branches of Chiang Mai nobility. From this perspective, Inthanon's marriage to the king's daughter, and subsequent assumption of the throne, was consistent with traditional Lan Na marital practices. In any event, it meant no loss of power for Chao Mae Thipkraisorn, as we will soon see.

Lan Na women, both elite and common, benefited from cultural practices that accorded them a high level of agency and status. Lan Na women retained

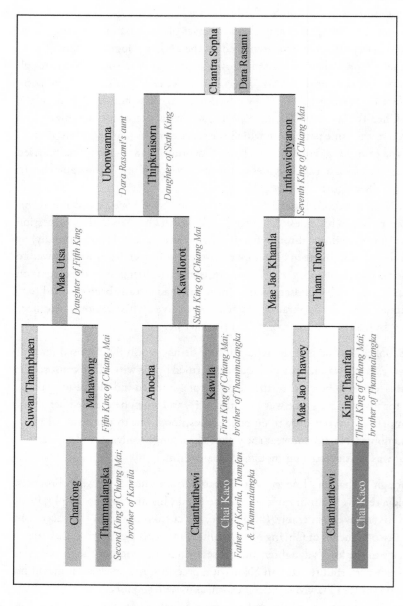

FIGURE 2. Family tree of Dara Rasami (five generations). Chart created by the author, based on information from Prani, *Petch Lanna*, and Wijeyewardene, "Northern Thai Succession."

rights over their property after marriage and could inherit equally alongside their brothers—though typically ownership of the family's domicile and lands fell to the family's youngest daughter.[87] In Lan Na social practice, this correlated with a "more general expectation that women remain in the place of their birth, while men may move."[88] Late nineteenth-century Western observers also noted that "it was the normal [Lan Na] rule that a man altered his allegiance to the home state of his wife if it differed from his own."[89] This in turn contributed to the largely matrilocal orientation of Lan Na villages. On marriage, the Lan Na groom typically moved into his bride's household for at least the first year following marriage.[90]

Traditionally, Lan Na's communities were not strictly matrilineal, but were "organized into matriclans, [where] muang matrilocal ideology is closely linked to a matrilineal mode of descent."[91] These matriclans were organized around women who maintained their family's relationship with their ancestral spirits, particularly through their roles as spirit-mediums.[92] This combination gave Lan Na women a higher level of influence and agency than even their relatively high-status sisters in Siam.

In terms of the high level of agency enjoyed by Lan Na women, perhaps no better examples can be found than Kawilorot's daughters, Thipkraisorn and her sister Ubonwanna, both of whom possessed great personal charisma and exercised considerable political and economic influence in Chiang Mai. Thipkraisorn was widely acknowledged to be the real power behind the throne in Chiang Mai. As one American Protestant missionary wrote, "The present queen [Thipkraisorn] is the one who truly has ruling power in her hands. As for her husband, he is the king in name only."[93] Her younger sister, Ubonwanna, was a wealthy businesswoman in her own right, trading in timber and the local caravan trade, as well as textiles produced by the sizable atelier of women weavers working at her residence. To many Westerners, Thipkraisorn embodied the strong yet proper (married) Lan Na noblewoman:

> [Thipkraisorn] was evidently a perfect lady, quiet and self-possessed, received us with a gracious and dignified manner, and offered us the usual refreshment of tea, as though she had been accustomed to European society all her life. There was neither gaucherie on the one hand, nor effrontery or undue familiarity on the other, in the manner she adopted when conversing at any time with the various members of our party. In person she was delicate-looking, by no means devoid of good looks, and perhaps form

thirty-six to forty years of age. Firm and intelligent, and possessed of excellent business capacity. . . .[94]

Within both Lan Na and Siam, many recognized Thipkraisorn's intelligence and political acumen. In Siam, King Chulalongkorn's circle favored Thipkraisorn, who was more receptive to the young king's pro-Western stance, while another faction at court favored the second king, *Uparat Chao* Bunthawong.[95] Some local observers saw Thipkraisorn as a check against Bunthawong, who missionary Daniel McGilvary called "ambitious and less-principled" than either Inthanon or Thipkraisorn.[96] Bunthawong's influence, however, ended at the same time as Kawilorot's reign. The very next day after King Kawilorot's death, Bunthawong was found dead by Ubonwanna, who called the local missionary doctor to confirm his condition:

> The Princess wished to get my judgment whether he was really dead beyond all hope of resuscitation. But it required no skilled physician to answer that question. He had evidently died by a dose of opium administered by his own hands. . . . Whether it was intentional suicide . . . or simply designed to ease the troubles of the night, they could tell as well as I. . . .[97]

Ubonwanna was a powerful figure both politically and economically. As the second daughter of the prior king, she leveraged her timber-derived wealth to engage in a number of different industries, from overland caravan trade to textile weaving and liquor distillation. Her business interests brought her into contact with foreigners of many stripes: Burmese foresters, Yunnanese and Indian caravan traders, and Western explorers, surveyors, and diplomats. She was said to be fluent in English and well-versed in Western customs, and was particularly interested in spending time with Western visitors to Chiang Mai (including the local community of American missionaries). Several of those travelers, including A. H. Hildebrand, Holt Hallett, and Archibald Colquhoun, noted Ubonwanna's friendliness and curiosity about their ideas, and she frequently invited them to dine and socialize at her home. Hallett describes how keen Ubonwanna was to discuss the possibility of a British railway connecting upper Burma with southern China, as she could see the immense mercantile benefit afforded by such a trade conduit.[98] Ubonwanna's personality and love life also made an impression on Hallett:

> This princess was no ordinary person, and her life was a romance. Highly intelligent, and a capital woman of business, a great trader, and the owner of large tracts of land, extensive teak-forests, and numerous elephants, serfs, and slaves, love was yet to her "the summer's sun, nature gay adorning." She

was very amorously inclined, and during many years had given the queen great anxiety and trouble in controlling her headstrong fancies. . . .[99]

But Ubonwanna's greatest influence on Chiang Mai's political landscape was in her capacity as the official royal spirit-medium. As Hallett noted: "As an instance of her power, Wilson [an American missionary] stated that when called in to consult the spirits after the late. . . . Second King [*uparat*] was struck down with sickness, she boldly told him that the spirits were displeased at his oppression of the people, and advised him at once to abolish certain vexatious taxes, particularly the monopoly of arrack, or rice-spirit."[100] In another description of the incident, it was Thipkraisorn—rather than the Second King—who was ill.[101] In either case, the message was the same: that the (Chinese-held) monopoly on rice whisky offended the local spirits and should be revoked. Beyond causing offense to the spirits, however, more likely the real-world impacts of the liquor monopoly outweighed supernatural ones: it negatively affected Ubonwanna's distillery business. Thus Ubonwanna's spiritual connections provided her with an expedient means of influencing Chiang Mai politics. (It worked so well that the Siamese outlawed it in 1884.)[102] Though Lan Na's royal women had enjoyed the power to choose kings for generations, Thipkraisorn and Ubonwanna exercised an unparalleled level of status and power between them in Chiang Mai during the late nineteenth century.

Rumors and Realigning Allegiances

Sometime between 1881 and 1882, the rumor began to circulate in Bangkok that Queen Victoria had offered to adopt Dara Rasami. The best Thai-language source states that "a British official from southern Burma approached King Inthawichyanon [of Chiang Mai] in 1881" to see how receptive he might be to an offer of adoption.[103] Several Thai authors note that no records of such an offer exist in the Thai archive; but what about the British side?

A focused search of the records of the British consuls at Bangkok and Chiang Mai, as well as Rangoon (Burma), the India Office at Calcutta, and the Foreign Office in London (including the Political and Secret records housed at the British Library) reveals that Dara Rasami's existence registered only faintly on the consciousness of British diplomatic officers in Siam. One of the few mentions of her found in the British consular records of the period indicates, if anything, some disdain on the part of the British consular officials toward her. In an 1888 letter from the British consulate in Chiang Mai to the consul at Bangkok:

The marriage of the daughter of the Chief of Chiengmai with the King [of Siam], about two years ago, was another important step [in the extension of Siamese control into the region], for she is, as you know, the only true heiress-apparent of Chiengmai—though it may be said that here, even more than in Siam, the succession is by no means necessarily by descent. Still, the child, if any, of the Princess might justly be looked upon as the rightful future ruler of Chiengmai; but I am told that there is thought to be little chance of any issue. . . .[104]

Nonetheless, the adoption rumor persists. Nearly every Thai-language biography of Dara Rasami mentions it, as do local Chiang Mai sources (such as the Dara Phirom Palace Museum, located in Mae Rim). If the British never considered making such an offer, where did the rumor come from? Rather than undermining its significance, the fact of the rumor's untruth makes it even more historically interesting, as it betrays other actors and motives. Why would such a rumor have been invented, and whose interests did it serve?

The answer provides fresh insight into the imperialist pressures felt by both Lan Na and Siam in the late nineteenth century. Though there is little data to support a definitive answer, several Thai accounts credit Dara Rasami herself as the source of the rumor.[105] As Dara Rasami was only eight or nine years old when the adoption rumor began to circulate, it is doubtful that she herself originated the story. However, there were others in Chiang Mai more than capable of such an invention. British traveler Lowndes notes in 1871 that King Inthanon had "...asked about the Queen, the war, and my own personal affairs" during his journey to Chiang Mai, illustrating that the Chiang Mai nobility were informed about global events and politics.[106] Given Thipkraisorn and Inthanon's numerous contacts with Western travelers and missionaries over the prior decade, such cosmopolitan awareness is not surprising.[107] Most likely Dara Rasami's parents themselves invented the rumor as a means of improving their political currency with the Siamese.

Even if this was not their strategy, it nonetheless succeeded in prompting Bangkok to upgrade the status of Chiang Mai's rulership. Soon after the rumor reached royal ears in Bangkok in 1882, King Chulalongkorn ordered his new commissioner to Chiang Mai, *Chao Phraya* Phichit Prichagon,[108] to act as his emissary to Dara Rasami's parents, bringing a gift of diamond earrings and a matching bracelet along with a letter requesting Dara's hand in marriage.[109] Phichit Prichagon then stayed in Chiang Mai to participate in the ceremonial cutting of Dara's topknot and the festivities that followed it.[110] Although this

ceremony—which marked a child's entry to adolescence—was commonplace among Siamese noble families, it was not usual practice in Lan Na; in fact, it had never been done before, nor again since. The lavish celebrations, like the ceremony itself, were supervised by Siamese administrator *Phraya Racha* Samparakorn, and the accompanying events were held in "both Lan Na and southern [Siamese] style."[111] That Dara's parents arranged the event in concert with local Siamese officials indicates that the dual nature of the event was quite intentional. And while it was customary to give gifts of gold, silver, and rings on the occasion of a topknot-cutting, the meaning of Chulalongkorn's gift of earrings clearly expressed matrimonial intention.[112]

Such a marital offer was highly unusual, as the accepted practice among Siamese noble families was to gift female relatives to the king as consorts. According to Thai sources, this is the only instance in which King Chulalongkorn asked a family to send a woman to serve as his consort in the palace.[113] It was so unusual, in fact, that Chulalongkorn made the Chiang Mai royal family promise to "[keep] this a private matter," rather than offend Siamese noble families whose daughters were not so ardently pursued.[114]

That may not have been the only reason Chulalongkorn wanted to keep the matter quiet. The Siamese had their own agenda for pursuing such a marital arrangement. In late 1883, he wrote to Samparakorn that

> You must also understand the intentions of Bangkok and say we believe Muang Chiang Mai continues to be a tributary state and not part of our territory. It will still be a tributary state as long as we don't think to eliminate its royalty. But we wish to hold real power . . . in short, to make it like a machine that we can control or guide forward or back as we please. . . . However, it is necessary to use intelligence more than force; we must not make them feel oppressed, and must point out the advantages of the current situation as the basis.[115]

Thus what the Lan Na rulers may have seen as a victory in terms of heightening their status and sovereignty with the Siamese—and an honor for their native princess—was to Bangkok merely another step in the process of making Lan Na part of the Siamese machine. In the words of *Phraya* Songsuradet, commissioner of the Lao Chiang *monthon* from 1893 to 1899, Siam's bestowal of titles and offices was merely "a trick to seduce the Lao," to convince the local rulers to appoint Siamese officials to do the actual work of governing their territories.[116] Little did Lan Na's nobility know of the true nature of the bargain they made in that moment.

A Cross-Cultural Education

In 1884, a scant year after the marital alliance between young Dara Rasami and the Siamese king was brokered, Queen Thipkraisorn died—leaving King Inthanon grief-stricken and adrift. According to a Siamese administrator reporting to Bangkok at that time, Inthanon "is neither conscious nor unconscious. He sprinkled water [to purify] his wife['s body], but did not bring his child [i.e., Dara Rasami]. He goes out to hide away in the trees of the garden and won't speak to anyone. All matters of state must be canceled or stopped. I don't know if anything can be done. . . ."[117] Although Inthanon retained his title as Chao Luang and de facto ruler of Chiang Mai, another member of the ruling council, Chao Rachabutr, had to step in to handle the day-to-day duties of rule, and Dara Rasami was sent to live with her aunt Ubonwanna.[118] Though Inthanon's grief may have played a role in this decision, it was in fact common practice in Lan Na for a deceased woman's children to be taken in by her sister's family (particularly since husbands engaged in trade or warfare could be absent for long periods of time). Thus young Dara Rasami spent the critical two-year period between Thipkraisorn's death in 1884 and Dara's departure for Bangkok at the end of 1886 in Ubonwanna's care.

Ubonwanna's household was very different from the royal home where Dara had been raised. While Thipkraisorn was widely acknowledged to be the true power behind the throne, her younger sister was equally as powerful, but in the realm of commerce. Besides the substantial timber tracts accorded her as a member of Chiang Mai's royal family, Ubonwanna was also invested in bullock caravans, distilleries, and the textile trade. Where Thipkraisorn was concerned with raising Lan Na's status in the eyes of Siam, Ubonwanna was more interested in how Chiang Mai could potentially benefit from strengthening its links with the wider world—especially via the Burma-Yunnan railway proposed by Britons like Holt Hallett.

Nonetheless, Ubonwanna took her responsibility for raising her niece seriously, and young Dara's education continued apace in Ubonwanna's household. Though she was merely eleven years old, Dara "was trained in politics, and then the ways of the royal court in Bangkok."[119] Given that "Ubonwanna secretly opposed the Siamese assimilation of power" in Chiang Mai, no doubt Dara's political education was informed by her aunt's suspicion of the Siamese as well. Under Ubonwanna's care, Dara was instructed in the languages and customs of both Siam and Lan Na, and perhaps English as well, as Ubonwanna had herself learned it from the local American missionaries.[120]

Though Dara would have been taught to weave by her mother, she had ample opportunities to learn more at Ubonwanna's house, where dozens of enslaved women wove textiles for commercial trade. To secure Dara's future in the Siamese palace, Ubonwanna made sure that Thipkraisorn's (substantial) timber-leasing income was inherited by her daughter. Additionally, Ubonwanna also arranged for part of her own timber income to go directly to Dara Rasami to maintain the honor of Lan Na's royal family in Bangkok.[121] Despite the early death of Dara's mother, Thipkraisorn, her aunt Ubonwanna ensured that her preparation for life as a future political princess was complete.

The marital alliance between Lan Na and Siam reflected the increasing pressures on Siam's peripheral territories being felt by Chulalongkorn in the 1880s and the elaboration of the prior king's policy of appeasement into an assimilationist stance toward the Lan Na rulership. Dara Rasami's arrival in the palace, however, was no tidy happily ever after. Over the next twenty years of her career as a royal consort, the struggle between the kingdoms continued to play out in the Inner Palace, rendering Dara Rasami both a hostage and diplomat in Siamese palace politics.

Dara Rasami's Career in the Siamese Royal Palace

ARA RASAMI'S ARRIVAL IN the palace marks the beginning of her career as a royal consort at the same time that Siam's King Chulalongkorn was implementing structural changes to the Siamese state that would eventually end palace women's political relevance. While Dara Rasami's parents were aware of Chulalongkorn's "modern" mindset, they did not suspect he had already begun reshaping Siam into a form fundamentally different from their understanding of how kingdoms had traditionally worked in mainland Southeast Asia. As discussed in the previous chapter, Chulalongkorn and the elites who served as his cabinet were keenly aware of European powers' efforts to expand their colonial footprints in Southeast Asia. In a bid to make Siam appear too civilized for Europeans to colonize, Siamese elites embarked on a program of self-modernization that depended largely on emulating key colonial practices—a mode described as "crypto-colonialism." This term, coined by anthropologist Michael Herzfeld, denotes the imposition of colonial practices and structures by states that were never formally colonized by a European power—a practice sometimes referred to in the Siamese context as semi-colonialism or self-colonization.[1]

In the Siamese case, crypto-colonial practices were exercised over subjects by the elites themselves, led by King Chulalongkorn. Not long after ascending the throne in 1868, young Chulalongkorn traveled to various colonial states in the region to observe their administrative practices and "was deeply impressed with what Europeans had done" in Singapore, Java, and India.[2] On his return to Bangkok, he set about making changes intended to bring Siam more in line with these states, so as to demonstrate Siam's fitness for membership among the ranks of civilized modern states.

Britain in particular served as Siam's ideal model of a modern monarchy: Chulalongkorn created a royal privy council on the British model; he sent his sons to be educated in England; and he also took the unprecedented step of appointing his successor, anointing his eldest son Vajirunhit Crown Prince (an event which coincides with Dara Rasami's entry to the palace as a consort). He

also abolished the requirement for commoners to prostrate themselves before royalty, expanding on his father Mongkut's efforts to render the monarch more accessible to the common people.[3] Nonetheless, Chulalongkorn embraced royal polygyny despite his keen awareness of Western disapproval of the practice. Indeed, his reign became the high era of Siam's palace women: the population of royal consorts reached its zenith of 153 women. Hence Dara's career provides both a window into the rarefied world of Siam's palace culture and a convenient frame for viewing the historical changes underway that ultimately brought that culture to an end.

Dara's Arrival in Bangkok

In late 1885, thirteen-year-old Dara Rasami stepped aboard a houseboat to accompany her father, Intawichyanon, several hundred miles downriver on one of his semiannual visits to Bangkok. This journey's purpose, however, was unique: to present Dara Rasami for service as a consort to King Chulalongkorn in the Inner Palace. The trip was timed to coincide with the events celebrating the appointment of Chulalongkorn's son, Vajirunhit, to the rank of Crown Prince in January 1886. Dara Rasami's father would play a special role in these events—and receive a royal promotion to boot.

Because the river route offered far quicker and more convenient transport in those days than overland travel, a caravan of boats was laden with the food and supplies needed for the journey. For several weeks, Chiang Mai's royal entourage traveled down the Ping and Chao Phraya rivers, disembarking at waterfalls and rapids while the boats were portaged. It took three weeks traveling down the Ping River for Dara and her father to reach central Siam, where their arrival was received with great fanfare.[4] The floating convoy of houseboats was met by King Chulalongkorn himself at Bang Pa-In palace, located about forty miles upstream from Bangkok.[5] There Dara Rasami underwent a *tham khwan* (spirit-calling) ceremony, after which she was fêted with a grand feast attended by a number of the Chakri nobility. Afterward, Dara and her attendants, Khai Kaew and Bua Rawaan, returned to their boat and were guided the rest of the way down the river to Bangkok by Siamese officials. After docking at the pier next to the Royal Palace, the young princess was conducted "in an honorable manner" to the interior of the Royal Palace, which had been decorated to be "glittering and dazzling to the eye."[6]

Having safely delivered Dara Rasami to Bangkok, her father took a prominent position in the procession of royals celebrating Vajirunhit's elevation to Crown

Prince. Intawichyanon rode in seventeenth place among the highest members of Siamese high royalty, the king's own brothers and sisters, in the royal cavalcade through Bangkok; he was also allowed to participate in the water blessing ceremony for the Crown Prince.[7] Noteworthy here is that Intawichyanon was the only ruler of a Siamese *prathet sarat* (tributary kingdom) to participate in these events. Chulalongkorn also presented King Intawichyanon with the medal of the Order of *Chula Chom Klao* (the Siamese equivalent of a knighthood, established by and named after Chulalongkorn himself); he was also the only ruler of any of Siam's tributary kingdoms to receive this honor during Chulalongkorn's reign.[8] It appears that Intawichyanon and Thipkraisorn's gambit—circulating rumors of Queen Victoria's desire to adopt Dara Rasami—had succeeded, greatly benefitting the Chiang Mai royal family. Whether the plan ultimately improved the fortunes of their subjects (or the future sovereignty of Lan Na), however, is highly doubtful.[9]

Intawichyanon's promotion and new name accorded him an even higher level of social status back home and helped raise the status of the rest of Chiang Mai's nobility as well: they were allowed to use the surname *na Chiang Mai* (of the city of Chiang Mai) in parallel to Siam's royal elites who used the surname *na Ayutthaya*. At the same time, however, Chiang Mai's sovereignty was fatally undermined by Bangkok's "blessing." After the ratification of the second Chiang Mai treaty in 1883, dozens of Siamese officials were stationed in Chiang Mai under its provisions, making the international court a permanent fixture (and a model for the nascent Siamese court system). The treaty also established a local police force to keep law and order and prevent banditry. At the same time, a new system of taxation was put in place, shifting the collection of taxes to (mostly Chinese) collectors who preferred cash over goods—a move that greatly burdened many cash-poor small landholders and traders, while putting more money in the pockets of Chiang Mai's nobles. These measures would lead to conflict in the coming decades, widening the gap between local nobles and their people—and making it impossible for our young princess to return home again.

The World of the Siamese Inner Palace

Young Dara Rasami must have wondered about the new world to which she was traveling. What was Bangkok like compared to her hometown, the capital city of Chiang Mai? Would she be able to have her favorite foods and music, or other familiar things from home? Dara Rasami's parents, who had visited the Royal Palace in Bangkok many times, had likely described to her their impressions of

what they had seen there, although Dara herself had never been there before. To prepare her for her entry to the Siamese palace, Dara Rasami had undergone several years' training in the Thai language and the customs of the Siamese royal court. But it would be very different to live there under the watchful eyes of the Siamese palace folk, without the protection of her parents—or aunt—to fall back on. One imagines a nervously excited Dara Rasami and her attendants stealing glimpses of the busy streets of Bangkok from within the curtained palanquins carrying them from the riverside to inside the high walls of the Royal Palace. Once they entered the women's quarters there, it would likely be their last sight of the outside world for a long time. The Inner Palace, as it was known, was a space within the space of the Royal Palace: a world run by women, complete with its own walls, guards, and administrators. Although Dara Rasami was undoubtedly the last political princess of her kind to serve here, she was hardly the first. The Inner Palace had a long history all its own that provides an intimate window into Siam's political development over the course of the nineteenth century—the era of European imperialism.

A Brief History of Political Consorts

Polygyny had in fact been practiced by Southeast Asian monarchs long before the Ratanakosin (or Bangkok) era began, and it conveys the central importance of humanpower in the chronically underpopulated region.[10] Like the monarchs of Lan Na discussed in the last chapter, Siamese kings also practiced polygyny throughout the Sukhothai and Ayutthaya eras. But in many ways, Bangkok itself was very new. After the Burmese invasion of Ayutthaya in 1767 reduced the Siamese capital to a smoldering ruin, Siam's elite class, its literature and high culture were largely destroyed. In the years immediately following, General Taksin gathered the remaining Siamese nobility to establish a new seat at Thonburi. When the Chakri clan took the throne in 1782, they moved their capital across the Chao Phraya River, and a new palace was built on Ratanakosin Island, now considered the heart of "old" Bangkok. Siamese palace life, in other words, essentially restarted in the 1780s, when the Siamese built their new capital at Bangkok.

The newly established Chakri rulers were intensely concerned with both rebuilding their elite culture and preserving the security of their new capital. (As we discussed in the last chapter, these are the same security concerns that prompted the Siamese to assist Lan Na rulers in ousting the Burmese from their territories as well.) Regional security concerns shaped both the population of the

Inner Palace and the fledgling Chakri dynasty's external political practices in
the early Bangkok era. Because the control of humanpower (or the lack thereof)
had been a major factor in the loss of Ayutthaya, the Chakri nobility was anxious
to consolidate political loyalties in the region. This they proceeded to do in a
number of ways.[11] First, the Chakri court centralized its administrative control
over these new provincial administrators, creating separate chief ministers to
oversee the provinces: the *Mahat Thai* minister supervising those in the north
and the *Kalahom* supervising the southern provinces.[12] Second, marital alliances
were arranged with daughters of the noble families ruling provincial capitals
around Siam's peripheries. At the same time, however, Siam's need for external
territorial security was counterbalanced by an intimately internal one: that of
rebuilding the elite class and the institution of the palace itself. These dual con-
cerns shaped the ethnic makeup of the women who served as royal consorts in
the early Bangkok era.

From the inception of the new capital, the practice of marital alliance was
central to the Chakri dynasty's program of reestablishing ties with neighboring
polities. The first Chakri monarch, Phra Phutta Yotfa (r. 1782–1809), had a total
of seventeen consorts: four were the daughters of provincial rulers, and two more
came from the prathet sarat of Lan Na and Lan Xang (now Laos). Another seven
women were the daughters of various noble families based in Bangkok; one is de-
scribed as the daughter of "wealthy Chinese," while the origins of the last three
were not recorded.[13] In the wake of the destruction of the court at Ayutthaya,
there were few women of royal blood available to serve as consorts during the
early Bangkok era; the nearest available candidate was the granddaughter of an
Ayutthayan consort. But what is most notable about the population of palace
women in this period is the preponderance of women who came from beyond
Bangkok: fully 35 percent of the women serving in the Inner Palace during this
reign came from distant provincial or tributary regions. Rather than send male
Siamese administrators out to govern the peripheries, women circulated from
the peripheries into the center to ensure the loyalties of their home regions.
These circulations highlight the centrality of bodies (or biopower, á la Foucault)
to the traditional structure of Siamese political power, the inextricability of local
elite women's bodies to rebuilding the Siamese kingdom, and the necessity of
anchoring it at its center, Bangkok.[14]

As the new dynasty found its footing, however, the makeup of the Inner Pal-
ace gradually shifted. During the reign of the second Chakri monarch, Phra
Phutta Lertla (r. 1809–24), a total of three provincial women served among his
eighteen royal consorts; the rest were daughters of Bangkok nobility.[15] By the

Third Reign (1824–51), the numbers skewed even further toward local nobles, with twenty-two women from local families versus four from the provinces among the total number of royal consorts.

Siam's relative political strength in the region initially benefited from the decline of their old enemy, Burma, following their loss to the British in the first Anglo-Burmese War in 1825.[16] As Siam's confidence grew in its regional security, the demographics of the Inner Palace shifted ever further to the center and away from the tributary kingdoms at the peripheries. During the Fourth Reign, King Mongkut's (1851–68) Inner Palace population rose to a new high of fifty-three consorts. The ever-shrinking percentage of women from its peripheries present in the Inner Palace reflects Siam's sense of regional security at this time. Only two women came from tributary kingdoms (Lan Na and Lan Xang/Laos); another came from Cambodia (which was still a tributary under Siamese control) and another from the Malay peninsula (the sultanate of Lingga). But the vast majority of royal consorts were local: the majority of women came from either the royal family itself or Bangkok's noble families.

King Mongkut, who ascended the Siamese throne at the age of forty-seven, seemed eager to make up for the twenty-seven years he had spent as a Buddhist monk during his brother's reign. Over the course of his seventeen-year reign (1851–68), he fathered sixty-five children by thirty-two consorts.[17] Mongkut's reign also saw the formation of a sizable pool of royal-born women from which consorts could come. Having reached a sort of critical mass in sheer numbers, this large cohort of consorts required further differentiation, so the palace began to utilize new ranks and titles for royal women.[18] Mongkut's three highest queens were the prior king's daughters (i.e., Mongkut's nieces); they became the mothers of the next king and his high queens as well.[19] From the very start of Mongkut's reign, the population of royal women in the Inner Palace surged exponentially over a relatively short period of time. Though the Fourth Reign still demonstrated a long geographical reach—counting consorts from Cambodia, Lao, and Malay kingdoms—the makeup of the Inner Palace in the 1840s and 1850s demonstrates that the locus of Siamese political power had shifted solidly to the center: the noble families of Bangkok.[20] This trend continued during the next reign, that of King Mongkut's son, Chulalongkorn.

King Chulalongkorn's reign, like that of his English contemporary Queen Victoria, was a very long one. Compared to his father Mongkut, who reigned seventeen years, Chulalongkorn (Rama V) reigned forty-two years, from 1868 to 1910. Chulalongkorn's Inner Palace grew to 153 consorts, only three of whom—like Dara Rasami—came from peripheral, tributary kingdoms.[21] Though the

number of provincial consorts represented in the Siamese Royal Palace made up a mere 2 percent of its total population, the aggregate number is higher than at any time since the Third Reign (1825–51). This reflects changing regional context surrounding Siam in that period.

While Siam's political position in mainland Southeast Asia in the last quarter of the nineteenth century had become secure against its old enemies, a formidable new threat had crept into the picture: European imperialism. As the British moved into Burma to the west, and the French into Vietnam and Cambodia in the east, they slowly but surely undermined Siam's tributary relationships while establishing outposts under European imperial control. As we will explore in this chapter, Dara Rasami's presence in the Inner Palace provided Siam with its own buffer state—Lan Na—against British encroachment. At the same time, Chulalongkorn had begun reforming the Siamese state into a structure more recognizable to colonizers in a bid to keep them from subverting Siam's sovereignty. This was an era when the traditional and modern coexisted and overlapped in the Siamese state at both the micro (palace) and macro (state) levels, as Dara Rasami's role in the palace will reveal.

Space and Place in the Royal Palace

Inside the palace, Dara and her attendants were taken to a palace residence adjacent to the king's own home, the *Chakri Maha Prasat* (great Chakri castle), located in the center of the palace grounds. The king had begun construction on this imposing structure in 1878, early in his reign, making his own mark on palace architecture as had the Chakri monarchs before him.[22] While the building was largely complete by the time of Dara's arrival in 1886, King Chulalongkorn continued to make changes and additions for several years afterward. The two-story, three-wing structure was designed in a hybrid Siamese-Western architectural style by John Clunis, a Briton who designed the British regent's residence at Singapore.[23]

The Chakri Maha Prasat was not just the king's residence: it was also where he conducted the business of state. The northward-facing lower levels included royal reception halls and functionary rooms, while the upper floors of the southward-facing rear wings housed the living quarters of the king and his closest family members. The Chakri Maha Prasat was a nexus between the Inner and Outer Palaces where both the public affairs and events of state occurred—such as meetings with foreign diplomats—as well as the private affairs of the king's daily life.[24] These spaces included the king's bedchamber, the "Blue

Room"; the "Green Room" where he dined with various wives and children; and the space where he held the daily Inner Palace review of consorts, called the "Yellow Room."

Dara Rasami and her attendants were assigned a space in the Phra Thinang Damrong Sawat Hall, called the Hong Pakkard (Cabbage Room). This location reflects the high status and importance accorded her as Siam's political link—both hostage and diplomat—to Lan Na. But it also served a very practical purpose. Dara Rasami's physical closeness to the king was also meant to ensure the creation of a more lasting bond between the two kingdoms: a royal child. Since a royal consort remained free to leave palace service until she gave birth to a child by the king, it was a high priority for King Chulalongkorn to get Dara Rasami pregnant quickly, as it would prevent her from leaving the palace and cement the Siamese-Lan Na alliance for once and for all.[25] Thus Dara's close proximity to the king in the palace reflected both the symbolic recognition of her political status and the urgency of ensuring Lan Na's loyalties in an era of imperialist anxiety.

The Chakri Maha Prasat bridged the Inner and Outer spaces of the Royal Palace. The Outer (or Front) Palace (the *Wang Na*) comprised the northernmost zone; just to the south was the Middle Palace (*Wang Klang*), where one could enter the Chakri Maha Prasat; and the southernmost zone contained the Inner Palace (*Wang Nai*). Encircled by yet another wall, the Wang Nai housed the royal women's quarters, the residences of the *fai nai* (inner group): the king's female relatives, his children, his consorts and their entourages, and also their cooks, servants, officials, and guards—all female.

While the palace grounds were walled off from the outside world, a second set of walls enclosed the Middle and Inner areas as well. This inner wall was punctuated by a series of gates that both opened to the outside and connected each zone to each other. Thus the Chakri Maha Prasat spanned the boundary between the Middle and Inner Palaces.

The Royal Palace in Bangkok functioned as far more than the residence of the Siamese king and his relatives: it was also the sacral, political, and social heart of the kingdom. As a *dharma raja* (righteous Buddhist king), Siam's king exercised both political and spiritual authority over the state.[26] The monarch anchored the center of the cosmologically ordered kingdom's social and political universe from his residence in the Middle Palace.[27] In the Siamese worldview, proximity was everything: the closer one was to the king physically and spatially, the higher one's status—and conversely, the higher it could become. Thus the king's own residence—the Chakri Maha Prasat—was an especially potent site,

as the intersection of both his sacred and worldly activities. The sacredness of this center accrued to everyone associated with the place: even a slave inside the palace had social status higher than many free people outside its walls.

The Siamese monarch's power was thought to radiate outward toward the peripheries of the kingdom, ever diminishing as it grew more distant from the center.[28] This worldview made it critical for the Siamese king to build alliances with kingdoms at the peripheries—especially through marital alliances with women like Dara Rasami. In addition to the political function served by the Inner Palace, it played another important role in Siamese society: a crucible where high culture was reproduced and broadcast to the greater society at large. Because the daily lives of Inner Palace women were at the heart of this process, Dara Rasami's experiences there provide a lens through which to view the workings of Inner Palace culture.

A Consort's Life in the Siamese Palace

Although Dara had been educated in Siamese language and customs prior to entering the Siamese palace, she was still considered to be in training once she got there. As attendants under the patronage of Saovabha Phongsri, Chulalongkorn's favorite queen, Dara and her ladies-in-waiting were required to serve as members of her entourage on a daily basis. Saovabha was one of three sisters who became King Chulalongkorn's highest queens: Princess Sunanda Kumarirat (1860–80); Savang Vadhana (1862–1955); and Saovabha Phongsri (1864–1919).[29] His fourth high queen was Sukhumala Marasri, a descendant of the politically important Bunnag family. In addition to being the highest-ranking consorts in the palace, these women were also spatially closest to the king: Saovabha occupied rooms inside the Chakri Maha Prasat, while the residences of the other three were adjacent—and even connected—to the royal residence on the interior side. They formed a mini-society of ultraelite women and children who circulated constantly between their own residences and the Chakri Maha Prasat, making up the rarefied social world that surrounded Dara Rasami and her foreign ladies-in-waiting.

Queen Saovabha's entourage included the daughters of several important noble families as well as the queen's own children. As her attendants, Dara Rasami and her ladies spent several hours each day in the company of the high queen and her circle. The girls were expected to observe and practice elite Siamese manners and comportment; at the same time, their behavior was also constantly monitored by the other women there. It was neither an easy nor

carefree environment for an adolescent girl from a foreign land, and the stakes were high—a fact of which Dara herself was highly aware.

Dara Rasami's family had an interest in ensuring her good behavior as well. Dara's father allegedly told Prince Damrong that if she should do anything wrong, Damrong should send word to Inthawichyanon, so he could "come down from Chiang Mai and give her a thump on the head."[30] To this Prince Damrong jokingly replied that he would be happy to spare Inthawichyanon the trouble and simply do it himself, since he would be, after all, Dara's brother-in-law.[31] Prince Damrong, who was a full decade younger than his half brother, the king, was much closer in age to Dara Rasami. Since his duties as head of the Mahat Thai (Ministry of the North) included territorial oversight of Lan Na, he met with Dara Rasami regularly to disburse the forestry-derived income (colloquially called stump money) provided by Chiang Mai. This regular interaction was the basis of a friendship that lasted throughout their lives.

During the three years she served in Queen Saovabha's entourage, Dara endured much teasing and humiliation from the other women there. Dara continued to wear her northern *muay* hairstyle (long hair coiled and pinned up in a bun) and *phasin* skirts rather than Siamese-style *chongkrabaen* trousers. While her mode of dress was a statement of pride in her Lan Na identity, it also made her difference from her Siamese counterparts immediately recognizable—and also an easy target for gossip and practical jokes by other women, despite her status as Lan Na royalty. (Dara's dress will be discussed in greater depth in the next chapter.)

In addition to taking great care with her own behavior, Dara Rasami also had to contend with the sometimes challenging behavior of other royal women. On one occasion, *Chao Chom* Sae, a former lady-in-waiting of one of the other high queens, teased young Dara Rasami that her "flat chest . . . wasn't very pretty." Dara Rasami's response was one of stunned silence: she sat and smiled as if nothing had occurred, shocked and unable to respond.[32] After all, what could she say to such a remark without risking offending a senior palace woman? Prince Damrong's daughter Phunphitsamai, who was then serving as a lady-in-waiting in the palace, noted:

In the palace, [Dara Rasami] had no rank or authority, no importance at all; so she came by the name used for her by all the consorts: *Chao Noi* (little noble). Chao Noi didn't know anything; Chao Noi sat there, smiling happily to herself at nothing. Of all the consorts there, no one knew anything about her besides the words "Chao Noi."[33]

Outside the king's residence, other palace women derisively called Dara and her entourage fish-paste stinkers, a reference to the distinctive Lan Na foodways they practiced in the palace. In private, Dara Rasami complained to her attendants that "these Bangkok ways would drive her back to Chiang Mai."[34] When Chulalongkorn learned of Dara Rasami's travails, however, the king "warn[ed] the various chao chom and *mom* [royal mothers and concubines] to forbid their ladies [to tease her] . . . [and] put a stop to the persecution and various pranks, which could affect Dara Rasami's feelings permanently."[35]

Such intervention by the king may sound like unnecessary royal intervention in petty interpersonal conflicts within the palace. Yet it clearly reflects the intersection of personal and regional politics at play in the Inner Palace. Alienating Dara Rasami could ruin cordial relations with her father, King Intawichyanon, putting Siam's relations with Lan Na at very real risk. The king thus considered it important to intercede on Dara Rasami's behalf, as she was a critical political emissary of Lan Na whose political loyalties were considered precarious.

One particular episode that illustrates this precarity occurred in early 1889, when Dara was sixteen years old. That spring, British consuls in both Bangkok and Chiang Mai expressed anxiety over a possible alliance between Chiang Mai and the (Burmese) Shan city of Chiang Tung. At that time, the headmen of four Shan states (Maung Ta, Maingtun, Mainghan, and Maingsut) came to Chiang Mai to profess their loyalty to King Inthawichyanon. Since the question of ownership of Shan territory was not yet settled between the British and Siamese, such an alliance between Chiang Tung and Chiang Mai would likely upset the already delicate political balance between the kingdoms of the Inland Constellation. A marriage between a prince of Chiang Tung and a maiden of Chiang Mai could cement a relationship between the Shan and Lan Na kingdoms, at the expense of both Siamese and British interests in the region.

Around that time, Dara Rasami received a letter from Intawichyanon discussing the Chiang Tung alliance and asking her to return home, possibly to take part in the arrangement. As palace law allowed a consort to leave the palace if she had not yet borne a royal child, such a move was possible, at least in theory. But what Intawichyanon did not know was that Dara Rasami had just become pregnant; thus his suggestion could be considered treasonous. Breaking palace law could have dire consequences. In 1886, one of the king's half sisters was caught in an illicit affair with a former monk, who had disguised himself as a woman in order to enter her residence inside the palace. The lover was executed and the

princess imprisoned in the palace jail, where she purportedly died within the year.[36] This incident, which occurred the same year Dara Rasami arrived in the palace, was still fresh in palace minds.

Sixteen-year-old Dara Rasami faced a daunting situation: if she attempted to hide the letter, her life—and that of her unborn child—could be in danger. But to divulge the letter meant betraying her father. As her aunt Ubonwanna had died suddenly—allegedly by poisoning—not long after Dara left Chiang Mai in 1886, Dara had no other relative with whom she could discuss the issue.[37] She faced a terrible choice that pitted her loyalties against each other. How could Dara Rasami choose? The story goes that:

> [When] Dara Rasami learned of this, she offered her father's letter to King Chulalongkorn. . . . After that King Chulalongkorn proceeded with a clever policy, giving Dara Rasami a royal letter in answer to her father's letter, which said that if the king of Chiang Mai would allow Chiang Mai to become part of England, then he should prepare himself to come collect Chao Dara Rasami's body from Bangkok.[38]

However close Dara Rasami was to the king and his inner circle, the fact remained that she was essentially a political hostage in the palace. Understandably, she feared the threat expressed in Chulalongkorn's response to her father and worried that her life was in danger. The episode marked a dark time for her emotionally: "When she had sunk to the very lowest, [it was] enough to seek happiness just sitting down to listen to the sound of [her] own heart. . . . [Her] thoughts drifted down a dark path that she could not follow."[39]

No doubt the threat was hollow, but it was intended to compel good behavior on the part of the Lan Na rulership without resorting to military force, as Siamese control over events in Chiang Mai was anything but direct. On the contrary: it could take anywhere from six to twelve weeks to traverse the 450-mile distance between the two capitals, depending on whether it was the dry or rainy season.[40] With such a time lag in communications, the Siamese had no way of deploying military forces to Chiang Mai with any speed. Decades earlier, such looseness between Siam and its prathet sarat of Lan Na was a virtue, allowing the local ruler to respond to local needs in a more timely fashion than Bangkok could. But in the imperialist context, Lan Na could easily decide the British, recently (1885) advanced into Rangoon, would be a more beneficent ally, and betray Siam before they could intervene. Such Siamese fears find expression in the story about the secret letter and the acute contingency of Dara Rasami's role within the Siamese palace.

Space and Status inside the Palace

Dara's pregnancy greatly improved her fortunes in the palace. King Chu-lalongkorn gifted her space for a new residence big enough to house Dara, several more ladies-in-waiting, and any officials who might visit from Chiang Mai. The original house was located in the high-status zone adjacent to the Chakri Maha Prasat. However, because it was not quite large enough to accommodate the full complement of Dara's entourage at the same time as visiting officials, Dara requested permission to add an additional floor to the building. Intawichyanon, still unhappy about Dara's disclosure of his secret letter, nonetheless sent substantial funds to accomplish the renovation—and demonstrate Chiang Mai's honor amid the Siamese royals. Thus both the location and size of Dara Rasami's new house reflected her ongoing political importance to both kingdoms.

Dara's new residence was located in the zone nearest the Chakri Maha Prasat, next to the homes of the high queens and the king's eldest female relatives (including his sisters and former wet nurse). Although Dara Rasami's residence was not as large as those granted to royal Siamese women, its location in the interior sector can be viewed as a gesture of goodwill from the Siamese to Lan Na. Alternatively, the architecture and materials used in the enlargement of Dara Rasami's new house were a gesture from Lan Na to Siam, chosen to maximize the prestige of Lan Na's royalty. The imposing three-story structure was built in the latest Italianate-cum-Siamese style, constructed of Western-style bricks and mortar, and filled nearly the entire tract. The house's floor plan was a rectangle of bedrooms and corridors surrounding open, spacious interior parlors, topped with a roof-level garden. Wide shutters flanked its large windows on all three floors, with elaborate carved detail in their wooden frames. The exterior masonry was painted pale pink with green shutters and trim, a color scheme consistent with other Inner Palace residences at the time.[41]

The house's size reflected both utility and status: the new residence was intended to house not only Dara Rasami and her entourage, but also any visiting officials from Chiang Mai (mainly Dara Rasami's older half brothers).[42] The residence's imposing size and up-to-date architecture, as funded by Chiang Mai, can be seen as an architectural discourse proclaiming Lan Na's continued strength as Siam's most prominent prathet sarat and commanding acknowledgment by Siamese royalty. Though not exactly a discourse of resistance against the Siamese, the stature of Dara Rasami's residence nonetheless makes clear the status Chiang Mai asserted for itself—and its princess—in Bangkok.

Many other consorts were not so lucky. By this time in Chulalongkorn's reign, the palace was chockablock with the housing needed to accommodate 153 consorts, their ladies-in-waiting, servants, cooks, workers, guards, and palace officials. The space was ordered largely by status: lower-ranking consorts and palace workers lived in progressively smaller homes located in the middle to outer regions of the Inner Palace. The farther a woman's residence was located from the Chakri Maha Prasat at the palace's center, the less royal blood likely ran in her veins—and the less space allotted to her living quarters. Adjacent to the center zone, the homes of the former queens and consorts of prior kings could measure up to 18.5 by 26.5 meters each; in the next zone lived the daughters and royal mothers of prior reigns in slightly smaller homes of 18 by 20 meters. The next outward zone housed consorts and important officials in long adjoining buildings of six units, each measuring 10 by 40 meters. The lowest ranking of all—servants and low-ranking officials—lived in the *Tao Teng*, conjoined two-story row houses that lined the eastern and southern peripheries of the Inner Palace. Each unit had an upstairs bedroom, with a small main room, kitchen, and bathroom on the ground floor below.[43] The facing rows of the Tao Teng formed a corridor to the most frequently used gateways to the outside, which were flanked by fierce female guards (called *klone*) who kept an eye on palace comings and goings.

Despite their seclusion, the women of the Inner Palace exercised great political, social, and cultural influence from within the double walls of the Royal Palace. Though Anna Leonowens viewed the place as a prison, and every woman there as a slave without agency, the Inner Palace was perceived quite differently by the average Siamese of the time: as an unparalleled opportunity for social and economic advancement in Siamese society.[44] (In contrast to the freedoms enjoyed by noblewomen in Lan Na described in the previous chapter, however, it is important to note that these opportunities were ultimately circumscribed by the agency of a single man: the Siamese king.) Though the Inner Palace brought together women of all levels of Siamese society, from indentured slaves to noble-born ladies-in-waiting, the opportunities for social advancement were greatest for those of lower birth, as we shall discuss later on. Even the lowest palace servant enjoyed great prestige in Siamese society by virtue of her association with the royal center.[45]

The Inner Palace contained a carefully self-regulating bureaucracy, in which senior women—many of whom held official titles and duties—carefully monitored the behavior of junior women both in their own households and those of others. Their observations contributed to the king's promotions of royal consorts on a semiannual basis. Such promotions carried economic rewards:

each rank was associated with *sakdina* entitlements, which provided the holder with lifetime income.[46] For chao chom and higher-born women, their promotions rested largely on their personal compatibility—and face-to-face contact—with the king himself.[47] Accordingly, some of the highest positions in the Inner Palace bureaucracy were those with direct responsibility for the king's person: the keepers of the royal wardrobe, and the director of the royal kitchens.[48]

Most women presented to the Siamese king entered the Inner Palace at the rank of *chao chom* (royal consort), though some entered as servants or dancers, to be promoted to the rank of consort later on. Since families typically presented their daughters to serve in the Inner Palace early in their adolescence, girls were usually first sent to serve in the household of an elder consort or princess as a sort of apprentice in palace customs and manners. For the noble families of Siam, such palace training was the equivalent of a university education in an era before any such institution existed in Siam.[49] Such elite education was not limited to the female children of noble families, however. While young girls—like Dara Rasami—were sent to begin their service in the household of a senior royal woman in the Inner Palace, boys went to serve in the Outer Palace as pages in the *Mahat Lek*, the Royal Pages Corps. The palace was where young Siamese elites were trained in the myriad royal customs and manners that distinguished the *phu dii* (good people) from their social inferiors. Through the women of the minor nobility, fresh blood was infused into the royal ranks, and elite culture circulated back into Siamese society. As the young men and (especially) women serving in the Royal Palace moved from service within the palace to married life in elite households outside, they carried with them the manners, practices, customs and arts they had learned within the palace. The households of royal princes and other male nobility functioned as miniature satellites of the Siamese Royal Palace, where former palace women reproduced Siamese elite culture both literally through their offspring and figuratively through their exercise of elite customs and culture outside the palace.

For the daughters of nonelite families, being sent to serve in the palace—even if not as consorts—offered myriad opportunities to greatly improve their social status and marriage prospects.[50] All newcomers to the Inner Palace were required to pass a series of tests to establish their proficiency in the use of polite language and manners. Following this initial training, palace women could take courses in traditional literary forms, from poetry and verse to composition.[51] Those who demonstrated talent were encouraged to pursue further training, provided by the palace. Women were also trained in the arts of music and *lakhon* (Siamese

dance-drama), and talented girls were assigned to the household of the *lakhon fai nai*, where they could practice the demanding art form daily.[52]

Besides excelling in the above arts, there were a number of other ways in which women of both common and noble birth could attain higher status—and indeed, build a career—within the context of the Inner Palace. However, the sole automatic means for a consort to improve her status was to give birth to a royal child, which elevated her title to that of *chao chom manda* (consort-mother). Within such a system and the context of the Inner Palace, what was the nature of a woman's agency? How was her career trajectory constrained (or not) within the power structure of the Inner Palace?

The success of a woman's palace career depended heavily on two factors: first, the woman's socioeconomic background, and second, her personality and charisma. The first factor encompasses the issue of whether the woman was of royal, noble, or common birth. Whether of noble or common birth, the major issue was the political-economic importance of her family and its circle.[53] For Dara Rasami, this factor was what guaranteed her position as a special status chao chom on her entry to the Inner Palace. The second factor, a woman's personal level of charisma, comprised not merely her physical appearance, but also her social competence and skill in handling her relationships with both the other consorts within the Inner Palace and the king himself. It was this factor that most influenced the careers of the highest-ranking royal consorts, including Dara Rasami herself (as will be explored later in this chapter).

For royal-born women, rank depended first and foremost on their birth mother's family and her social and political status. For Dara Rasami, her parents' rank as the rulers of Chiang Mai accorded her special status on her entry to the palace, as she (and her attendants) were housed in the Damrong Prasat (or Hong Pakkard) palace residence. For women of nonroyal birth, there were two ways to enter palace service: they were either presented to the palace as a consort by their families, or they went to serve in the entourage of a woman who was already a consort or royal relative. Once inside the palace, a woman could earn additional promotions for good service in the duties assigned her. Thus the Inner Palace provided career opportunities for enterprising and charismatic women of both noble and common birth.

Ironically, for the highest-born women, opportunities for social movement were also the most restricted. Though royal rank declined over generations, allowing royal granddaughters to marry outside the Inner Palace, the king's daughters, sisters, and half sisters ranked too highly to do so. In a sense, the value of their social currency was too high: without high-status male counterparts

besides their own brothers, they were effectively priced out of the marriage market.[54] While many of their royal brothers became high ministers in charge of running the kingdom, the highest-born royal women were restricted to life within the walls of the Inner Palace from birth to death. This restriction on royal women's circulation outside the palace conversely contributed to the popular notion of "the Inside" as a rarefied social space belonging to the most elite in the land.

Motherhood and Daily Life in the Inner Palace

On October 2, 1889, Dara Rasami gave birth to a daughter, Wimon Nakhonna Phisi: her first (and only) child by King Chulalongkorn. Though Queen Saovabha herself had had a baby herself just three months earlier, she "came to stay [in the birthing room with Dara Rasami] to provide moral support the whole time."[55] Queen Saovabha was sympathetic, especially as she and her sister, Queen Savang Vadhana, had suffered numerous miscarriages, stillbirths, and losses of infant children in epidemics that periodically swept through the overcrowded space.[56] These frequent and agonizing losses piqued Saovabha's interest in new medical interventions from the West that promised relief. In an effort to improve medical knowledge of childbirth early in the twentieth century, she even attempted to send several young Siamese women to England to be trained in the latest Western midwifery techniques.[57] Thus births from which both mother and child emerged unscathed were something to celebrate in the palace. It was also customary to mark the occasion of a baby's survival of its first thirty days with a special ceremony. As part of the first-month celebration for Dara's new daughter, Queen Saovabha sponsored a special performance of the Lan Na-influenced dance-drama *Lilit Phra Law* in the Inner Palace.[58]

Dara's rank automatically went up a notch after she gave birth: from chao chom (consort) to chao chom manda (consort-mother). This rank was shared by a number of other royal consort-mothers, but for many women, even that level was out of reach. Of the 153 consorts resident in the palace in that era, only thirty-six had children with the king; some women, gifted to the palace to serve their family's political ambitions, were accepted out of politeness and rarely seen in the king's presence. For these women, their best chance for face-to-face contact with the king was to attend the king's daily audience in the Yellow Room of the Chakri Maha Prasat—hence they were nicknamed the ladies of the Yellow Room. Further ascending the promotion ladder in the palace depended primarily on the individual woman's family of origin and her service within the palace.

The king and his inner circle of Inner Palace officials assessed promotions on an annual basis, using reports from royal women of the highest rank, who vigilantly surveilled the activities of the queens, concubines, and the women of their entourages.

The arrival of her daughter brought Dara Rasami both a new title and a new home, where she could surround herself with a proper entourage of Lan Na ladies-in-waiting to attend her. By all accounts, Dara was a devoted mother, and her daughter was immersed in every comfort Lan Na's royal family could afford. Her ladies described the little girl's coming as *sadet Chao Noi*, or arrival of the Little Noble (borrowing her mother's palace nickname). In photographs of Wimon Nakhonna Phisi, she wears copious jewelry, a Lan Na-style phasin skirt, and a lacy Victorian blouse (like her mother)—but her hair is pulled into a topknot like other Siamese royal children, signaling Dara's accommodation of Siamese custom, versus Lan Na style.[59]

After a somewhat rough start to her life in the palace, Dara Rasami put her training and talents to work in forging relationships with various palace folk. Her "excellent temperament and [beauty]" made her "a 'pet' or favorite of the royal family. Many sons and daughters of Rama IV and Rama V who were respected officials throughout the palace, became close to her. She came to be loved by all those near her—royal consort-mothers and consorts alike—even those few who had bad aims towards her. With those royals, she could be impassive, giving no reaction or answer of any kind. . . . She changed the anger of those that thought harmfully in that way, until at last those individuals were close companions."[60]

Dara made several important friends among the fai nai, including Queen Savang Vadhana, Chao Chom Manda Hem, and Chao Chom Manda Mote; several of the Bunnag sisters, Ieyem, Ohn, and Erb; and fellow Chiang Mai native Chao Chom Manda Thipkesorn. Hem's daughter noted that her mother often went to play cards with Dara at her residence, where they smoked cheroots and made merry until late at night; when the king built a new palace in the Dusit district, their residences were built next door to each other.[61] Though Dara Rasami was known for her love of cards, she was not a reckless gambler and did not get into trouble with gambling debts (as other palace women and her relatives sometimes did). Prince Damrong (who administered the timber money sent from Chiang Mai to Dara's household) even commented favorably to his daughters on Dara Rasami's wisdom in handling money, and his daughters noted Dara's generous gifts at their tonsure ceremonies.[62] A royal consort of any rank did well to find whatever friends she could in the Inner Palace, as she was very rarely allowed to leave the palace, except by special permission, and never on her own.

In the daily life of Siam's palace women, as for commoners outside, the tropical climate necessitated a constant effort to keep their bodies clean, scented, and dressed. In an era before the advent of indoor plumbing and the convenience of running water, one might well wonder how the women of the Inner Palace dealt with the body's natural functions and personal hygiene. There were a number of ponds and fountains in the Inner Palace grounds that palace women could use for relief from the tropical heat and humidity.[63] Their water came from a fresh water pipeline running under the palace from just below Wat Phra Sri Rattana Sudaram (the Temple of the Emerald Buddha) and southwest through the Inner Palace, supplying its gardens and fountains.[64] Besides this, there was also the bathing pool known as Lady Orathai's Pond, which was located south of the Tao Teng rowhouses. Here Inner Palace women obtained potable water, drawing it into vessels and transporting it to their mistresses' households for their cooking and bathing needs.[65]

Human waste was dealt with by two main methods; which one depended on a woman's status level. If a woman was a Mom Chao (royal relative), palace official, or consort of chao chom (or higher) status, she could use a chamber pot within the comfort of her household; if a woman was a lady-in-waiting or servant, she had to use the public toilets. These facilities were located between the Tao Teng (administrators' row houses) and the outer wall, as they drained outside the palace grounds. Housed in a long, low brick building colloquially known as the *umong* (cave), the site also functioned as an important meeting place for Inner Palace women:

> In the past, the area near the entry to the cave was a place where women of all ages and generations met together. It was also the site of debts, quarrels, reversals, or "understandings." There was much moneylending and "tools for gathering high fruit," or selling businesses. For example, getting prices for clothing; selling small trifles, like cosmetics, soap, needles, combs, and handicrafts and sweets that the palace folk made themselves, like fried lotus seeds, cookies, rice noodles, etc.[66]

As a site which probably experienced the greatest circulation of bodies within the Inner Palace, one can imagine that the umong was a lively point of exchange for news and rumors from both inside and outside the palace.[67]

Within a noblewoman's household, her toilette was attended to by her ladies-in-waiting and servants, who assisted her in bathing, dressing, and emptying her chamber pot. A custom peculiar to the Siamese palace was dressing in the color(s) of the day. This system, still observed informally by some Thais,

assigns a different color to each day of the week based on astrological associations between each day and a different ruling planet or deity. As former palace resident Kukrit Pramoj explains, each day had both a dominant overall color and complementary ones that functioned as accents:

for Monday—the yellow *phalai* with the light blue top or the pigeon blue phalai with the top in champa red. For Tuesday, this lime pink or this *maprang*-pit purple, topped by *sok*-leaf green, you see? Or, if you prefer a green phalai, then your top should be in pale purple. . . . Both bean color and iron color are correct for your Wednesday phalai, to be worn with champa orange. And for Thursday, green phalai with bird's-blood red, or orange phalai topped by pale green. For Friday it's dark blue with yellow on top, and for Saturday the phalai in maprang-pit purple with the cloth in sok-leaf green. Dark purple is also acceptable for Saturday—lovely shade, isn't it?—and oh so hard to find. . . . For Sunday, you may dress as on Thursday if you wish or you may choose a lichee red or a pig's-blood red phalai, with the top in sok-leaf green. . . . You must learn these combinations and not dress like a clumsy peasant.[68]

Adherence to this convention required women to have several changes of clothing, plus different-colored accessories and accoutrements to complement each outfit. During Chulalongkorn's reign—which coincided with the high Victorian era, when European fashions were popular among the royal women—many consorts incorporated Western elements into their dress as well. (This will be discussed in greater detail in the next chapter.) The highest-ranking consorts also adorned themselves with strings of pearls and jewelry gifted to them by the king. Given this combination of practices and conventions, the sheer visuality of women's dress in the Inner Palace on any given day must have been dazzling. Compared to the average single set of clothes owned by most commoners, palace dress represented a level of luxury unreachable by all but the wealthiest in Siamese society at the time.

Outside the eastern palace walls lay a plethora of shops and fresh markets where palace servants could find the supplies needed to feed and clothe their households: "The area near this gate swelled with young women who came to sell merchandise, necessities, utensils, clothes, finery/silks, and various other items."[69] Books and periodicals could also be obtained there; Dara even employed a reader to pore through historical texts and current publications to keep her up to date, as Dara was known for her keen interest in politics.[70] The markets were also a source for domesticated animals—cats, dogs, birds, fish, and

turtles—which many palace women also kept as pets in their households. One observer noted that "some people liked to keep cats, as they were small and liked to sleep; they let them eat from silver dishes and crystal bowls, as it if were quite ordinary."[71] Dara's household was no exception: two small pugs appear in several photographs of Dara and her entourage.

The palace market was also a place where go-betweens brought eligible young men to identify possible marriage partners from among the ladies-in-waiting who otherwise were rarely visible outside the palace.[72] It must have been a lively scene, with consorts' cooks and maidservants constantly running in and out of the palace on errands for their employers, and commercial vendors coming and going to sell their wares to the women's households within.

Life within the double walls of the Inner Palace bustled with activity from dawn to dusk. Considering the women of the palace were frequently referred to as the *nang haam*, or forbidden wives, the boundaries of the Inner Palace were in reality remarkably porous. Each morning before dawn, monks from the nearby royal temple would make the rounds of the Inside with their begging bowls; commercial vendors and construction workers could enter and exit the Inner Palace with permission, and even commoners could also enter the Inner Palace on special business. In the afternoons, Queen Saovabha herself held audiences on the steps behind the Chakri Maha Prasat, where she would entertain commoners' entreaties:

> At the end of the afternoon, about 5pm, *Somdet* would come out to receive guests on the last step herself. If it was a regular village person, they would be directed down the steps. But the steps of the palace were very wide, made with beautiful black and white stone. Some guests said they would rather sit along the lower circle level.[73]

Traders selling gems, silks, and other finery also periodically made the rounds of the women's residences. Consorts themselves also frequently engaged in small business within the palace, selling handicrafts, sweets, and other treats from their residences to supplement their official stipends.[74] Dara's household participated in this informal marketplace, selling betel-chewing supplies and other dry goods from a cabinet in the rear of her residence.[75] She found a receptive audience among palace women for the exotic Lan Na-style snacks called *mieng*: fermented tea leaves wrapped around savory fillings of herbs, chilies, lime, dried shrimp, and peanuts (which can still be found on the menus of many Bangkok restaurants today). As Kukrit tells us, "Chao Dara Rasami's residence . . . was the only one that always handed out tidbits wrapped in leaves."[76] Perhaps these

unique snacks brought new friends into Dara's circle, in addition to contributing to her already substantial household income.

Circulation and Status in the Inner Palace

As the potential mothers of Siam's future monarchs, consorts' bodies were not to circulate freely: their sexual circulation had to be restricted exclusively to the domain of the king. The high value of their social currency translated into limits on their physical circulation. During the Ayutthaya era (1350–1766), Siamese royal women had also been sequestered[77]; elite women were restricted to the Inner Palace in the Ratanakosin era (1782–present) as well. The sequestration of elite women became socially coded in Siamese society, with the near invisibility of high-ranking palace women synonymous with their eliteness. Considering the perpetual shortage of humanpower common to mainland Southeast Asia, and the grinding difficulty of the daily lives of many Siamese women laboring in fields and marketplaces, such limited circulation must have seemed a luxurious state to which most people could only aspire. Additionally, any consideration of the social value of the Inside should not ignore the immense spiritual bonus accorded to those living in such close proximity to the sacred person of the dharma raja, the king himself.

It follows that those who enjoyed the highest status in the Inner Palace were not allowed to circulate as freely as those of lesser status. Of the fai nai (inner group), those who had the greatest freedom of physical movement between the Inner Palace and the outside world were actually the lowest-ranking members of the royal households: guards, servants, cooks, and go-betweens. These women would have been free to enter and exit the palace gates as necessary to complete their assigned errands, giving them the greatest physical freedom of any of the women living within the palace. Some servant women and officials—excluded from being selected as consorts—even had husbands and families outside the palace, elsewhere in the city.

Indeed, for the highest-status royal consorts and queens, the very fact of their invisibility (and corresponding inaccessibility) to the outside world was a mark of their royal rank. Inner Palace women were limited to movement between the Inner and Middle Palaces, or, if outside the palace, mainly to various nearby temples for important ceremonies or seasonal sermons.[78] On these occasions, palace women entered temple grounds on walkways lined with screens or curtains, and their seating area was partitioned off to hide them from the gaze of the populace—and vice versa. A consort's movement outside the palace could only

be achieved by royal permission and in the company of an official chaperone; even then she would also be accompanied by her customary entourage. Thus an elite woman was highly unlikely to travel anywhere alone. Even to see relatives visiting Bangkok, a royal consort had to obtain permission to exit the palace, and she could host visits from only her immediate family members inside her palace residence.[79] In addition to regulating consorts' behavior in their external circulations, their internal, emotional orientations were policed as well—via oaths of loyalty.

Oath-taking and Policing Women's Bodies

On entering palace service, Dara Rasami—like any other nonroyal-born woman—took an oath of loyalty to the king during the ceremonies marking her entry into palace life. The chao chom's oath, which was sworn to the person of the king himself, pledged the consort's sexual fidelity to the king to the exclusion of all others, both male and female. The oath also entailed that the consort would not tolerate the advances of other men, would not act as an accomplice to other consorts in infidelity, and would not engage in any other acts considered disloyal. These included stealing from or assaulting other consorts and "associating with fortune tellers and practitioners of magic love charms."[80] Additionally, the oath was sworn before "supernatural powers... invited to torture the oath-taker in a variety of painful and long-term ways before causing death if the chao chom betrays her oath."[81]

In premodern Siam, oaths were a common practice by which individuals, both male and female, had pledged their fealty to Siamese monarchs since the Sukhothai period.[82] The consort's oath can be seen as a parallel to the oaths of allegiance taken twice a year by male officials serving in the provincial administrative roles.[83] Male Siamese officials, like the rulers of Siam's prathet sarat (tributary kingdoms), took a water-drinking oath, in which the blessed water was thought to turn to poison in the oath taker's body if he later acted disloyally. The chao chom's oath functioned similarly: as magical language that, if contravened, would bring physical consequences directly on the consort by supernatural means. In both forms of Siamese oath taking, the oath functioned not as a mere verbal warning to remind the oath taker, but more like a vaccination that carried the potential for physical effects in the oath taker's own body should they act disloyally. Siamese oath taking centered the body as the foundation of governance.

The chao chom's oath functioned through both the self-regulation of her own behavior and the informal surveillance of other women's actions within

the Inner Palace. Besides the transgressions listed above, several more offenses were officially proscribed during Chulalongkorn's reign. Issued in 1875, the edict reads as follows:

> All chao chom living here . . . must behave according to the points of the royal decree as follows:
>
> 1) It is forbidden for chao chom living here to drink except alone, or associate together. . . . Carousing [is] the worst on *ya dong* (fermented medicine; medicinal spirits). If one takes ya dong, it is specifically for one's own health alone. If one induces one or more of one's friends to take it, that is absolutely forbidden.
> 2) It is forbidden for royal ladies, *mom chao* (royal granddaughters), official workers who live both inside and outside the palace, wives of officials, and bad women in the palace to be "love friends," or "husbands who are women," and gamble together as if gold and silver were only words.
> 3) Forbidden for royal ladies, mom chao of various palaces or within palaces, wives of officials in their houses. To eat or stay over at their own houses if they have relatives coming to stay at those homes, they must inform the *tao nang* (palace matron) with a bow; if they give their permission the [lady] may go to stay.
> 4) If a person comes to stay in [a lady's] house, [only] parents or direct siblings may come to stay in the home of their relative, and do not need to report to the [palace matron]. But they must take care not to allow other situations; if there are too many other issues, they must report their mistake to the palace official.
> 5) They must have respect, fear and pay attention to the directions of the Palace Matron, high nobles, and chao chom with higher status, according to their rank. As to these orders, chao chom who do not obey them, whether they defy one or more, will receive royal penalties to be weighed out according to the crime.
>
> ~ *Declared on day 3-12/10 night 12 of J. S. [Minor Era] year 1237 (1875–76).*[84]

This edict highlights for us a number of issues among the women of the Inner Palace: drug use, lesbianism, and gambling among them. Of these problems, Dara Rasami's household encountered at least two over the course of her career in the palace. The first issue was the recreational use of medicinal drugs, which Dara appears to have faced when she was still a lady-in-waiting in the queen's

household. According to Chiang Mai historical sources, Dara Rasami com-
plained privately to her attendants that "the royal women who ate jimsonweed
[i.e., took hallucinogens] were crazy, and would drive her back to Chiang Mai
yet."[85] As medical care was readily available to the women of the Inner Palace,
such drugs were not hard to come by. That the king felt the need to prohibit these
drugs strongly suggests that some consorts and royal women of the Inner Palace
remained unfulfilled by their palace lifestyle, however rarefied or luxurious it
may have appeared to those outside its walls.

Another issue addressed by Chulalongkorn's edict was the phenomenon of *len
phuan* (literally "playing friends"), a popular pastime of late nineteenth-century
palace women that involved intense girl-to-girl friendships and crushes. It
touched Dara Rasami's household directly in 1906, when an affair was discov-
ered between one of Dara's ladies-in-waiting, Lady Yuang Kaew Sirorote, and
Mom Rachawong (Siamese royal granddaughter) Wongthep. The affair might
have gone unnoticed if not for Wongthep's jealous former lover, *Nang Sao* (Miss)
Hoon. (See figure 3, in which both women appear.) It was Miss Hoon who spread
the news that Yuang Kaew had regifted a gemstone ring to Wongthep—a ring
which Dara Rasami had originally given to her. On learning this news, Dara
Rasami became enraged, scolding Yuang Kaew harshly and making her repeat
every criticism heaped on her. Knowing that she was about to be expelled from
Dara Rasami's entourage and sent home in shame to her family in Chiang Mai,
Yuang Kaew committed suicide.[86]

It remains unclear which of Yuang Kaew's actions was considered worse: en-
gaging in len phuan with another palace woman, or passing along an item be-
stowed on her by her patroness. Though her affair—with a royal granddaughter,
no less—does not appear to have called Dara Rasami's loyalties into question,
Yuang Kaew's bestowal of such a precious item to Wongthep betrayed a high
level of emotional involvement, which constituted an inappropriate diversion of
her loyalties away from her patroness's household. In any event, the consequences
were serious for Yuang Kaew and her family, who bore a heavy burden of shame
as a consequence of her transgressions. Whether any punishment was meted out
to Mom Rachawong Wongthep as a consequence of the affair is never mentioned
in these sources.

The above case is an example of some of the petty crimes and misdemeanors
within the Inner Palace. Most likely such cases only rarely reached the ears of
the king himself, nor were they often formally recorded in palace records. Such
transgressions were punished by the chao chom themselves within their own
entourages, without recourse to formal proceedings.[87] However, things were

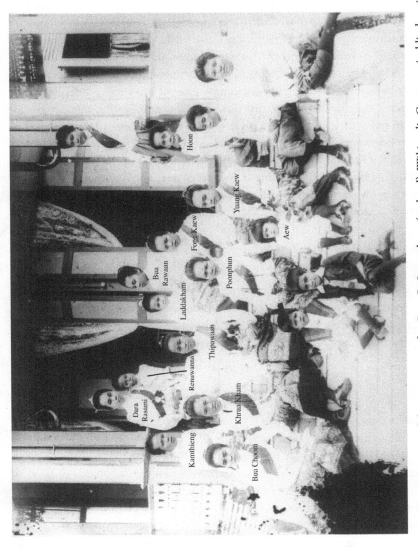

FIGURE 3. Dara Rasami with her entourage at her Bang Pa-In residence (undated). Wikimedia Commons/public domain.

different for women of royal birth. Though they were not bound by the semian-
nual loyalty oaths taken by nonroyal chao chom, royal women faced a different
set of punishments for their crimes in the Inner Palace.

Transgressions of the royal space of the Inside were governed not only by pal-
atine law, but also by a royal council who reviewed each offense on a case-by-case
basis, ultimately deferring to the king himself. Though a royal woman could not
be placed in irons like any commoner, royal punishments could range "from
probation down to reduction of the annual stipend. In cases considered espe-
cially egregious, there might be a confiscation of one's royal order and one's
property, decorations, and punishment of 'dit sanom.'"[88] Dit sanom was sim-
ilar to house arrest, in which a royal woman would be essentially confined to
her residence; in addition, her participation in royal ceremonies was permitted,
but only if she was led in golden irons behind the rest of the royal procession,
subjecting her to significant shame and loss of status.[89] Nonetheless, it was rare
for a royal woman to suffer the loss of her annual stipend or residence. Only in
extreme cases, such as sexual transgressions of palace law, were palace women
ever jailed. Though it is difficult to find mention of actual punishments in the
Siamese records, American missionary Mary Cort noted the nature of one con-
sort's punishment in 1886:

> The latest instance of flirting [in the palace] resulted in the disgrace of both
> [parties]; the flogging of the young nobleman, and banishment from the
> capital; while the lady who dared be faithless . . ., was condemned to wear
> chains and cut grass for the royal elephants all the rest of her life.[90]

Male Bodies' Circulation in the Inner Palace

This brings us to the question of how males navigated the space of the Inner Pal-
ace. Though readers of Leonowens's books might be left with the impression that
no man besides the king of Siam himself was allowed into the Inner Palace, men
did indeed circulate there, although their movements were closely regulated. A
Western observer noted, "Men on special work of construction or repair were
admitted, and the doctors when they came to visit the sick."[91] Consorts' male
relatives could also enter the Inner Palace and stay in their daughters' residences.
However, no man could enter the Inner Palace unmonitored, or move around
unsupervised. Female palace guards, called klone, were assigned "to accompany
all men who were admitted and to remain with them until they left."[92] Even boys
born and raised inside the palace had to leave once they reached puberty.[93] For

male officials and royal pages visiting the Inner Palace, there was a host of rules designed to preclude casual contact with the women of the Inside. According to the official rules of the Mahat Lek, or Royal Pages Corps:

> Do not allow Mahat Lek to part the curtains to look into the Inner Palace. They are to seek out and speak to only the one person. . . .
>
> When a page has received something from the Inside, or needs to send something into the Inside, he must call a go-between. It is forbidden to go raise or part the blinds or curtains that would allow them to look inside, and to speak/converse with those of the Inner Palace is forbidden. . . .
>
> In fact, the Page's government duty is to enter into the Inner Palace at one time or another. [He should] exercise great caution and care in his deportment, i.e., he should come and go directly, not drop by to chat with one person or another. Those so charged should speak with only who is there, the matron, and see her only. Therefore, [the page] should speak only about government business. It is forbidden to have conversations, or make speeches, or associate with [those within], and when you enter the Inner Palace, you must tell them that you have an audience Inside. It is forbidden for you to enter, and going alone is especially forbidden.[94]

Another male population allowed to enter the Inner Palace was that of royal monks. Since the highest-status royal women did not circulate regularly outside the palace walls, they were precluded from earning Buddhist merit by giving food to monks making their daily rounds of the local community, which was (and still is) a common daily practice of Siamese women. To restore this important merit-making opportunity to the women of the fai nai, a group of monks were allowed to visit the Inner Palace daily, walking a limited route through the women's residences to collect daily alms.[95] As we saw in the aforementioned episode of the royal woman whose affair with a monk was discovered, the loneliness of some royal women was such that even the briefest contact could spark romance. Nonetheless, serious consequences awaited transgressors when the boundaries of palace law were crossed—a fact that was not lost on Dara Rasami herself, whose role encompassed that of both Lan Na diplomat and hostage.

Illness and Medical Treatment in the Inner Palace

In the close quarters of the overbuilt Inner Palace toward the end of the nineteenth century, illness was an increasingly regular occurrence among the women and children there—including Dara Rasami herself. (This was ultimately part

of what motivated Chulalongkorn to build the new palace grounds in the Dusit district at the turn of the century, which will be discussed in the next chapter.) Siam's palace women had access to a remarkable level of medical care in this era. Though Western medicine had come to Siam with Christian missionaries in the 1830s, the hospital was still a novel idea in late nineteenth-century Siam. For women within the palace, traditional Siamese medicine was usually their first option, but it was often augmented with Western medicine if the first course of treatment was unsuccessful. Archival records demonstrate that (unlike most other aspects of daily life within the palace) a consort's medical care was tracked meticulously, while her intake of food, water, and medicine and any changes to her physical condition were carefully monitored throughout the day. In special cases, a consort could request to be sent elsewhere to recuperate; the palace up-river at Bang Pa-In and the coastal retreat of Ang Sila (southeast of Bangkok) were frequent requests. Dara Rasami herself suffered from occasional respiratory ailments, no doubt exacerbated by her custom of smoking cheroots. In 1906, she requested a visit to Ang Sila to recuperate, the reasoning being that she would benefit from the cleaner air there.[96]

More records are available for Dara Rasami's Chiang Mai compatriot Chao Chom Manda Thipkesorn, who also suffered from illness from late 1901 to early 1903. Official notes indicate that when Siamese doctors proved unable to cure her in late 1902, a Western doctor was brought in to take over her care. Perhaps sensing the fatal trajectory of her condition, Thipkesorn requested to be sent north to see her family in Phitsanulok, but due to unrest in the area at the time, her request was denied.[97] Instead, the palace administrators suggested she go to Bang Pa-In to recover. However, her condition declined rapidly, and not long after she was declared "hopeless," she died on January 26, 1903.[98]

Coping with Illness and Loss in the Palace

Dara's own happiness as a young mother was short lived. Following a short (unexplained) illness, her daughter died suddenly on February 21, 1892, at the age of only two and a half years. Dara was reportedly distraught with grief and had her ladies destroy all images of Wimon Nakhonna Phisi that could continue to remind Dara of her. She even asked King Chulalongkorn to allow her to go back to Chiang Mai to live as she had before (though the king put her off, saying it would be decided later).[99]

When the news of his grandchild's death reached Intawichyanon in Chiang Mai, he wrote a long and touching letter to Dara. In this letter he expressed

sadness and compassion for her loss, and shared his own experience of having lost one of his own children (Dara's older sister, Jantrasopha). He urged her to find the strength to carry on:

> [Your] father [has wanted to] speak to you from the heart since you were fourteen and went into service in the royal palace. The body of the child might be gone, but a father's heart is always focused on life with his child. Your father misses his child with every breath. . . . Please do not fall apart, even a little. Please try to strengthen yourself, a thousand times over. This I wish a million times over. . . . [100]

Though her daughter's death darkened the following months and years for Dara Rasami, she eventually found the will to carry on out of a sense of "duty... over love."[101]

Yet Dara's daughter was never promoted to the same royal rank as her Siamese half brothers and sisters, despite the fact that her mother descended from the Lan Na royal family. Wimon Nakhonna Phisi received the title *phra chao luk ther phra ong chao* at birth, a rank she shared with several of the king's children by noble consorts—but notably not the rank of *chao fa*, which was only accorded to the children of the high queens. Even though Dara Rasami nominally held the same status as a Siamese royal woman, her child was not awarded the same birth rank as those of the king's half sisters. However, the rank could have been granted at the king's discretion. After the little girl's premature death, Chulalongkorn expressed his regret for not having promoted her. In a letter to Prince Damrong, he wrote, "I made a mistake. She should have been a chao fa, but I forgot until she was already gone."[102]

What should we make of this "mistake"? It is perhaps understandable that the promotion in rank of this one daughter could get lost in the shuffle of the larger issues that Siam was dealing with at the moment. The year 1892 witnessed a vast reorganization of the Siamese government's internal administrative structure, as well as Siam's surrender of five contested Lan Na/Shan provinces to the British. Additionally, there was growing concern about the French activities in both Cambodia and the Lao territories, which culminated in the Paknam Crisis the following year.[103] However, while such promotions were at the king's discretion, they could still be given posthumously (Chulalongkorn had, for example, promoted his young queen Sunanta Kumarirat after her accidental death by drowning in 1880).[104] The most likely explanation is that since Dara Rasami remained at the rank of a mere chao chom manda, such a promotion was not considered warranted. Only once Dara Rasami was promoted to the rank of

high queen (phra rachaya)—a scant year before Chulalongkorn's death—did
his successors find it appropriate to upgrade Dara Rasami's deceased daughter's
status. Thus Chulalongkorn's mistake was remedied by subsequent kings Rama
VI (Vajiravudh) and Rama VII (Prajadhiphok), both of whom elevated Dara's
daughter, Wimon Nakhonna Phisi, to a higher rank during their reigns.[105]

Nonetheless, Dara Rasami managed to find other outlets for her maternal
instincts. When her cousin—her aunt Ubonwanna's daughter—died suddenly
at age twenty-eight, Dara Rasami took in her two young children, Kawilowong
and Renuwanna, with Chulalongkorn's blessing.[106] Dara also took in another
great-niece, Laddakham Chotamra, her half brother Intawarorot's granddaugh-
ter. When Laddakham and Kawilowong reached adolescence, Dara sent them to
school in Europe (sources disagree as to whether they went to Paris or London).
While King Chulalongkorn sponsored Kawilowong's European education (as
he did for all his princely sons), Dara paid for Laddakham's schooling herself.[107]
This pattern continued, with Dara adopting children from her extended family
even in her retirement and later life in Chiang Mai. In palace portraits of Dara
and her entourage taken at her Bang Pa-In residence sometime in the 1890s, we
can identify five children (three girls, two boys) under the age of ten (see figure 3).
When Laddakham's father later asked her to return to live with her family, Dara
made Laddakham promise that she would someday send her own daughter to
live with Dara Rasami. Laddakham, who married a Siamese nobleman, kept
her promise to Dara, sending her eldest daughter Chatrsudha (née Chatrchai),
to live in Dara Rasami's Chiang Mai household in the late 1920s.[108] Despite
the fact that her only child by the king did not survive infancy, Dara Rasami
created other opportunities for mothering and caring for children until the end
of her life.

What happened when a royal woman (or child) died in the Inner Palace?
Typically, family members were summoned to ritually bathe the body of the
deceased before it was folded up into the fetal position and sealed in a large
earthenware jar. The jar was then kept in a temple for a year, after which the
remains were cremated. A ceremony was held for mourners and friends to mark
the passing before the body was taken from the palace, and another ceremony
was held at the time of cremation. Because the rate of infant mortality in the pal-
ace was so high, a single cremation ceremony could be held for several children
at a time. For most women of nonroyal birth, their remains were sent home to
their family, who handled their cremation and interment.

Siamese royal customs and cosmology dictated that corpses could only be re-
moved from the palace through the gate in the appropriate direction: westward

through the *Prahom Sri Sawat* gate. The bodies of nonroyal women were returned to their families, who cremated them in their hometowns (for example, the remains of women of the Bunnag family are interred in Petchaburi, the Bunnag family's longtime provincial home). For some royal women, another new practice originated during the Fifth Reign: interment of their ashes in the royal women's mausoleum next to Wat Rajabophit.[109] This cemetery was created specifically by King Chulalongkorn for the remains of royal women and high consorts following the death of Queen Sunanta Kumarirat in 1880. As Sunanta was herself a royal princess, and there was no existing location within the palace that could accommodate the remains of (so many) royal women, the king built a women's cemetery. Queen Saovabha's ashes are interred there, as are those of a number of other high-status consorts. Dara Rasami also has a funerary monument there, which contains the ashes of her and her daughter.[110] One can still visit this cemetery today, which contains nearly two dozen monuments housing the remains of various royal women and their children.

Ethnic Difference in the Palace

Dara Rasami had been groomed from early in her childhood for her life in Siam's Royal Palace. She was educated in Siamese language and customs prior to leaving her homeland to become a royal consort in Bangkok in 1886, and had even undergone the Siamese tonsure ceremony at puberty, though this custom was not ordinarily practiced in Lan Na. Despite these efforts to adapt, life for her within the Siamese Inner Palace was hardly easy. As a cultural outsider, Dara faced differential treatment by her Siamese contemporaries, ranging from subtle snubs to open hostility. As mentioned earlier in this chapter, Dara herself was teased and taunted while still a young girl serving in Queen Saovabha's entourage. Even after her daughter was born and Dara moved into her own impressive residence, she disliked leaving it because she so keenly felt the disdain of other Siamese consorts.

But was she unique in this unpleasant experience of feeling like an outsider among her Siamese counterparts? Were there any other consorts who brought a similar level of cultural difference into the palace during the same era? A good test case for comparison is the aforementioned Chao Chom Manda Thipkesorn, who had served in the Inner Palace for three years before Dara Rasami's arrival and borne the king a son.[111] How did the experiences of these two foreign consorts compare? This comparison will demonstrate how a woman's political stature and personal relationship with the king affected her career trajectory.

Chao Chom Manda Thipkesorn (not to be confused with Dara Rasami's mother, Thipkraisorn) came from a less prominent branch of the Lan Na royal family, providing the Siamese with yet another northern woman among the ranks of the Inner Palace consorts, additionally reflecting the political importance of Lan Na at the time.[112] Lady Thipkesorn took a very different path into the Inner Palace than Dara Rasami. Thipkesorn started out as a lady-in-waiting to Chao Chom Manda Phae (Bunnag), sometimes described as Chulalongkorn's first love, as they were married while he was still a teenage prince.[113] To work in the entourage of an important Siamese noblewoman, Thipkesorn had to cut her hair short in the Siamese style and wear the chongkrabaen (a wrapped and tucked trouser-like garment) worn by her patroness—in contrast to the long hair and Lan Na-style tube skirts worn by Dara Rasami and her entourage. Thipkesorn had a son by King Chulalongkorn in May 1884: Prince Dilok Nopparat, whose title was *phra ong chao,* which denotes the status of a child born to a nonroyal consort. Surprisingly, there are no extant photos of Thipkesorn, though her son grew up to become a significant individual: the first Siamese to earn a European doctoral degree.[114]

Thipkesorn's house, unlike Dara Rasami's, was located well outside the high-status zone near the Chakri Maha Prasat. Despite her son's achievements, Thipkesorn did not have a particularly close relationship with King Chulalongkorn, and she was never promoted beyond the rank of chao chom manda.[115] Thipkesorn had few friends among the Inner Palace ladies besides Dara herself, with whom she was reportedly close. (One imagines that because they were the only two Lan Na consorts in the palace at that time, and Dara's household spoke *kham muang* [Lan Na language], Thipkesorn and her young son, Prince Dilok Nopparat, probably spent a good deal of time in Dara's house.) Following Thipkesorn's death in 1903, King Chulalongkorn prompted other ladies of the Inner Palace to attend her cremation ceremony, so that Dara Rasami would not be the only consort in attendance:[116]

Noppaporn—The funeral for *Nang* [wife] Thip will not have any family. [Only] Nang Dara will be there, tirelessly, by herself. I agree that it will be too quiet. Please have the royal siblings and consort-mothers, and other similar-level consorts who get along well enough, come to help out. Those that follow their hearts to come make an appearance will be a help to Prince Dilok. But the *Chao Nai* [Inner Palace people] should come for the cremation [only], as it would be an inconvenience [to come to the funeral itself]. ~ Siammint [King Chulalongkorn]

As Thipkesorn's case illustrates, without the financial support and special treatment accorded a high-profile figure like Dara Rasami, life for a consort inside the Siamese palace could be one of genteel poverty and isolation. For many women of the Yellow Room and royal female relatives, their marital and career prospects were limited. For their servants and ladies-in-waiting, however, the palace offered unparalleled opportunities to better one's social station—particularly through marriage. Several of Dara Rasami's own ladies found matches with high-born Siamese and Lan Na men that illustrate this point. Lady Poonpun Thepsombat, Dara's great-niece, found love with a young Siamese man serving in the Royal Pages Corps named Sunga Singholaka; when the married couple moved to a new residence across the river, Lady Poonpun founded Bangkok's Chao Phraya River ferry service, which is still run by her descendants today.[117] Dara's attendant Bua Choom married Chao "Noi" Sukkasem, a high-ranking Chiang Mai noble who was in line for the governorship.[118] Lady Thipawan married one of King Chulalongkorn's brothers, Prince Boworadet Kridakorn, with whom she lived in England and France for several years while he was appointed ambassador. After several years abroad, the couple returned to live in Chiang Mai when Boworadet was made vice-governor of *monthon* Payap from 1915 to 1919, though they divorced when he returned to live in Bangkok.[119]

The perceived ethnic distance between the chao Lao and the Siamese still presented obstacles to such relationships, however. Another of Dara's ladies, Kamthieng, fell for high-ranking Siamese nobleman Anou Chitchanchai Singhaseni, who headed up the palace police force. Even though both were aware that their families would disapprove of their relationship, the couple married in Chiang Mai—but because he was already married, Kamthieng's status was that of minor wife. When they returned to Bangkok, her miseries began:

Life in the capital at the status of "mia noi" [minor wife] brought heaping humiliation and mistreatment all the time, especially great for a minor wife who was "Lao," in the opinion of Bangkok people . . . Lady Kamthieng who had been cheerful and jolly like a little bird, became a sad and depressed person, pondering hard until she was very somber.

The adversity of this life made for frail health for Lady Kamthieng, and was the reason it was damaged permanently. . . . In the end, Kamthieng fell into great distress with heart disease, and had to leave the palace. To recuperate, she went to stay at Tha Tien near Wat Chetupon, and ended her short and sad life there, though she was only 28 years old.[120]

Another of Dara's ladies, Fong Kaew, became involved with Siamese noble Mom Rachawong Phoom Malakun na Ayutthaya, but broke off the relationship when she refused his demand to cut off her long, Lan Na-style hair.[121] Yet another of Dara's servants, Tunkaeo, was so eager to make a good marital match that she narrowly escaped being sold into a brothel.[122] As these stories illustrate, the issue of the ethnic distance between the Siamese and Lao was still contentious during Dara Rasami's tenure in the palace, and depended largely on the attitudes of the individuals involved (and their families). In matters of love, Lan Na women in Siam—regardless of status—remained at a distinct disadvantage from their Siamese counterparts. Much depended on a woman's social status, and whether she was considered an insider (*nai*) or an outsider (*phrai*.)

Birth and Status: The Nai and the Phrai

Perhaps the most telling reflection of Dara Rasami's difference in the context of the palace were the terms used by others to refer to her. As palace memoirist Chunlada Phakdiphumin writes of traditional Siamese society, there was a clear class distinction to be made between nai and phrai: the nai being those of noble birth, while the phrai was a broad category including both commoners and slaves.[123] Among those of the generation of the Fifth Reign, nai included only nobles born directly to the Chakri royalty; all others, even those of *mom luang* or mom rachawong rank, were considered phrai. Given Dara Rasami's royal Lan Na lineage, one might assume that she would automatically be considered a member of the nai, but this was not the case. According to Chunlada, Dara Rasami was considered not nai, but phrai—due primarily to the court's perception of her as a cultural outsider, a Lao princess.[124]

This is reflected in the manner by which King Chulalongkorn himself referred to Dara Rasami in a number of letters written about (but not to) her. Though Dara's official title was Chao Chom Manda Dara Rasami, starting in 1889, she is referred to in these letters not as chao or chao chom but as *nang*—nang being a nonroyal term, which today denotes merely wife. The king did not reserve his use of this term exclusively for Dara Rasami, however. He also used nang for a few other consorts who were not part of the Chakri royal family (and who qualified as phrai, given the above conditions). These nang included several of his favorite consorts, namely Nang Sadup, Nang Erb [Bunnag], and Nang Choom. In contrast, the king called *Chao Khun Chom Manda* Phae, a member of the Chakri royal kin group, *Khun* Phae in similar communications.[125]

Other palace folk were not so kind. Some referred to Dara Rasami as *Ai* Dara, ai being a personal pronoun indicating low status, which today is used as an insult.[126] It appears that while Dara Rasami's northern royal blood commanded some special treatment in the palace, her ethnic difference neutralized that status in day-to-day palace life. In the king's estimation, Dara Rasami shared the same status level as Siamese consorts of nonroyal blood; to others, she ranked little better than a common foreigner. Despite her special status as a political princess,

> Many still regarded her as "Lao," and were condescending towards her in many ways. Some Inner Palace ladies said "The Lao eat fermented fish" to embarrass her. . . . Those close to her objected to it, so they were called "Chao Beung" [serious ladies], or "lily-skinned princesses."[127]

Even after she was awarded her own palace residence, Dara and her ladies were vexed by various pranks:

> The cutting of an effigy into a tree caused her to faint from fear. Besides this, there was also a creeping plant that climbed down into her bathroom, down which someone had loosed caterpillars all around where one would sit. Excrement was spread around the garden where she lived. All these kinds of acts of persecution were forbidden to the consorts and lesser wives who were envious of Dara Rasami, and those who detested her for being "Lao." But they were all condemned by the King, who reprimanded them to put an end to it.[128]

Thus Dara Rasami remained an outsider to Siamese palace culture, languishing at the rank of chao chom manda for the next twenty years of her palace career. It was not until much later—in 1909—that Dara was finally promoted to a higher rank. By that time, however, Dara's role in the Siamese palace had come to signify something quite different than when she first arrived.

The year 1892 marked not just the death of Dara Rasami's only child, but also the start of a period of rapid—and sometimes unwelcome—political change in Siam. The following year, 1893, witnessed the brief Franco-Siamese War, in which France forced Siam to concede all tributaries in Laos and Cambodia east of the Mekong River.[129] Soon afterward, the king directed his ministers to begin reorganizing the administration of Siam's provinces in a more Western fashion. As Prince Damrong drew up *monthons* (provinces) divided into *changwat* (subregions), *tambon* (districts), and *mubaan* (villages), the traditional system of alliance-based rule gave way to a "rational," European-style model. By 1896, the new system had supplanted the layers of local and regional sovereignty at Siam's

peripheries, and negated the need for marital alliances with women like Dara
Rasami to maintain control over distant territories. The new *thetsaphibaan* sys-
tem relied on the circulation of male Siamese bodies outward to Siam's periph-
eries—versus female bodies circulating into the palace at the center—to create
a new level of political control similar to that of the British and Dutch colonial
possessions in South and Southeast Asia that King Chulalongkorn had visited.

The year 1893 also saw the birth of King Chulalongkorn's last child, born
in the king's forty-first year. The rise of the rational thetsaphibaan system oc-
curred in tandem with the decline of biopower (á la Foucault) in Siam. For
Dara Rasami, the deterioration of royal fertility also scuttled her chances of
bearing another royal child.[130] Nonetheless, the traditional system of regional
alliance-making that was in place when Dara Rasami entered the palace shifted
radically in the 1890s, as kinship-based rule was displaced by bureaucratic ad-
ministrative structures.

While her political capital had declined greatly by 1895, however, Dara Rasa-
mi's presence in the palace took on a new significance relative to a shift in the
Siamese worldview described as *siwilai:* the practice of ranking peoples within
a hierarchy of civilizations. The next chapter will explore how Dara Rasami—
whether intentionally or not—became useful to the Siamese construction of
siwilai as an "Other within," performing her ethnic identity via dress, drama,
and music.

CHAPTER 3

Performing Identity and Ethnicity in the Siamese Court

A T THE BEGINNING OF the twentieth century, a revolution took place in Siamese court life. Not only was the palace's geographical space completely reimagined, but the day-to-day activities of high-status royal consorts changed radically as well. These changes reflected the new, crypto-colonial worldview that had taken hold of Siam's elites called *siwilai*, which in turn reshaped the significance of Dara Rasami's ethnic difference within the Siamese palace. Siwilai, a Thai-language adaptation of the term "civilized," serves as shorthand for a set of discourses based on European notions of a hierarchy of civilizations through which Siamese elites reordered their worldview. These discourses, which eerily echoed their European colonial counterparts, were both scientific and cultural, including geography, ethnography, exhibition, and the museum—technologies that were used to more clearly describe, delineate, and justify the distance and difference between the elites at Siam's center and the "others" at its peripheries. In addition to the aforementioned scientific modes, I suggest that cultural modes of discourse—namely, dress, drama, and diplomatic gestures—embodied the discourse of siwilai within the context of the Inner Palace, allowing Siam's elite further opportunities to consume and commodify the peoples at their peripheries. Chao Dara Rasami played a significant role in creating and communicating discourses relative to Siam's view of Lan Na and the position of Lan Na in the new (crypto-colonial) hierarchy of civilizations. These new discourses were to transform both the intellectual and physical environments of the Royal Palace in ways that directly impacted the royal women in general, and Dara Rasami in particular.

Siwilai Space: A New Palace for a New Century

Following his return from a tour of the European continent in late 1897, King Chulalongkorn undertook a building project that made a major impact on the women of the Inner Palace. The king had been impressed by the garden-like

country residences of European monarchs and nobles, and returning from his travels, found the Inner Palace unpleasantly overcrowded.[1] In an 1898 letter to Prince Krommyn Retsuwanryt, Chulalongkorn expressed his belief that the environment of the Inner Palace was not merely stifling, but actually unhealthy:

> I think I'll build a house to get out and relax. . . . I notice that when I stay at Bang Pa-In [palace, roughly thirty miles upriver from Bangkok], I feel well because I can walk every day. When I come back, though, no one here feels well every day.[2]

Using funds from the royal privy purse, Chulalongkorn purchased several tracts of farmland located a few miles north of Ratanakosin Island, stretching east to west from the recently completed railway line (along today's Sawankhalok Road) to Samsen Road, and north to south between *khlong* (waterway) Phadung Krung Kasem and khlong Samsen.[3] This area, which he named *Suan Dusit* (Celestial Garden), consisted of former farmland and orchards, which were then cleared of much of their existing vegetation. The area was relandscaped completely, with lakes, khlongs, and streets of its own. The first structure built there was a simple, single-story wooden pavilion intended only for occasional stays by the king, his consorts, and his children; it was inaugurated in March 1899. From that time on, Chulalongkorn regularly brought his entourage—including several of his favorite consorts—on bicycle outings from the old palace to Suan Dusit (Dusit Park), sometimes even spending the night there.[4]

Soon the rest of the grounds at Dusit were allocated to a variety of royal uses: throne halls, residences, and pavilions dotted the spacious, garden-like landscape of the new royal palace park. A large section of these grounds, named *Suan Sunanta*, was set aside exclusively for the residences of a select group of royal women: consorts, royal relatives, and children, less than two dozen in all.[5] Here the king built residences for his most favored consorts and royal female relatives without male children who would otherwise have nowhere to live following his death.[6] Dara Rasami was one of the handful of women included in this select group. The open environment at the new palace was park-like with its wide lawns, trees, and flowers, and wide, paved streets. The new environment was ideal for several activities that became popular with the royal ladies at Dusit: walks, picnics, croquet, and bicycling, which the king himself had enjoyed since his boyhood days.[7]

Suan Dusit was at first imagined less as a replacement than as an extension of the existing Royal Palace grounds described in the previous chapter. In the context of the new "garden palace," the space of the women's residences was completely reimagined. Though the new palace grounds were securely walled

off from the outside world as before, the consorts' new quarters could not have been more different from those of the old Inner Palace. The orientation of the buildings still echoed the division of Outer/Middle/Inner Palace, but the areas were separated by canals and landscaping versus walls. The layout of Suan Sunanta would likely put contemporary viewers in mind of a suburban housing tract: individual houses were set along a winding road surrounding the central lake, with ample spaces between the residences planted with grass and trees. A pastoral feeling was the explicit goal of this arrangement.

The new Middle Palace was anchored by the stately golden teak Vimanmek Mansion, around which clustered the residences of a select number of King Chulalongkorn's female relatives and high queens.[8] Immediately across a wide moat from the mansion the king built himself a sprawling, single-story wooden house on the traditional Thai model, called *Ruen Ton* (Wooden House) Palace—an intentionally rustic residence where the modern king could enjoy informal dress and family time.[9] The king divided his time between Ruen Ton and Vimanmek, where queens Saovabha, Savang Vadhana, and Sukhumala Marasri, Chao Chom Erb, and Chao Chom Uen (of the Bunnag family) lived with a number of the royal children. The segregation of the consorts' space from that of the king was no longer strict as it had been in the old palace, as their new residences abutted the tract surrounding Vimanmek. As we can see from the aforementioned stories of royal bike rides and picnics, consorts' bodies began circulating outside the palace in wholly new ways (at least, while they were in the company of the king).

But what of Chulalongkorn's 140-plus other wives? Other than the aforementioned women above, fewer than a dozen others made the move to the new palace park—only the king's favorite and highest-status consorts, which included Dara Rasami. Though her official status remained at the rank of chao chom manda (consort-mother), as she had not borne the king another child, Dara's career within the palace continued to advance along a slow but steadily upward trajectory. As one of Chulalongkorn's first generation of royal consorts, she was awarded the Order of the Chula Chom Klao medal in 1893.[10] The fact of her membership among the select number of royal consorts brought to Dusit demonstrates her continued favor with the king and status at court. This is also reflected in Chulalongkorn's letters to the planners of the new palace, in which he requested that Dara Rasami's new residence be situated next to the homes of two other consorts—Hem and Mote—with whom she was close friends.[11]

Though the layout and construction of the new palace at Suan Dusit were accomplished at the fiat of the Siamese absolute monarch, they nonetheless reflect

the shift in royal thinking about space under the growing influence of European ideas of siwilai. This phenomenon is described by Thongchai as a particularly geographical discourse through which Siamese elites reordered their worldview through a reassignment of spatial categories that emulated European ones.[12] Though Thongchai's analyses focus on how these ideas shaped Siam's elites' view of the national landscape, I suggest that siwilai can also be applied to the microgeography of the palace's space. In contrast to the space of the old Royal Palace grounds, Suan Dusit's characteristics clearly display an adoption of the garden palaces of European monarchs and a corresponding suburbanization of royal life.[13]

Performing Ethnicity: Sartorial and Bodily Expression and Consumption

The expression of identity through dress is often interpreted in terms of the wearer's intentions, yet more recent thinking in the late twentieth and early twenty-first centuries about clothing and the body problematizes this mode of interpretation as simplistic and reductive.[14] When viewed as discourses to be "read," the body becomes a multivalent site, potentially holding different meanings for the wearer than for the various audiences who perceive and consume them. In this section I will explore both the expressions of identity that Dara Rasami herself intended to communicate through her dress and hairstyle, and the ways in which those sartorial expressions were perceived and interpreted within the Siamese court.

Textile Traditions of Lan Na

To consider the ways in which Dara Rasami's clothing and textile choices signified within the palace, it is helpful to examine the context within which textiles were produced and exchanged in both Lan Na and Siam. For those interested in the textile traditions themselves, there are several excellent works by textile experts that provide a much greater breadth and depth as to the region's clothing styles and textile patterns than I can go into here.[15] For now, let us focus on Lan Na women's roles in textile production and exchange, and the cultural/political function of textiles as markers of ethnic difference and political exchange.

In both Lan Na and Siam, as with many of their neighboring polities within mainland Southeast Asia, textiles had been utilized as part of the tributary system for centuries. Dress and textiles had long been part of tribute and gift exchange between the courts of Lan Na, the Shan States, Luang Prabang, Sipsòng Panna, China, Burma, and Siam.[16] For example, silk garments from Chiang

Mai were sent to the Shan States as part of a peace settlement in the eighteenth century, while the Chiang Mai court accepted gifts of Siamese textiles in the nineteenth century.[17]

Textiles held particular cultural importance, both as gift items in both political and religious ceremonies, and as the main component of a Lan Na woman's wedding dowry. At the village level, weaving held particular social significance for girls and women in Lan Na. The loom itself, typically located in the shaded, open space beneath the traditional wooden stilt house, functioned as a site of both feminine labor and social exchange. In this space, the loom was visible to the entire village, which monitored a young woman's skill in weaving, and accessible to marriageable men, who were allowed to visit with the young woman while she was weaving. The loom itself became such a potent object, so symbolically charged with women's creative and reproductive energies, that it was not to be touched by courting males.[18] A young woman's mastery of the most complex weaving patterns found in local textiles signaled her fitness for marriage, as she could then produce the household textiles needed to clothe and care for an entire family. Gittinger and Lefferts quote a Lao saying that once a woman learned to weave the difficult, discontinuous weft pattern known as *teen jok,* it was said she could weave anything.[19] Though not every woman became a weaver, a woman's skill at the loom made her more desirable as a marriage partner, as weaving competence also translated to higher commercial incomes for her household (as will be further discussed later on in this section).

Textiles played a central role as markers of ethnic identity within the Lan Na region. According to Susan Conway, "The strongest expression of ethnic identity is represented in the female skirt, or *phasin.* The phasin was valued as an expression of female creativity, stability and continuity."[20] A Lan Na woman wore the textile pattern and garment styles of her hometown or village, even in the event that she married and relocated outside her village. This was done primarily as a means of acknowledging her matrilineal clan and placating its spirits. (Though Lan Na marital patterns tended to settle exogamous males into matrilocal households, women could marry out to other villages, though this occurred far less frequently.) As various ethnic groups (particularly the Lawa, Tai Lue, and Tai Khoen) were resettled around Chiang Mai in the early nineteenth century, they began to adopt the elements of the dominant local group, the Tai Yuan, into their weaving patterns and clothing designs. This helps explain the wide variety of designs utilized by the peoples of the Ping River valley, and the occasional trespass of one design's elements into those of another group, even as each group's textile tradition remained distinct.

Women's roles as carriers of ethnic identity through textiles were central to
Lan Na culture. Nonetheless, not every woman was a weaver—despite some as-
sertions to the contrary on the part of contemporary textile experts.[21] This myth
is bound up with the idealized notion of the self-sufficient village, which persists
in perceptions of the Thai past. Drawing data from both Chiang Mai archival
sources and local oral histories, we find that "the component aspects of the pro-
duction process... were not performed in each individual household but rather
were divided by household, village, and even region."[22] Some villages produced
cotton and silk both for local use and for commercial exchange among the *man-
dala* of the Inland Constellation, with some villages functioning as weaving cen-
ters and others as markets for their finished goods. Thus the distinctive textiles
that women used to identify themselves with their ethnic group need not have
been produced by them, or even in their town, so long as such textiles could be
obtained through exchange with neighboring production centers.

Lan Na did not utilize the same sort of sumptuary regulation as Siam did in
constraining the textiles (and even colors) that wealthy commoners could use
in their dress. Conway notes that even "the wives and daughters of [northern]
minor rulers and officials, of powerful village leaders in satellite domains, and of
wealthy farmers, owned costumes made with expensive imported materials ob-
tained from itinerant traders."[23] However, even without sumptuary laws, the cir-
culation of such materials and textiles in Lan Na still flowed largely along class
lines. While village women wore a simple, horizontally-striped cotton phasin for
their day-to-day activities, fabrics shot with metallic threads or trimmed with
fancy teen jok borders were worn only on special occasions like weddings or mo-
nastic ordinations, if a woman could afford them at all (or weave them herself).
For the abovementioned wives and daughters of local chiefs and wealthy farm-
ers, such garments represented a statement of wealth and status. For Lan Na's
noblewomen, such garments were worn more frequently at court, and royal cen-
ters kept extensive ateliers of weavers to produce them. Although Dara Rasami's
mother Mae Chao Thipkraisorn likely knew how to weave, no sources directly
reference her weaving activities. As noted by one Western observer of the time,
"Even a wealthy princess is not exempt from the necessity for making the silken
garments which are the symbol of her rank, any more than the poorer women
can do without weaving their cotton clothes."[24] For Dara's aunt, Ubonwanna,
there is greater evidence of a personal involvement with weaving, which indicates
that she herself may have been a skilled weaver. In merchant traveler Holt Hal-
lett's account of his visits to Chiang Mai in the early 1880s, he describes seeing
Ubonwanna's female servants weaving at looms set up on the front veranda of

her house.[25] Dara's aunt was known to be an expert on local textiles, and she showed Hallett several examples from her personal collection.[26] Whether or not Ubonwanna did very much weaving personally, Chiang Mai's royal women had no need to weave anything themselves: their wealth allowed them to employ the most highly skilled weavers as well as the best raw and finished materials. This was especially true of Ubonwanna, who was an experienced trader in Chiang Mai and who was friendly with most Western visitors to the city. For example, through her connection with Hallett, she ordered some English lace she had been unable to obtain locally.[27]

Nonetheless, the textiles produced by Lan Na's elites—royal or common—reflected the dominant ethnic textile tradition of their locale. What is significant for our purposes is the role played by locally distinct textiles in the system of political alliances between Lan Na and its neighbors. When noblewomen of inland polities were sent as consorts to the rulers of neighboring states, they brought their textile traditions with them, continuing to dress in the style of their home culture even after they settled far away. Thus elite female dress within Lan Na courts often represented a panoply of different textile traditions and patterns as a result of marital alliances between the inland mandala of Sipsòng Panna, Luang Prabang, and the Shan States. The Chiang Mai and Nan chronicles both record early nineteenth-century alliances that brought women of Tai Yuan, Tai Lüe, Tai Lao, and Tai Khoen origin to live within Lan Na courts.[28] Within the context of the Inland Constellation, representations of sartorial difference within a ruler's household indicated the power and reach of his influence into the surrounding territory. Thus difference among the dress traditions of women in Lan Na courts was of great political value to Lan Na's rulers and was to be maintained, rather than homogenized.

Following Lan Na's refounding in the late eighteenth century, Chiang Mai's ruling families came largely from the Tai Yuan ethnic group. This ethnic identification informed the style and patterns of textiles worn by Chiang Mai's royal women. Their phasin (skirts) featured three main elements: (1) The "head" (*hua sin*) or waistband segment of cotton in red, white, or black; this piece could be easily detached and replaced when worn or dirty; (2) A horizontally-striped "body" (*dtua sin*) segment that reached from the waist to shin, striped in black and another color (usually yellow or green); fancier versions featured designs of metallic gold or silver thread; and (3) The lowest segment, or "hem" (*teen sin*) portion of the skirt, was usually a separate piece of fabric attached as a decorative border (see figure 4).[29] These three pieces were sewn together into a tube skirt, which the wearer then wrapped, rolled, and tucked to fit at the waist. On

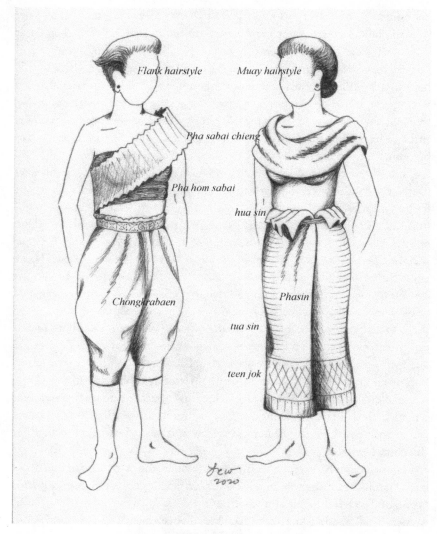

FIGURE 4. Comparing the Thai *chongkrabaen*
with Lan Na's *phasin*. Illustration by the author.

fancier phasin like those worn by Dara Rasami, *luntaya* pattern could be used
for the body segment, while a more intricately woven piece of fabric such as teen
jok was used for the hem segment. For daily wear, a phasin made up of only the
head and body pieces usually sufficed. On top, women wore a loosely draped
shoulder cloth called a *pha sabai chieng*, under which the breasts were mostly

exposed. Women at work sometimes wore a chest wrap that covered the breasts, but often went without it, as evidenced in photographs from the early twentieth century. By the late nineteenth century, Lan Na's royal women had adopted a slim-fitting, long-sleeved white blouse. Bock wrote of this innovation from Chiang Mai in 1882:

> A few Lao [Lan Na] women are beginning to wear tight fitting jackets cut to the shape of the figure, with equally tight fitting sleeves, something after the style of the "ladies jerseys" recently so fashionable in Paris and London, and involving no small amount of labour to get on and off, being not of elastic knitted work but of unyielding cotton or silk.[30]

This jacket stopped just above the waist of the phasin, with a pha sabai chieng sometimes draped diagonally across the chest and over one shoulder. (See the image of Thipkraisorn, figure 1.)

In addition to the photograph of Dara Rasami's mother referenced above, her aunt, Chao Ubonwanna, was also photographed wearing a phasin with teen jok, in addition to earrings, bracelets, and other jewelry reflecting her wealth and high rank. One element of dress seen in photographs of both women is especially interesting, however: both wear a pleated, Siamese-style pha sabai chieng together with their Lan Na-style phasin. What might such an adoption/ adaptation of a Siamese element into their Lan Na attire signify? It could indicate a more pro-Bangkok orientation on the part of Thipkraisorn, particularly considering the possibility that she and her husband invented the rumor regarding Queen Victoria's desire to adopt their daughter, Dara Rasami, in a bid to improve their status in Bangkok's eyes. Such a reorientation of Lan Na's sympathies toward Bangkok is suggested by sources that describe a rift between Thipkraisorn and her father, King Kawilorot, whose questionable loyalties had aroused King Mongkut's suspicions in the 1870s. Thipkraisorn and her sister, Ubonwanna, were both very friendly with the local Protestant missionaries (in great contrast to King Kawilorot, who had executed several of their Christian converts) and many of the Western merchants and explorers who came through Chiang Mai in the 1870s and 1880s.[31] Perhaps this nod to Siamese style was a statement of Lan Na elites' cosmopolitan currency with Bangkok.

As princess of Chiang Mai's royal house, Dara Rasami was intimately familiar with these elements of Lan Na weaving, courtly textiles, and dress traditions. In the following section, we will explore how she maintained some of the traditions with which she grew up in Lan Na, while adapting certain elements to her life within the Siamese palace.

Siamese Court Textiles and Dress

In comparison with the style of court dress worn by the Lan Na princes, and by the royalty of many of the inland states, the ceremonial dress of the Siamese court was lavish and hierarchical.[32] As mentioned before, Siamese royalty utilized sumptuary codes that made the dress of elites immediately visually distinguishable from that of common folk. Not only were certain materials (e.g., silk) off-limits to people of less than noble birth, but particular textile patterns (called *pha laiyang*) were reserved exclusively for royalty.[33] Since the Ayutthayan era, pha laiyang silks had been commissioned from Indian textile producers and woven in royal workshops at court.[34] In the mid-nineteenth century, Indian and English imports gained a new currency as cotton chintzes and other printed fabrics became popular with Siamese commoners. By the last quarter of the nineteenth century, Siamese noblewomen were frequently photographed wearing examples of both types of textiles.

More than twenty-five years before Dara Rasami's arrival in Bangkok in 1886, the dress of nobles and consorts at court had already begun to reflect an awareness of the sartorial conventions of the West. King Mongkut (r. 1851–68) himself evidenced an acute awareness of how one's clothing affected the perception of one's level of civilization:

> People who do not wear shirts are like naked people. Their bodies may show skin diseases or sweat, all of which are very dirty. In other countries, which are great countries, of all languages, they all wear shirts [upper garments], except the Lawa [Mon-Khmer], Lao, and *Chao Pa* [jungle people], who do not have clothes as they are lowly human beings. But Siam is a great country. We know many customs and traditions, we should not follow the ancient customs of the primitives of the past. Let all of you wear shirts when you come to the Royal Audience Hall, every one of you.[35]

From that time onward, members of the Siamese royal family and royal officials were required to wear shirts (as opposed to lower garments only) at court.

In addition to the above sartorial accommodation to the West in the court, Siam's elites embarked on a love affair with many other things Western. Some of these items influenced Siamese elite bodily practices, such as sweet-smelling soap and perfume, which became popular among palace folk in the 1860s. For example, while Chulalongkorn was still a young prince, he gifted a set of perfumes and soaps—and a photograph of himself—to his first consort, Phae.[36] During this era, Mongkut's favorite consorts experimented with some curious

elements of Western fashion. During a royal visit to *changwat* Saraburi in 1860, five of the king's highest-status consorts dressed as Scots guards—complete with multicolored plaid *chongkrabaen* called kilts—as they rode on horseback alongside the king.[37] Photographs show that these consorts had even grown out their hair, which was worn in a bun and tucked under Scottish tam o'shanter hats. These conventions do not appear to have caught on among the remainder of Mongkut's consorts, however, and by the time of his death in 1868, Siamese women's court style appears to have reverted to what it had been closer to the beginning of his reign.

Such traditional Siamese court dress and hairstyle consisted of a set of several elements distinctly different from those of Lan Na women's dress. While in Lan Na women often wore the pha sabai chieng loosely draped around or across their shoulders, Siamese women more frequently went without any covering on their torso whatsoever (a fact that is assiduously catalogued in the photographs of many nineteenth-century Western male visitors to the region). Among Siamese women of noble or royal rank, a *pha hom sabai* wrapped around the breasts and torso, plus an accordion-pleated pha sabai chieng draped diagonally across the chest and over one shoulder, was standard costume in the 1860s. (King Mongkut's highest queen, Thepsirin, wears this style in the royal portrait of the couple taken in 1865.) There is nothing similar to the fitted cotton or silk jacket worn by Lan Na's noblewomen in the 1870s to be found in the dress of Bangkok's nobility.

Another marked difference between Siamese and Lan Na women's dress lay in the style of garments worn on the lower body. While Lan Na women wore the aforementioned skirt-style phasin, Siamese women (and men) typically wore the *phanung,* a single length of fabric wrapped around the waist. Among noblewomen, the phanung was twisted up between the legs to form trouser-like chongkrabaen. (See figure 4 for a comparison of these styles.) Phanung as worn by the Siamese populace were typically made of homespun cotton, while the chongkrabaen worn at court utilized the aforementioned pha laiyang silks.

In addition to different sartorial traditions, the women of Lan Na and Siam also practiced different modes of wearing their hair. In Lan Na, women grew their hair long, wearing it pulled up into a bun pinned to the back of the head. In Siam, both women and men wore their hair in a brush-cut style, shaved on the sides and back of the head with an inch or two standing straight on the crown of the head. Not long after young King Chulalongkorn ascended the throne in 1870, he expressed his dissatisfaction with the old-fashioned brush-cut, and how it "made Westerners perceive us as *chao pa* [barbarians]."[38] To combat this

perception, King Chulalongkorn encouraged both the officials of the Mahat Thai and the women of the Inner Palace to grow out their hair on the flanks, or sides and back of the head. Though male officials were quick to do so, and to adopt the oiled and combed hairstyles of their male Western counterparts, the ladies of the Inner Palace resisted the change at first. To motivate the royal consorts, it took the leadership of a senior woman, Chao Khun Phae, mother of Prince Damrong, who volunteered to grow her hair out first (having done so before as one of Mongkut's aforementioned high consorts).[39] To contemporary eyes, the new hairstyle does not appear much different from the old one: where the sides of the head were shaved before, the new style grew out the hair on the sides, but not very long—it rarely reached below the wearer's earlobes. During the decade before Dara Rasami's entry to the palace, the flank-style hairdo instituted at the start of Chulalongkorn's reign had become the default style among Siam's elite women.

Although contemporary Western observers might mistake Dara's upswept, semipompadour hairstyle for an adaptation to Victorian norms (or even the Gibson Girl style of the early twentieth century), in fact her hairstyle reflected an update of her native Lan Na style. Because the style is described in Thai sources as *baeb Yipbun*, meaning "Japanese style," I posit that her change was most likely modeled on the geisha hairstyle worn by Madame Inakaki, wife of the Japanese ambassador, who appears in palace photography of the time. Why reference a Japanese hairstyle? Japan's victory in the 1902 Russo-Japanese War likely played a role: Siamese elites admired Japan's resistance to European domination and its defeat of a dominant Western power.[40] Dara likely saw her hairstyle as aligning Lan Na with the aesthetic of a successful self-modernizing Asian power. While this particular fashion did not catch on with the Siamese women of the Inner Palace, it was widely adopted by Chiang Mai women after Dara's 1909 visit, and the style became an emblematic element of her sartorial practice from then on.[41]

By the time of Dara Rasami's entry into the palace in 1886, incorporating elements of Western fashion in order to modernize Siamese dress was no longer new. Along with Western-style haircuts for male officials and nobles, Chulalongkorn had also—in an explicit effort to conform to Western notions of siwilai—changed official dress to utilize jackets in the Western military style on top, worn with chongkrabaen, stockings, and shoes on the bottom.[42] Siamese women's court dress was also influenced: photographs demonstrate the adoption of the high-necked, puff-sleeved lace blouse made popular by Queen Victoria's daughter, Princess Alexandra.[43] In parallel with the dress of male officials, the women's blouse was paired with chongkrabaen, stockings, and shoes.

Royal consorts also typically wore a colored silk pha hom sabai draped across the chest, in a color appropriate to the day of the week (as described in the last chapter).[44] The pha hom sabai was often adorned with jewelry and medals indicating a woman's rank. Among Chulalongkorn's high queens, custom-made brooches shaped like the characters of a consort's initials became popular marks of favored status.[45] For an excellent example of these conventions in dress, one need look no further than to photographs of Chulalongkorn's highest queen, Saovabha Phongsri.

In addition to these conventions, Siamese elites also observed a system that dictated the wearing of a different color (and colors complementary to it) on each day of the week. As we can see from the above, these conventions—coupled with the strict sumptuary regulations—demonstrate the central position of dress in Siamese conceptions of elite status. These standards rendered one's rank and status immediately visually readable: whether one could wear cotton or silk, homespun or imported materials, in the appropriate color for the day of the week. During the Fifth Reign, Chulalongkorn added yet another layer of meaning to this system: a desire to appear siwilai (civilized), in order to better represent Siam's status within a crypto-colonial framework of European expectations. Throughout his forty-year reign, the king continued to shape and refine the sartorial conventions for the most elite Siamese men and women.[46]

Dara Rasami and Ethnic Difference within the Siamese Court

How did Dara Rasami's convention of dressing in Lan Na style signify within these recently reconfigured sartorial boundaries? Prior to Dara Rasami's arrival in Bangkok in 1886, it appears that most foreign women—that is, consorts sent from the tributary kingdoms at the peripheries of Siam—had assimilated to the Siamese mode of dress (though there is little photographic evidence to go by before the 1860s). The other Siamese consort who came from Lan Na during the Fifth Reign, Princess Thipkesorn of Chiang Mai, "cut her hair short, and . . . wore pha laiyang," indicating that she had given up both her Lan Na hairstyle and textiles, adapting to Siamese customs.[47] Princess Dara Rasami, in contrast, maintained the dress conventions of Lan Na after entering the Siamese palace. Chronology of extant photographs of Dara Rasami demonstrates that, after an initial period of conformity to Siamese/Western fashion, Dara dressed in the Lan Na style consistently over the subsequent decades of her palace career. In her earliest palace portrait, Princess Dara appears dressed in a somewhat jarring combination of Western and Lan Na dress: a Victorian-style beribboned plaid

blouse paired with a phasin skirt featuring an elaborate teen jok border at the hem. In the companion piece to this portrait, which appears to have been taken at the same time, Dara wears the same dress while posing with her infant daughter Wimon Nakhonna Phisi (b. 1889). The presence of Dara's daughter is important to note, as motherhood had the effect of both automatically raising her status (to the rank of chao chom manda) and entitling Dara to her own residence. On becoming mistress of her own residence around that time, Dara Rasami was allowed to gather her own entourage to attend her. These women, who came from Dara's extended royal family in Chiang Mai and Lamphun, were also required by Dara to dress in Lan Na style, wearing the phasin and *muay* daily.

As discussed earlier in this section, the wearing of local textiles was central to the expression of ethnic identity and continuity among Lan Na women. Dara Rasami's practice of wearing phasin that incorporated luntaya pattern or teen jok borders was also consistent with that of elite Lan Na women exchanged as consorts with neighboring rulers: such foreign women continued to wear the garb of their homeland, signaling the local king's power and political reach into the surrounding region. Though for Dara Rasami this practice connoted regional pride as well as political import, it did not favorably impress many of her Siamese counterparts. Even after the king officially forbade other ladies from teasing her (as described in chapter 2), Dara's Lao-ness continued to be problematic throughout her career in the palace—and her dress was the most visible marker of her ethnic difference. In the ultra–status-conscious world of the Siamese Inner Palace, the households of the highest queens were all readily identifiable by their dress alone, and Dara's house was no exception:

> [The] royal servants from [the household of] *Somdet Tii Bon,* or *Somdet Phra Nang Chao* Saovabha Phongsri, . . . had the greatest pride. They dressed better than the royal servants of any other residence, very elegant and chic, and usually chose the best children of the elites. Their manners were very traditional. Their knowledge of ceremony was the best, because they believed that, if it was a place of study, it was a higher school than that of their friends. . . . The servants of this palace were usually very arrogant and conceited. In other words, they thought their flesh and body to be higher than anyone else, which was accordingly true. Because the women from this palace left to start their own families, at least the size of this group did not increase. There were mostly of "Khun Ying" or "Than Phu Ying" [status]. It's said that powder, dressing, hairstyling, *hom sabai chieng* and wearing betel leaf behind the ear, all were beautiful and "gay."

Moving on to another residence, the palace of *Somdet Phra Nang Chao* Savang Vadhana, *Phra Boromma Ratchathewi*, the servants of this household were very serious. They dressed like mature women, not flashy at all, with very terse manners, steady and resolute; very intelligent in matters of ceremony. When they went out they looked like the servants of [Saovabha's house], but more sober. Most often they showed evidence of money used frugally, not frittered away.

The group from the household of *Phra Nang Chao* Sukhumala Marasri, *Phra Ratchathewi*, were called the servants of "Phra Nang's" household. These ladies were known as very "gay," almost garishly flashy, but with "sense." They spoke well, were bold and quick, always aware of their surroundings. When they left her household, it was usually as the wife of a military official.

Moving on to the palace of *Phra Akorn Chaiya*, or the palace of "Than Ong Lek" [the little one], the ladies of this household were usually appointed as servants. They were good at cooking rice and snacks, managed a kitchen well, and were good with children. They had basic knowledge, but were not terribly brilliant. They dressed properly, were polite and modest, and were usually musically skilled.

As for the household of *Phra Rajajaya Chao* Dara Rasami, this household was special because she was from the northern royal family. Consequently, they were strange in that they put up their hair, and wore phasin rather than chongkrabaen or *hom sabai* like the other residences. No one from this palace showed off outside.[48]

Prince Damrong's daughter Mom Chao Jong Jitrathanom, who served closely with Dara Rasami in the Inner Palace during the Fifth Reign, describes Dara's treatment by the senior Siamese queens:

Interviewer: Was *Phra Rajajaya* intimidated by the older women at all?
Jong Jitra Thanom Diskul: Yes, she was afraid to leave her house; they would call her "Ai." She was a little scared of them. . . . Though she was regarded as "*phu yai*," the high queens saw her as a young upstart because they were older than she was by several years—they were only a year or so younger than the king himself.[49]

Given the haughty attitude of Saovabha's women, and the clear social differentiation expressed through dress and manners, it may come as no surprise that

neither Dara nor the women of her entourage showed off outside their house-hold, nor that Dara keenly felt their disdain.[50]

Though the cool treatment of the older queen-consorts certainly affected Da-ra's social currency within the palace, it did not dampen her relationship with King Chulalongkorn himself, nor with a number of other Siamese nobles and consorts. Among other Siamese elites with whom Dara Rasami had regular contact, her personality was considered charming and pleasant. Indeed, there appears to be a semigenerational break between the highest queens and those consorts with whom Dara Rasami established friendships: Chao Chom Manda Mote, Chao Chom Manda Hem, and Chao Chom Erb Bunnag (although Dara also established a friendship with Queen Savang Vadhana, even returning to visit her in Bangkok after Dara retired to Chiang Mai in 1915). Despite her difficulties with the other members of the first generation of royal consorts, Dara and her en-tourage were friendly with several younger consorts, who often appeared to treat her ethnic difference more with polite curiosity than contempt. Chao Chom Manda Hem's daughter, Mom Chao Phunphit Amatyakun, recounts that her mother spent many evenings at Dara Rasami's residence playing cards, smoking, and gambling.[51] (As mentioned in the prior section, Dara's friendships with Chao Chom Manda Hem and Chao Chom Mote were even close enough that King Chulalongkorn requested that their Dusit residences be built next to each other.)

One of Dara's next-generation friends was Chao Chom Erb Bunnag, a mem-ber of the *Kok Oh* group of five sister-consorts from the Bunnag family. Chao Chom Erb, a favorite consort of King Chulalongkorn, was also a skilled photog-rapher. In addition to the many posed portraits and more casual shots taken of various figures around Suan Dusit, Erb also featured Dara Rasami in a curious series of photographs taken sometime between 1902 and 1910.[52] In this series, Dara literally performs her ethnic difference for the camera. Dara appears in her customary striped phasin and lace blouse before a staged toilette table and two strategically placed mirrors, before which she lets down her knee-length hair. These photographs, like many Erb shot of scenes from within the palace, repre-sent her personal practice of the craft for its own sake, rather than images created with the goal of publication.[53] As with many of the amateur shots taken by Erb and other women and children of the fai nai, such images were circulated only among other Siamese royal and noble elites—the biggest audience at that time for such photographs. But for what purpose? Primarily for their novelty value: the novelty of Dara's ethnic distinction in an otherwise ethnically homogenous (Siamese) environment. In Erb's photographs, Dara's most prominent markers of ethnic difference—her phasin and long hair—are performed for the novelty

FIGURE 5. One of *Chao Chom* Erb Bunnag's series of photos
of Dara Rasami, ca. 1905. Wikimedia Commons/public domain.

of their difference. Given the ultimate audience for these images, Dara's difference was performed explicitly for consumption by other elites within the palace. These photographic representations thus render Dara knowable to the Siamese elite as a cultural "Other within" Siam's center. However, Dara's status as an outsider who was at the same time an elite insider serves to complicate where Lao or Lan Na ethnic identity should fall in the Siamese hierarchy of siwilai.

Dara Rasami and Making Lan Na Siwilai

Dara's mode of dress similarly reflected her intervention in locating Lao-ness within the Siamese siwilai hierarchy. Though Dara maintained the custom of wearing phasin on the bottom, the garments she wore above differed from those worn by her Lan Na kinswomen. Instead of the close-fitting jacket that had been fashionable among Lan Na women of her mother's generation, Dara adopted the upper garments worn by her Siamese counterparts: the lacy Victorian blouse draped with silken sash and adorned with jewelry. Subsequent photographs of Dara Rasami show her and her entourage wearing this ensemble (see figure 3).

The photographic evidence indicates that Dara probably did not utilize the lacy blouse in her informal everyday dress. However, the presence of the blouse—along with Dara's jewels and official decorations—in her official portraits signals its role in representing Lao-ness in a particular way. Rather than merely marking an adaptation to Siamese style, I suggest Dara's hybrid dress style signified an effort to adapt her ethnic difference to the notions of siwilai then current among Siam's elites. As such, I suggest that this adaptation helped shape the Siamese perception of Lao or Lan Na identity within the new hierarchy implied by siwilai. As Thongchai notes,

> Both *chaopa* and *chaobannok* were two categories of the Others of the more siwilai elite. The chaopa were the uncivilizable; the chaobannok were the loyal, backward subjects. The gazers were the educated elite in the city, the people and space of siwilai and *charoen*. It should be noted that there were peoples who were described in one way or the other between the two categories. The prime example was the Lao (people and regions).... Writings about the Lao during the period we are discussing mostly described them in details like chaobannok. At times they were mentioned as non-chaopa, similar to Thais. Yet, Lao people were also mentioned as chaopa and some accounts dissected Lao customs and described them topically similar, to the description of chaopa (see *Latthi Thamniam Tang*, parts 1 and 18). For the Thai elite, the Lao were somewhere between the two kinds of Others.[54]

Though (as mentioned at the opening of this chapter) palace women do not figure into Thongchai's analysis of siwilai, I suggest that the Siamese confusion over these "two kinds of Others" has everything to do with Dara Rasami's presence among the Siamese elite. As a Lao woman within Siam's most elite circle, Dara's representation of civilized other-ness through hybrid dress problematized the discourse of siwilai as it applied to Siam's northern periphery. The difficulty of locating the Lao/Lan Na people among the categories of chaopa, chaobannok, and siwilai related to the difficulty of reconciling Dara Rasami's hybrid elite identity (that of a siwilai Lao) with the Siamese at the apex of the siwilai hierarchy.

While many palace memoirs and other accounts mention the distinctiveness of Dara Rasami's style of dress, observers rarely discuss its reception by other members of the Inner Palace. Without direct observations, how might we understand the significance of Dara Rasami's sartorial difference within the Siamese palace? In this context, I suggest we consider dress as discourse. As such, Dara's dress signifies on two levels (which may well be too entangled to pull apart entirely): the personal and the political. As I demonstrated earlier in this section, Dara's native traditions invested the textiles and garment styles with particular meaning for Lan Na women, as indicators of an advanced level of weaving skill as well as readiness for marriage. Some types of Lan Na textiles also functioned as sumptuary items, which were more easily produced or obtained by the elite class. Thus, as a personal discourse, Dara's style of dress can be read as an indicator of both her life status and noble station.

As political discourse, Dara's dress carries an additional—and potent—set of meanings. In order to emphasize the political reach of a Lan Na ruler through the strength and breadth of his political alliances, Lan Na's political tradition entailed that elite women exchanged in marital alliances continue to practice their particular dress and textile conventions. Thus Dara's use of Lan Na textiles and garment styles in the Bangkok palace might be read very straightforwardly as carrying on this tradition, and even extending it into the Siamese palace. But without the political sensitivity surrounding Lan Na's relationship to Siam in the 1870s and 1880s, such a point would have been moot. Earlier (and less politically important) Lan Na émigrés to the Bangkok palace had changed their dress and hairstyle to Siamese style without any comment. Dara's obvious ethnic difference entailed difficult social consequences throughout her life in the palace. It appears that the visual discourse of Dara's dress could also be read by the Siamese elite to reinforce notions of their own cultural superiority and dominance over the "Others" at its peripheries, no matter how intimate their relationship with the king.

Dara's dress functioned as a multivalent site that held very different meanings for its wearer and the Siamese consorts around her. But there were other performative modes that additionally demonstrate the Siamese understanding of Dara Rasami's hybrid identity within the discourse of siwilai: dramatic works and their performances.

Drama and Performing Difference within Siamese Siwilai

During the Fifth Reign, the Siamese elites had become intensely concerned with siwilai, especially as it related to ethnic difference. While Thongchai has discussed the scientific modes by which Siamese elites delineated these differences, here I will explore how ethnic differences were expressed through an entirely different mode of discourse: popular entertainment.[55] Concurrently with the crypto-colonial scientific construction of ethnic categories in the 1880s and 1890s, Siamese elites began to communicate discourses of ethnic difference to the broader populace through *lakhon rong* and *lakhon dukdamban*, forms of Siamese dance-drama that became popular as mass entertainment in Bangkok in this era. Within this context, I contend that Dara Rasami's participation in a number of lakhon works played a major role in the Siamese categorization of the Lao, or Lan Na peoples of Dara's homeland, in order to situate them as a more siwilai "Other within" Siam's new hierarchy of civilizations.

Siamese Dance-Drama during the Fifth Reign (1868–1910)

Siam's traditional art of dance-drama, or *lakhon ram,* had begun to undergo significant changes during the reign of King Mongkut (or Rama IV, 1851–68). In an 1855 decree, Mongkut dropped the restrictions on all-female lakhon troupes, which had been the exclusive province of the palace up until that time.[56] At the same time, the king reserved a few classical dramatic texts for royal use. These two moves sparked a resurgence in both the writing and performance of new lakhon works outside the palace. The subsequent growth of commercial lakhon troupes led to another royal decree in 1861, in which Mongkut spelled out terms by which all types of performances would be taxed.[57] Since many of the commercial lakhon troupes had found a profitable niche providing entertainment to the patrons of gambling halls, the new taxes "did not much affect them at the beginning, since they could add it on to the admission charge for any performance."[58] The new taxes began to generate a steady new stream of revenue for the Siamese government, reaching as high as 4,400 baht per year during Mongkut's reign.[59]

In the 1870s, dramatic texts began to circulate outside the palace in another new way: via print. According to Mattani Rutnin, Protestant missionary Dr. Smith initiated the first publication of the *Ramakien* "in serial installments and sold them at 25 *satang* per copy," making it the first play introduced to the Siamese reading public by mass production.[60] Following the popularity and success of the *Ramakien*, Dr. Smith published *Inao* in 1874 (also for the first time). From then on, other publishers followed suit. Although at the price of 25 satang (one-quarter of a baht) such publications were still well beyond the reach of the average citizen, they succeeded in making dramatic texts available to a wider reading audience than ever before.[61]

Unlike his father Mongkut, King Chulalongkorn was not as keen on promoting the lakhon within the court. After training a select group of women to dance a special performance of *Inao* on the occasion of Bangkok's centennial (*Sompot Phra Nakhon*) in 1882, formal lakhon training for the women of the Inner Palace ended.[62]

Outside the palace, Chulalongkorn's decrees ending slavery (1874) and gambling (1888) greatly impacted the popular performance of lakhon within gambling halls, driving many troupes out of business. The troupes that survived sought the private patronage of noble houses, many of whom subsequently opened theaters of their own. The viability of lakhon productions in the commercial environment of the 1890s depended largely on the ingenuity of the new productions. Under noble patronage, new modes of dance-drama evolved to appeal to a paying audience drawn from both the elite and the populace. Three nobles—two of whom were Chulalongkorn's own half brothers—became the most prominent dramatists of the era's new forms: Prince Naret, Prince Narathip, and *Chao Phraya* Thewet. These nobles were largely responsible for creating and elaborating on the two variants of lakhon that came to dominate the Bangkok theater scene in the early twentieth century: *lakhon dukdamban* and *lakhon phan thang* (also known as *lakhon rong*). Prince Naret and Chao Phraya Thewet (the official Minister of Royal Performances) wrote dramas in the lakhon dukdamban (ancient) style, in which performers sang and danced their own parts in condensed scenes from classical dance-dramas against minimalist background scenery, wearing traditional Siamese costumes. In contrast, the style practiced by Prince Narathip, lakhon rong, utilized a Western-style play structure, and dialogue was spoken between songs performed by the characters, who were usually dressed in a modern style appropriate to the setting of the play.[63] Accordingly, lakhon dukdamban works consisted mainly of adaptations of classical dance-dramas, while lakhon rong—with its focus on the play's most

emotional moments, sometimes verging on the melodramatic—became the vehicle for adapting exotic and foreign stories for the Siamese audience.[64] Both forms were patronized by King Chulalongkorn, who brought various visiting foreign dignitaries to see performances.[65]

Prince Narathip's lakhon rong form, which at first focused its subject matter on current events and domestic issues, took time to find its footing with Bangkok's audiences. As Chulalongkorn himself remarked in a letter to Dara Rasami,

> The "Lakhon Krom Nara" seems to be gaining a little more success. Even so, there are still such small audiences that the elite rarely see it, because it is a new thing. They don't understand it. They have to do a lot of listening and watching, and cannot look the other way, as they won't be able to follow the story. Usually, people who go to see a play like to sit and talk with each other. Just to see the dancers moving about here and there, to hear a little singing and some sounds from the orchestra, that's enough. They only want to talk, that's why they don't like it.[66]

With a little experimentation, however, Prince Narathip struck on a winning formula: one that married exotic subject matter (such as *The Arabian Nights*, *Lilit Phra Law*, and *Madame Butterfly*) with melodrama. Soon his plays began to attract the largest paying audiences Bangkok had ever seen. In creating and adapting works for the lakhon rong form, Narathip found a special local resource to add culturally authentic elements to his productions, particularly those of northern works. He called upon Dara Rasami to provide consultation on both the texts and musical/dance elements of both *Phra Law* and Narathip's later adaptation of *Madame Butterfly*, entitled *Sao Khrua Fa*. It was through these works that notions of the northern "Other" were expressed and communicated not only among Bangkok's elites, but also the city's theater-going public. In the following segment, I will discuss Dara Rasami's musical background and her relationship to Prince Narathip's dramatic workshop.

Dara Rasami's Musical and Dramatic Interests

As mentioned briefly in the last chapter, Dara Rasami and her entourage were themselves practitioners of music and dance within Dara's household. It appears that Dara had undergone some training in the arts of music and dance during her childhood in Chiang Mai, but the record is unclear as to the nature or extent of the training.[67] Within the Inner Palace, however, Dara and her ladies were well known for their talents in singing, dancing, and playing various musical instruments:

Upstairs, [Dara Rasami] had many musical instruments, including the *jakay* [a three-stringed musical instrument], *saw* [a fiddle], *kluy* [flute], *glong* [drum], *tone* [a shorter, smaller tom-tom drum], *ramanah* [one-sided, shallow drum], a piano and a mandolin; but they did not play the *phipat* [or Thai orchestral instruments], because they were instruments for a man. There was a stringed band and a mixed combo; the governor and family practiced energetically. [Dara Rasami] would sing central Thai songs and was not shy in her merriment while singing. They said that those who came to stay at her residence, besides being beautiful and sweet-voiced already, looked like they had nearly equal talents in singing, dancing, and music.[68]

Playing some kind of musical instrument "at least a little" was apparently a requirement for kinswomen who wanted to become part of Dara's entourage.[69] Dara's musical interests encompassed the musical traditions of Lan Na and Siam, and embraced Western music as well. In addition to training an all-female orchestra in Siamese music, Dara incorporated several Western instruments—including the violin, mandolin, piano, and pedal organ—into her ensemble's repertoire.[70]

Dara Rasami's musical talents and interests reached well beyond the walls of the Inner Palace. One of Prince Narathip's early dance-drama productions, *Phra Law*, was based on an old northern story, the dramatic poem *Lilit Phra Law*. Prince Narathip's wife and musical director, *Mom Luang* Tuan, sought out Dara Rasami as a resource, learning Lan Na vocal styles and instruments from her to enhance the northern setting of the play. "Chao Chom Manda Dara Rasami was pleased to have Mom Luang Tuan visit her often for instruction in Lao musical intonation. This resulted in the palace playing Lao songs more often."[71] In addition, since a major component of the lakhon rong style was the incorporation of foreign elements to suit the story, it was only appropriate that *Phra Law*'s dancers also "dress in Lao-Thai costumes, dance and sing to Lao-type musical tunes, and speak with touches of Northern dialect."[72] Through their relationship with a Lan Na "Other" residing within the palace—Dara Rasami—it was possible to incorporate authentic Lan Na cultural elements to create exotic appeal for a popular audience outside the Inner Palace.

Dara Rasami was also involved in developing the texts of Narathip's northern works. Chulalongkorn himself sent parts of Narathip's script of *Phra Law* for her to review while visiting Chiang Mai in 1909.[73] Later that year, King Chulalongkorn ordered a performance of *Phra Law* to celebrate the first fruit of Dusit's recalcitrant lychee trees.[74] For this occasion, a theater was built in *farang*

(Western) style, complete with an authentic stage, located in between Amphon Hall and Phanumat Hall. Prince Narathip arranged for the middle section of his adaptation of *Phra Law* to be performed in this celebration. His wife, Dara Rasami's friend Mom Luang Tuan, arranged the songs, music, and orchestra.[75]

In addition to Narathip's success with this production, his expertise in creating audience-pleasing works based on exotic tales like *Nithra Chakhrit* (*The Arabian Nights*) and *Khon Ba* (*Jungle Man*) resulted in Chulalongkorn's favor of lakhon rong over lakhon dukdamban. In 1907 Chulalongkorn granted Narathip's theater the status of "royal company." This marked a new era in Siamese drama, as Chulalongkorn initiated the practice of attending performances at private theaters outside the royal court.

Having been impressed by Puccini's *Madame Butterfly* during his 1906 tour of Europe, Chulalongkorn assigned Narathip to create a Siamese adaptation of the work.[76]

> *Ruang Khrua Fa* [*The Story of Khrua Fa*] is the story of *Madam Butterfly*, which I mentioned in my [letters home from Europe in 1906] about Paris. The Japanese is changed to Lao, and farang to Thai, that's all. . . . Prince [Narathip] composed the lyrics to imitate farang opera. . . .
> ~ Chulalongkorn to Dara Rasami, April 24, 1909[77]

In the Siamese version, the roles of the American soldier and Japanese woman are transposed in a uniquely Siamese (and crypto-colonial) way: the American soldier becomes a Siamese man, while his Japanese lover becomes a maiden from—where else?—Chiang Mai. True to the lakhon rong style, the cast were dressed in costumes appropriate to contemporary characters, with the heroine dressed in the same style as Dara Rasami herself: hair pulled up into a bun, lace blouse on top, phasin below, worn with stockings and shoes.[78] The production, first staged in the summer of 1909, became a huge hit:

> In observing the preference of the people in these later dates, they seem to like *Sao Khrua Fa* more than any other play, to the point that there have been letters by mail asking for repeat performances at a particular *wik*[79] [theater] because it is a *lakhon farang* story. Another is because they think the king likes it since he mentioned it in the *Nangsue Klai Baan* [*Letters Far from Home*]. But the most important reason is *Ee Nang* Phrom, who plays the role of the heroine. When she came in to perform at the Wang Tha Palace, she was given as much as 100 baht at one time for cutting her throat [in the suicide scene]. Some people suggested that there should be

a *lakhon sompot* [dance-drama for a special royal celebration] for three days when you return [from Chiang Mai]. I am afraid that we shall have to repeat the plays because you have missed seeing many of them. They are guessing that you will ask for a repeat performance of this *Sao Khrua Fa*.

Many of the new works developed by Prince Narathip and others were often first performed privately for the king and members of the Inner Palace. Word that a particular lakhon had found favor with the king often resulted in huge interest among Bangkok's theater-going public; if the king went to Narathip's theater to see a particular play, it would often sell out performances in the weeks following. In a subsequent letter to Dara Rasami, Chulalongkorn describes the growing popularity of *Sao Khrua Fa*:

> Talking about "madness," the courtiers are now "mad" about "*Lakhon Krom* Nara," every person, every name, from the masters to the servants. Since you left [for Chiang Mai], . . . the ones who did not see it are very frustrated. It's up to [Prince Narathip], whether he will perform the play again after having performed it in the royal court at the Pridalai Theater. If he does, the audience will be large. In the past, I went to [his] theater, and there were not more than 500 present. But since he has performed in the Royal Palace, there are not enough seats. This happens only to the plays which have been performed in the palace and are later performed outside. The money collected from outside performances is over 10,000 baht. *Krom* Nara exclaimed that it was due to "the glorious virtue of the king."[80]

As the usual takings for a week-long performance run at a Bangkok theater averaged around 1,000 baht at that time, we can see that *Sao Khrua Fa* was hugely popular with Bangkok's theater-going populace.[81]

We might see this performance of Lan Na "other-ness" through dance-drama as domesticating Lan Na identity for Siamese consumption. As discussed in the prior section, discourses of Dara's ethnic difference carried political value to Chulalongkorn, demonstrating the political dominance of Siam's center over its peripheries (i.e., Lan Na). At the same time, through Dara Rasami's presence in Bangkok, Lan Na retained the agency to write back against this Siamese discourse to some extent. It appears that although Dara was consulted to contribute elements of dress, music, and dance to *Sao Khrua Fa,* her involvement with its writing was limited. Indeed, her responses to it indicate that she may not have agreed entirely with the message it communicated about the strength and agency of Lan Na women—and perhaps by extension, Lan Na itself. In two of his letters

to Dara in 1909, Chulalongkorn mentions her request that men be banned from the audiences of early palace performances of *Sao Khrua Fa*.[82] Unfortunately, her reasons remain unknown: Dara's original request was either made orally or the written record lost, and Chulalongkorn does not mention it in his letters either. Did Dara object to the model of the Siamese soldier abandoning his Lan Na lover, and wish to discourage Siamese men from imitating his behavior? Did she not want her friends among the Siamese male nobles to identify her with the tragic heroine? Did she wish to raise "Miss Butterfly" as a cautionary example to a women-only audience? Or did she wish to provide a viewing environment in which women might freely express their sympathy for the heroine? We cannot know. In any case, Dara's desire to restrict viewership of *Sao Khrua Fa* to only elite women applied only within the palace. Once its potential had been demonstrated in the popularity of its palace performances, Prince Narathip opened the public performances of *Sao Khrua Fa* to both men and women.

To further illuminate this issue, we might look to the play that Dara herself wrote, entitled *Phra Loh Waen Kaeo*, or *Noi Chaiya*. Though Dara wrote the original plot and characters herself, she commissioned Siamese noble *Thao* Suthon Photchanakit to compose the dialogue in verse.[83] This (undated) work appears to have been written sometime after *Sao Khrua Fa*, and it features a romantic heroine of a very different stripe. The story line involves a pair of star-crossed young Lan Na lovers, a Miss Waen Kaeo (Crystal Ring) and her lover, Noi Chaiya. Though Waen Kaeo's parents arrange a match for her with an older and much wealthier man, she rejects him and stays true to her (penniless) lover. The course of this love relationship expresses a completely different perspective on the Lan Na woman's emotional strength and loyalty. Whereas in *Sao Khrua Fa* (as in *Madame Butterfly*) the heroine commits suicide on discovering her lover's abandonment, Waen Kaeo plays anything but a passive role in her love relationship, seizing control of her own destiny to remain with her chosen love.[84] The elements of this story echo the experiences of Dara Rasami's aunt, Chao Ubonwanna, whose famously complicated love life Dara witnessed firsthand during her childhood in Chiang Mai.[85] Though this play was produced by Dara herself for performances within the palace, it never garnered the same attention as did *Sao Khrua Fa*, and consequently it was never performed in public (in Bangkok, anyway). Thus the discourse of Lan Na feminine agency and strength that Dara Rasami desired to communicate never traveled beyond the palace walls. The image of *Sao Khrua Fa*'s beautiful and tragic heroine became dominant in the popular image of Lan Na women—and by extension, Siam's domination of Lan Na itself—in the minds of Bangkok's populace.[86]

Domesticating Siam's Peripheries through Lakhon Rong

Sao Khrua Fa and *Phra Law* became the most popular of Narathip's lakhon rong. As such, they are emblematic of the new dramatic form, which utilized themes and elements adopted from foreign sources and incorporated elements (i.e., costume, music, dance) drawn from Siam's peripheries. While Lan Na was amply represented in the body of works by *Phra Law* and *Sao Khrua Fa*, they were by no means the only works featuring exotic elements. Mattani describes how lakhon rong utilized "costumes, set designs, . . . [and] dance movements accompanied by foreign orchestration" from Burmese, Mon, Lao, Chinese, Indian, Cambodian, Malay, Javanese, and Western cultures.[87] However, in terms of lakhon rong that demonstrate ethnic representation as discourse, the exotic work most comparable to those representing Lan Na is that of *Ngo Pa (Wild Man)*, written by Chulalongkorn himself in 1905. This play is based on the presence at court of another Other from Siam's periphery: Khanung, a boy from the Semang tribe of the Malay peninsula. This child was adopted by Chulalongkorn during a state visit to Siam's southern provinces in 1905 as his own personal experiment in civilizing a savage. According to Prince Damrong: "That year, B.E. 2429 [1906] King Chulalongkorn had the desire to raise the [tribal] child that had lived in the jungle, in order to try and see whether this training could make a [jungle person] progress into a [regular person] or not."[88] *Ngo Pa*, written by Chulalongkorn during an eight-day illness, describes the Semang's physical appearance, way of life, religious beliefs, eating habits, merry-making, dressing, hunting, and courting. According to Mattani, "this was the first time that Semang tribal songs, dances, and music were introduced in the history of the Thai *lakhon ram*. . . ."[89] As Chulalongkorn himself explained,

> This book was written without the intention of its being performed as lakhon, and I did not think it was going to be good, because it is a story of the chao pa (jungle people), who are extremely deprived. It was like setting a table with only coconut shells, most of which had no stands or legs. It was therefore difficult to make it beautiful. But when it was finished, it looked quite pretty, more like blue, red, or purple color chinaware. I have discarded all the "high" words and created a new story by my own imagination, while mixing in facts in some parts to make it more interesting.[90]

Mattani suggests that "King Chulalongkorn succeeded in elevating the status of these jungle people to a level equal that of royal princes and princesses and

kings and queens in traditional *lakhon nai* and *lakhon nok*."[91] This seems very doubtful, particularly if one looks again at the language the king used to describe and refer to the tribal people: instead of the customary third-person pronoun "*khao*," which translates to "he/she," the pronoun used for Khanung and his people is instead "*mun*," which translates to "it." One typically sees "mun" used to refer to human beings only to indicate that the speaker feels they are of low status, or that they are, like most "things," somehow less than fully human.

I suggest that this play was not merely an exercise in Siamese exoticism and love of novelty; rather, it clearly reflects a crypto-colonial agenda at work. Similar to the use of northern elements in my earlier examples, this play can be seen as a means of knowing the tribal peoples on whom it centers. Through this play, the people and territory of the periphery could be aesthetically domesticated at the center. At the same time, the language utilized in the work indicates the author's view of his subjects as somewhat less than human—solidly within the racial category of chao pa that Khadikit delineated in his description of the hierarchy of siwilai.[92] In contrast to Dara Rasami's part behind the scenes in the constructions of northern lakhon rong, Khanung was enlisted to perform in the palace production of *Ngo Pa*. Here, the palace informant on Semang culture was but a child, Khanung, whose ability to contest or augment the representation of his people was far more limited than that of Dara Rasami. The photographs of Khanung—smiling, dancing, often dressed in elaborate costume—clearly reflect his place as a chao pa near the bottom of the siwilai hierarchy.[93] In Khanung's case, we can see that mere representation in palace drama did not guarantee that one's ethnic category would be improved. As *Ngo Pa* demonstrates, through a lakhon's demonstration of siwilai—or the lack thereof—the Siamese hierarchy of ethnic categories was only further reinforced.

Through the vehicles of these new dance-dramas, the "Others within" Siam's peripheries—northern and southern—were also being made familiar (known) and thus domesticated to the Siamese power center. The literal adoption of a tribal boy to be raised in the palace serves as the most powerful example of the shift in the centrality of physical bodies (versus Thongchai's geo-body) to the project of extending Siam's reach into her peripheries.

Diplomatic Gestures: Deploying Dara Rasami's Ethnic Difference

Another mode by which Dara Rasami's ethnic difference was performed within the Siamese court was diplomatic gesture. Here, I broadly define the category of diplomatic gesture to include both official and informal events where Dara

Rasami's public interaction with foreign or Siamese officials (including the king himself) played a central role. As in the previous section, such performances of ethnic difference will be considered within the context of Siamese *siwilai*, where she found a role as an exotic Other inside Siam's most elite circle. In this section, we will examine two episodes in particular: first, Dara Rasami's central role in the reception of a visiting Shan princess at the Siamese court in 1906, and second, her farewell gesture to King Chulalongkorn as she departed for her first visit home to Chiang Mai in 1909, and the major promotion of rank that she received afterward. Through these examples, we will see how Dara Rasami found ways of deploying her ethnic difference through gestures that positively affected her relationship with King Chulalongkorn. These gestures—which depended on her Lao-ness— ultimately resulted in her advancement to high rank in the Siamese court.

Dara Rasami as a Colonial Proxy: The 1906 Visit of a Shan Princess

In November 1906, a princess of the Shan States visited Bangkok, and a royal audience with King Chulalongkorn was arranged. In this audience, Dara Rasami was deployed as a kind of cultural attaché, in the nominal interest of speaking for the Shan princess during the event.[94] The visiting princess hailed from Chiang Tung, which had long ties with Chiang Mai within the historical Inland Constellation of *mandala* states (as described in chapter 1). As the languages spoken by the two women were mutually intelligible, it made practical sense that Dara Rasami participate in such an event. What is most interesting about Dara's participation, however, is her starring role: in the staging of the event, Dara Rasami was seated in the center of the room, her chair facing directly opposite that of the Shan princess, with an audience box of ten select royal women on each side of the room. King Chulalongkorn himself was seated at the head of the room—thus making the face-to-face encounter between the two foreign women the focus of the event.

In her status as a Lan Na princess and Siamese high consort, face-to-face with a princess from a state (Burma) that had recently fallen under British control, Dara Rasami's performance produced a critical moment of status differentiation. The meeting demonstrated Chulalongkorn's (and thus Siam's) preeminence and sovereign power over Lan Na, which had been the oldest and best established *muang* in the Inland Constellation—a fact that would not have been lost on a Shan princess of that era.[95]

In an important sense, however, Dara Rasami and the Shan princess can be seen as each other's "opposite numbers": subjects of a foreign colonial power that had subsumed the customary sovereignty of their homeland. One could read this diplomatic performance as a Siamese diplomatic discourse of parity with

England as a colonial power: facing off two foreign subjects against each other under the aegis of the opulent Siamese court. In the Siamese reading, "their" princess undoubtedly won the day:

> Chao Dara Rasami sat with her chair directly facing [the Shan princess]. King Chulalongkorn came out to sit on his chair very properly. The Shan princess walked in[to the room] then crawled over to sit paired up with [Dara Rasami]. Though she was much younger than [Dara Rasami] at the time, and prettier also—she was not grander than [Dara]. . . .[96]

As a compliant foreign subject of the Siamese king, Dara Rasami performed a central role in this showcase of ethnic difference and colonial power. For this performance she was rewarded: later that day, King Chulalongkorn presented her with the Siamese shoulder sash of nine gems, and the royal women of the audience also presented her with gifts of luxury textiles.[97] The success of her diplomatic performance appears to have increased the value of Dara Rasami's political currency within the palace as well. According to Phonsiri, "Receiving these visitors on this occasion would result in Chao Chom Manda Dara Rasami becoming more acknowledged and accepted."[98] At the same time that Dara's ethnicity gained cultural currency through Prince Narathip's incorporation of northern elements in his popular lakhon works, the diplomatic performance of her ethnicity signals an awareness among the Siamese elites that ethnic difference could be effectively deployed for political purposes as well. Thus the currency of Dara Rasami's ethnic difference attained greater value during the last decade of Chulalongkorn's reign. That this new currency ultimately benefited Dara Rasami personally brings us to the next episode in this section, as Dara performs her own discourse(s) of northernness.

Deploying Lao-ness: Dara Washes the King's Feet with Her Hair

During the semiannual visit of the governor of Chiang Mai, Dara's half brother Intawarorot, to Bangkok in January of 1909, Dara requested permission to make her first return visit to her hometown.[99] Her homecoming had been prevented over the years by a series of rebellions and banditry, including the Phya Phap revolt of 1889 and the Shan Rebellion of 1902. With these conflicts finally quelled, her request was granted, and preparations got underway to safely transport the princess from Bangkok to Chiang Mai. Since the two cities were not yet connected by railway at the time, the last part of the journey—from Phitsanulok to Chiang Mai—had to be made by riverboat. Accompanying Dara Rasami was a

royal entourage that included doctors, guards, and attendants, numbering nearly thirty in all.[100] Prince Damrong was to accompany the procession to the end of the railway, at which point the caravan would travel by boat the rest of the way via the Ping River.[101] On the days leading up to Dara Rasami's departure, there were several celebratory events, including a lakhon performance at Prince Narathip's Pridalai Theater.[102] Finally, on the date of her departure—February 12, 1909—she returned to Amphon Sathan Hall at Suan Dusit to say a formal farewell to King Chulalongkorn just before she went to board a northbound train at the Samsen railway station.[103] At this moment, she deployed a gesture that quickly became well known around Bangkok. Before the king and the assembled retinue, she "let down her muay [bun] and 'washed' the king's feet [with her hair] in the northern custom, then burst into tears."[104]

The Siamese cultural proscription against touching the feet, much less with the hair on one's head, goes only part of the way toward explaining the significance of this gesture. Dara Rasami's farewell foot-washing references a particular northern trope: it can be found in the Ayutthaya-era poem *Lilit Phra Law*, but also (and perhaps more pertinently) in an episode that occurred just a few years earlier in 1903, whose story is still well known in Chiang Mai today: the tragic love affair between a Chiang Mai prince and a Burmese woman named Ma Mia.[105] This story in particular provides important context for reading Dara Rasami's performance of this foot-washing gesture.

The story of Ma Mia concerns Dara Rasami's nephew, the son of her half brother Chao Kaew Nowarat, named Chao "Noi" Sukkasem. In 1899, Sukkasem went to study in Moulmein, Burma. There he met a beautiful young Burmese girl with whom he fell in love: Ma Mia, who worked in the local marketplace. They were young lovers: she was but sixteen, and he twenty years old when they met.[106]

Their troubles began when Sukkasem brought home his new bride to Chiang Mai in late 1902. Though Siam had been gradually increasing its administrative control over Lan Na's territories for the two prior decades, bandits and rebellions had continued to challenge Siamese control, and the old question of Lan Na's loyalties had still not been settled. As recently as 1897, Siamese authorities denied Dara Rasami's request to return to Chiang Mai for her father's funeral due to unrest in the region.[107] As a marital alliance between a Chiang Mai prince and a Burmese woman still bore the tinge of political disloyalty, Chao Noi Sukkasem's family objected to the match. Finally, Chao Noi Sukkasem's father insisted that the couple split up and Ma Mia be sent back to Burma, rather than arouse Siamese suspicions any further.

What followed has become the stuff of local legend. In April of 1903, a large caravan consisting of three strings of elephants and twenty porters was loaded up to carry Ma Mia and her belongings back to Moulmein. Finally, the lovers had to say their goodbyes at the city's western gate. As the local version colorfully explains:

> . . . the populace of Chiang Mai assembled at the gate to watch the separation of the pair of lovers, who Chiang Mai people were interested in, passed judgment upon, and spread rumors about throughout the land. Many people wanted to see Ma Mia's beautiful, young face: the Burmese who had won the heart of the young prince of Chiang Mai, but could not keep it. They talked interminably and indiscriminately about [her] complexion and threw themselves . . . into it. Miss Ma Mia climbed up to sit behind an elephant howdah, but it sapped all her energy. She had to come down, and cried almost as if her tears were blood, and the situation hurt the hearts of the people of Chiang Mai greatly. *When Ma Mia fell down at the feet of Chao Noi Sukkasem and used her tangled hair to wipe his feet,* it was an ancient expression of a young Burmese woman from the old days showing the highest loyalty. This event lived in the memory of the people of Chiang Mai for a very long time, until old people continued to tell the story into the next generation (era), even when everyone complained that it was too long ago. The procession of Ma Mia leaving from the Outer Gate created great suffering for Chao Noi Sukkasem.[108]

Following Ma Mia's departure, Chao Noi Sukkasem suffered terrible heartbreak, from which it was said he never recovered, though he eventually married.[109] The episode became quite famous and would have been known in Bangkok at the time—not least by Dara Rasami herself, as it concerned her own nephew. Ma Mia's foot-washing farewell gesture was therefore known to Dara as well, as both a northern gesture and one of romantic love and loyalty. As such, her deployment of this grand gesture on departing Bangkok for Chiang Mai can be read as both personal and political discourse: it indicates her personal attachment to King Chulalongkorn and serves as a reminder of her long-standing political loyalty as his consort.

Whether or not Dara's gesture was designed to improve her status in the palace, it nonetheless proved very effective in doing so. Not long after her departure for Chiang Mai, King Chulalongkorn created a new title for Dara Rasami, making her *phra rachaya* (high queen) on April 8, 1909.[110] This unique title had never been used before and has not been given again since Chulalongkorn's reign. The title

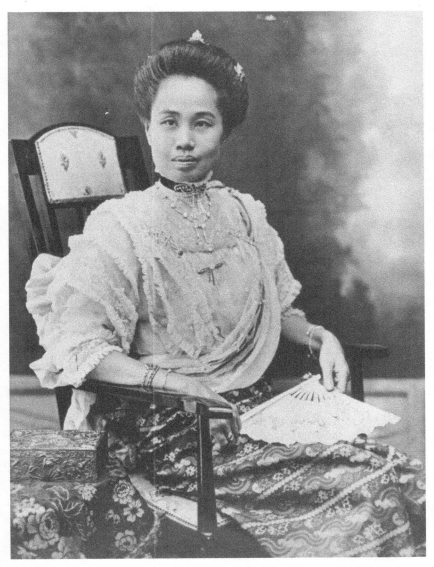

FIGURE 6. Official portrait of Dara Rasami on her promotion
to the rank of *Phra Rachaya,* taken by Morinosuke Tanaka
in Chiang Mai in 1909. Wikimedia Commons/public domain.

of phra rachaya elevated Dara Rasami to the status of high queen, an elite group which, until that time, consisted only of his four half-sister queens.[111] During Dara's long absence from Bangkok, Chulalongkorn sent a number of gifts to her in Chiang Mai (including a stereograph viewer) and began construction on a new palace residence adjacent to Vimanmek Palace. In honor of her third-cycle (thirty-sixth) birthday on August 26, he sent her a fancy gold betel box made for her and specially inscribed with a personal message. As Phonsiri mentions, the betel box was a fashionable accessory for high-status consorts in the palace in that era.[112] Figure 6 shows Dara in her customary Lan Na-style hairstyle and attire in formal portraits taken by a well-respected local photographer, Japanese emigré Morinosuke Tanaka, during her stay in Chiang Mai. In these images, the new betel box—a marker of her royal favor—sits prominently on the table next to her.[113]

Chulalongkorn's genuine affection and regard for Dara were amply demonstrated during the long months she was away from Bangkok. Whether in transit or during her nine-month visit to Chiang Mai, Dara and King Chulalongkorn kept up a regular correspondence that included seventeen letters and thirty-four telegrams.[114] In these communications, Chulalongkorn takes a warm, familiar tone in catching Dara up to the local goings-on in the palace as well as Bangkok's theater world, and often expresses his *khwam kit-tung* (the feeling of missing someone) in opening or closing the letter.

In addition to these personal expressions, Chulalongkorn also made gestures that supported Dara's activities in Chiang Mai. In these activities, Dara Rasami focused her efforts on two main areas: restoring local Buddhist monuments and temples, and reinforcing the legacy of her ancestors. In support of her efforts, Chulalongkorn provided funds for the restoration of various local wats, ordered the creation of metal plaques inscribed with Dara's image and her parents' names for her to install at Doi Suthep (Chiang Mai's mountaintop temple), and struck a special gold-plated medal featuring the intertwined characters "oh" and "doh," referencing the initials of Dara and her father, to be given away at the celebrations.[115]

In addition to these activities, Dara's visit brought more worldly amusements to the local populace as well. King Chulalongkorn supplied her with funds for a week-long celebration that attended the dedication of the new royal cemetery Dara built next to Wat Suan Dok, on the city's western outskirts:

> A large celebration of honor and joyous entertainment . . . began the fifteenth of October, and ran until the 30th of B.E. 2452 [C.E. 1908], altogether fifteen days and five nights. [She] built pavilions for Officers [*chao*

nai] and government officials to stay in, a ceremonial hall, movie hall, box-
ing field, orphanage, and a hospital; groups of guards, troops, and police
guarded over all, and moved all the fresh markets of the city. Altogether,
the cost was 100,000 baht. . . . [A]ll the [Lan Na nobles] came to assist with
the celebrations.[116]

The relationship of Dara Rasami's promotion to the timing of her visit to Chi-
ang Mai is suggestive. Dara's parting gesture—washing the king's feet with her
hair—may well have played an emotional part in Chulalongkorn's subsequent
decision to bestow her high promotion. Perhaps Chulalongkorn recognized
the role that Dara had performed within the palace, or the personal difficulty
and pain she experienced being separated from her family and homeland for
over twenty years. I suggest another discourse within which Dara's promotion
makes sense: Lan Na's own custom of son-in-law succession. In this pattern, Lan
Na's crown fell to the man who married the current king's daughter.[117] Dara's
own mother, Thipkraisorn, chose her husband, Inthawichyanon, who ascended
the throne after the death of Thipkraisorn's father, King Kawilorot. As a royal
daughter of Lan Na, Dara's husband would have been entitled to become the
next king of the realm. In this context, Dara Rasami's promotion to the status
of a high queen also functions as an assertion of Siamese sovereignty over Lan
Na. In effect, Chulalongkorn's promotion of Dara Rasami to the status of high
queen offered a brilliant public relations move with regards to Siam's relation-
ship with Lan Na, which had been feeling Siamese administrative encroachment
ever more keenly in the prior decade. During the two-week-long celebrations
held at the end of Dara's visit, one Siamese administrator wrote that:

> The best thing is that we [Siamese administrators] are greeted with sweet
> "*wais*" when we come to work. . . . It's given rise to a sense of purpose in
> almost everyone. This is the first time I can say that I've seen such *nam jai
> dii* [spirit, sympathy, generosity] by the people; several thousand people
> with abundant pride. The local people, who flocked to the events, said that
> they had never seen anything as large as this.[118]

In many ways, Dara functioned as a modernizer during her visit, working to
restore local wats and create a royal cemetery, in addition to building new public
amenities like hospitals, schools, and movie theaters. To some, however, these ac-
tivities were less welcome, appearing more like Siamization than modernization.
Dara's creation of a new royal cemetery at Wat Suan Dok, and her subsequent
relocation of the royal ancestors' remains from the riverside near what became

Warorot Market, were particularly controversial. Though no local newspapers survive from that time, a local monk noted his reactions to Dara's activities in the back matter of a temple zodiacal calendar used to calculate auspicious and inauspicious dates.[119] Though most of these notes list only the activity and date, we can sense the author's dismay in several entries. For example, in a note dated July 29: "[Dara] moved bones from Ping River down Thaphae Road and through city; out the Western Gate; this is a very bad thing." When Dara's half brother, then-governor Chao Intawarorot, died on January 5, 1910—a scant two months after her return to Bangkok—the writer comments that this misfortune was a direct result of Dara's actions, particularly her removal of Wat Chieng Mun's Buddha image to take back to Bangkok. This text demonstrates that at least some of Dara Rasami's activities were perceived by some as undermining local culture—and were perhaps even spiritually dangerous. When Dara Rasami returned to live in Chiang Mai permanently several years later, this suspicion resurfaced, resulting in skepticism regarding the authenticity of Dara Rasami's "Lan Na-ness."

Dara Rasami: "Self-Orientalizing" or Strategically Essentializing?

Did Dara Rasami's role in twentieth-century palace arts and diplomacy represent a "self-orientalization"? That is, did Dara Rasami accept the construct of her ethnic difference as less than that of the Siamese, internalizing the lower niche allotted to Lan Na's people in the siwilai hierarchy? I suggest we might see more agency and nuance in her expressions of ethnic difference, in what Gayatri Spivak describes as strategic essentialism. Through her dress, speech, and participation in lakhon, it is clear that Dara Rasami played a central role in making Lan Na difference knowable to the innermost circle of Siamese elites. Through her presence in the royal court, Dara Rasami helped construct Siamese notions of Lao or Lan Na ethnicity, earning higher status for her homeland in the hierarchical construct of Siamese siwilai than that of "Others within" like Khanung, the Semang tribal boy adopted by King Chulalongkorn who was also featured in royal lakhon performance and photography. At several key moments—Sao Khrua Fa and the 1906 audience with the Shan princess in particular—Dara Rasami was deployed as a "not-quite Siamese" elite against which the Siamese position at the top of the siwilai hierarchy could be reinforced. We can interpret her performance of Lan Na-ness at other moments—such as the washing the King's feet with her hair—as conscious deployments of her ethnic

FIGURE 7. Photo of Dara Rasami and several of her attendants, children, and pets outside Dara's new residence, Suan Kang Farang Sai, ca. 1909. Wikimedia Commons/public domain.

difference. Within the culturally hegemonic environment of the palace, Dara's performances—particularly those between 1905 and 1910—serve as examples of successful strategic self-essentialism. As an ethnic "Other within" palace culture, Dara Rasami's education in Siamese notions of siwilai ultimately allowed her to act as the agent of her own destiny, able to marshal and deploy novel and exotic elements of her ethnicity in ways that worked against Siamese cultural hegemony. Through deployments of dress, drama, and diplomatic gesture, I suggest Dara Rasami pushed back in various ways against the scientific discourses being adopted by Siamese elites of her era. By complicating Siamese understandings of Lao or Lan Na identity, Dara earned a place closer to the siwilai end of Siam's civilizational spectrum for the people of her home region.

Dara Rasami's Last Years at Suan Dusit

After returning from her first visit to her hometown of Chiang Mai in November 1909, Dara Rasami was feted in high royal style. King Chulalongkorn and his advisers sailed upriver to Ayutthaya to meet her, with the king personally escorting her back to Bangkok alone on his boat.[120] Her new residence, named

Suan Farang Kangsai (after a popular chinaware pattern), had been completed on a lot next to Vimanmek Mansion—a spatial reflection of Dara's new status as a high queen.[121] A musical concert featuring *Sao Khrua Fa* and *Lilit Phra Law* was held at the new residence in her honor.[122] Before her return from Chiang Mai, Chulalongkorn had commissioned new oil portraits of her mother and father to be hung in the new house, and had her belongings moved into the new building, as well.[123] Though the new structure was built with airy hallways and windows that could be opened to keep air circulating inside the building, such masonry buildings tend to heat up like ovens in Bangkok's climate. Informal photographs taken of Dara Rasami and a few of her ladies spending time outside in the building's shade indicate that this might have been the case with Dara's new residence (see figure 7).

Despite Dara's ostensible success in improving Lan Na's place in the hierarchical Siamese worldview of siwilai, it is important to remember that it did not alter the course of Siam's plans to bring Lan Na under its administrative control. Although Dara's efforts appear to have assisted in promoting Chiang Mai as Siam's northern capital, one might question whether her appearance in Chiang Mai in 1909 was anything more than a public relations initiative intended to ease local perceptions of ongoing Siamese domination. To my mind, however, Dara's activities represent a different discourse: that of a very siwilai Lan Na woman, attempting to bring her homeland up-to-date in a way that was entirely consistent with her upbringing and culture, utilizing the technologies available to her. In the next chapter, I will explore the last phase of Dara Rasami's life between 1915 and 1933, and the vastly changed political landscape she encountered in the Lan Na of the early twentieth century.

Inventing Lan Na Tradition and Dara Rasami's Legacy

O
VER THE COURSE OF Dara Rasami's time in the palace from 1883
to 1910, the political relationship between Siam and Lan Na was com-
pletely reimagined in a way that subverted Lan Na's sovereignty utterly.
Not long after the death of Dara Rasami's father, King Inthawichyanon, in 1896,
Lan Na's rulers rapidly lost the political autonomy Dara's parents had enjoyed.
From 1899 onward, Lan Na's ruling nobles were styled governors and paired with
resident Siamese officials.[1] As Siam instituted the new *thetsaphibaan monthon*
administrative system, political marital alliances that had traditionally bound
Siam's center and its peripheries became unnecessary.[2] Thus Dara Rasami's career
as a royal consort spanned a unique period in Siam's history: while her engage-
ment reflected the centrality of women to Siamese politics, by the end of the Fifth
Reign, her official role—and that of other royal consorts—had become obsolete,
and the practice of elite polygyny was under heavy fire. However, after decades
in the Siamese palace performing the political role of a foreign princess, Dara
Rasami reinvented herself as the primary promoter and preserver of Lan Na cul-
ture, history, and identity. Her efforts during this era were central to the creation
of core elements of what today are considered many traditional arts of Lan Na.

Life after Chulalongkorn: From Bangkok to Chiang Mai

The pleasant days Dara Rasami spent in her new house at Dusit as one of
Chulalongkorn's favorite queens were short lived. After a brief illness, King
Chulalongkorn passed away on October 23, 1910, at the age of fifty-seven. As in
past reigns, the king's wives and consorts cleared out of the royal residence to
make way for the new king—Rama VI, King Vajiravudh—and his entourage.
While High Queen Saovabha moved to the nearby Phyathai Palace, many of
the other royal consorts either moved into the households of their princely
sons or returned to residences on the old Inner Palace grounds. Dara Rasami's
household was no exception to this exodus. After the king's death, she was

allowed to stay on at her new house at Suan Dusit for another year, but then had to move back to her residence in the old Inner Palace. She continued to live there until late 1914, at which time she formally requested permission from the new king to leave Bangkok and retire to her hometown of Chiang Mai permanently. In a gesture reminiscent of Chulalongkorn's 1909 farewell to Dara Rasami, King Vajiravudh saw her off on her journey at the Samsen train station.[3] By that time, the journey had shortened considerably, as Thailand's rail lines now reached as far as Baan Pin, about 217 miles from Bangkok. From there, Dara Rasami traveled the remaining 124 miles to Chiang Mai by car. The week-long journey was a far cry from the six-week trek by train and river-boat that her 1909 visit had entailed.

Back in Chiang Mai, finally free from the constraints of Bangkok palace life, but materially secure in her family's financial legacy, Dara Rasami embraced a role new to the elite culture of Siam: that of a modern "matron" of Lan Na culture. Here I borrow the term "matronage"—recently coined by contemporary art historians to denote elite women's practices of artistic patronage[4]—to designate Dara Rasami as a "modern matron," reflecting her embodiment of a new mode of practice that combined elements of both traditional (i.e., Lan Na) forms and modern Siamese siwilai. Although Dara Rasami had strategically deployed her identity as a Lan Na "exotic" to great effect during her career in the Siamese Royal Palace in Bangkok, her matronage of Lan Na arts and culture evolved into something entirely different in the context of her retirement in Chiang Mai between 1914 and 1933.

Dara Rasami as Matron of Lan Na Culture: 1914–33

Dara Rasami truly began to come into her own as a siwilai matron of Lan Na culture following her return to Chiang Mai in 1914. In the last period of her life, from her retirement until her death in 1933, Dara's activities reflected the values of her particular worldview and its effect on the types of matronage in which she engaged. This period sheds additional light on the gendered aspects of her activities and the differences between the roles of Siamese and Lan Na elite women. In addition to promoting Lan Na arts and culture, Dara's participation extended to activities more consistent with masculine forms of patronage practiced by siwilai Siamese elite males—but which were quite consistent with Lan Na elite female matronage of prior generations. In addition to her matronage of dance, drama, and textile arts, there were two main areas in which Dara demonstrates a ma-tronage informed by notions of siwilai: as a matron of medicine and agriculture,

and as an amateur scholar of Lan Na cultural history. First, however, let us begin with a discussion of what matronage means.

Defining "Matronage"

In discussing Dara Rasami's activities following her retirement, I utilize the concept of "matronage" coined by Linda Nochlin, who was among the first to bring feminist critique to the field of art history.[5] Nochlin's essay challenged the field's structural sexism by questioning the absence of women from the categories of "greatness" and "genius," and the "system of gendered exclusion that rejected them in the first place."[6] In the nearly four decades since, feminist art history has responded by investigating the gendering of artistic activities and the division of artistic labor, furthering the critique by examining their intersections with race, class, and postcolonialism. More recently, scholars have begun applying these considerations to how women have acted as "matrons" (versus "patrons") of artistic endeavors in a variety of Asian contexts. Elsewhere I have explored Dara Rasami's use of her privilege as an elite Lan Na woman and royal Siamese consort to support particular forms of cultural expression that persist down to the present day in northern Thailand.[7] It is in this sense that I use the term "matron" to describe Dara as an important promoter of Lan Na culture.

Music, Dance-Drama, and Textiles

Since her days as a consort living in the Royal Palace in Bangkok, Dara Rasami and her ladies-in-waiting had practiced the arts of music and dance in her palace residence, in Lan Na, Siamese, and Western modes. This blending of styles and instruments continued after Dara Rasami's retirement in Chiang Mai.

Back in Chiang Mai, Dara Rasami's younger half brother (and new city governor), Chao Kaew Nowarat, had built her a new residence in anticipation of her return. The new house was called *Khum Chedi Kiu* (the Chedi Palace), after a small stupa/chedi located outside the compound's walls on the corner of the lot. The site was located—as were many elite residences in early twentieth-century Chiang Mai—between the eastern wall of the old city and the western bank of the Ping River. In addition to her residence, there was also a space called the *Rong Kii* (or Kii Hall), which was a "long, open room flanked by columns, used as a rehearsal space for dance and *lakhon*."[8] There, Dara Rasami oversaw the training of many young women in the traditional forms of Lan Na dance, as well as the new Siamese styles. Among her students were many of the daughters of the Chiang Mai nobility as well as those of the Siamese administrators living

FIGURE 8. Dara Rasami's dance troupe at Khum Chedi Kiu, probably taken on the occasion of Rama VII's visit to Chiang Mai in 1927. Wikimedia Commons/public domain.

in Chiang Mai. These high-born students included her foster daughter *Than Phuying* Chatrsudha Wongtongsri (née Chatrchai), who later became a teacher of Lan Na dance herself; also Chao Jamrut na Chiang Mai; Chao Saeng Sawang Sirorote; Chao Butsaban Sirorote; Chao Wowdao na Chiang Mai; Chao Khrua Gaew na Chiang Mai; Samruay (Manowong) Bunnag; Sompun (Duangsing) Chotana; and others. However, it was not only the elite who danced at the Rong Kii. Another source notes that "[there were] children of average villagers who were interested in dance—not a few—that she took on as dancers at the palace" (see figure 8).[9]

Dara Rasami employed several teachers (*kru*) at the Rong Kii, a number of whom had trained as dancers in the palace of her late half brother, former governor Chao Intawarorot, whose troupe had incorporated Bangkok palace dances into their repertoire.[10] The teachers of Dara's troupe at the Rong Kii included *Mom* [Lady] Sae, Kru Pun, Kru Puen, and Kru Thuy.[11] Dara took a personal interest in the training at the Rong Kii, often observing the rehearsals held there every morning from 10:00 a.m. to noon, and afternoons from 3:00 to 6:00 p.m. One observer noted that Dara would

. . . come to supervise the dance practice herself. If anyone made a mistake, they had to endure punishment—be hit, pinched, or thumped with a fist. All her nieces and the other dancers were very afraid of [Dara]. But in the end, when the work was authentic and proper, she was satisfied/happy.[12]

In addition to monitoring dance instruction, Dara Rasami was instrumental in recording and refining the various positions and gestures of both Lan Na and Bangkok dance styles. For example, she wrote down dances like the fingernail dance, which she adapted from old Lan Na palace dance forms, and the candle dance, both of which became styles identified with traditional Lan Na culture (even as she updated them to appeal to contemporary audiences).[13] She codified local forms of dance-drama that utilized northern instruments, rhythms, and vocalizations called *lakhon saw*, creating a dramatic form much closer to the new Siamese form of *lakhon rong*, or singing plays. The similarities of lakhon saw style to the modern lakhon rong, blended with elements of exotic northern difference, appealed greatly to the new Siamese audience in Chiang Mai. Most significantly here, however, Dara Rasami went a step further in creating her own lakhon saw play, called *Phra Loh Waen Kaew* (*Lady of the Crystal Ring*), sometimes also called *Noi Chaiya*. In contrast to the tragic northern heroine embodied in *Sao Khrua Fa* (the Siamese adaptation of *Madame Butterfly*), the female protagonist of Dara's play defied cultural norms to reject the man her parents chose to be her husband, and instead runs away with her lover, even though he is of lower social status than she is. Parts of this play were often performed in Chiang Mai during events held to receive official guests or celebrate high holidays, and its signature song, "Noi Chaiya," is still well known and performed for functions around Chiang Mai today.[14]

While Lan Na's nobility had a long tradition of court lakhon dancers, they were typically supported by the male ruler's household.[15] Dara Rasami's matronage of the arts in Chiang Mai was significant in consolidating existing local traditions and extending the appeal of Lan Na dance and music, which were in danger of losing ground to Siamese dance and dramatic styles following the political integration of Lan Na into the Siamese thetsaphiban administrative structure in the 1890s. As Chiang Mai continued to see an increasing flow of Siamese officials and Siamese culture into the area, Dara Rasami's matronage ensured the continued relevance of Lan Na dance and dramatic styles to the area. The training she provided guaranteed ongoing employment for local dancers by supplying the growing community of Siamese officials in Chiang Mai with performers and dances that they considered both sufficiently "exotic" and

"authentic" enough, but which simultaneously incorporated enough central Thai elements to render them comfortably recognizable to a Siamese audience.

Dara Rasami's promotion of local dance traditions had the additional effect of promoting Lan Na's distinct textiles as well. In her riverside compound in Chiang Mai, she had two rooms set up adjacent to the Rong Kii with looms for the weaving of phasin textiles.[16] This filled the need for special textiles required by palace dancers in particular, as "the [phasin] of northerners used in dance especially demonstrated the status of the wearer as well. If it was a 'dance' phasin, materials of silver and gold thread were woven into [its] stripes."[17]

Dara Rasami also promoted Lan Na textiles outside the dance and performance space. At the home she later built on a piece of rural farmland, Dara Phirom Palace in Mae Rim, she installed looms in the shady area underneath the raised house where local girls could learn to weave traditional patterns.[18] Her interest in textiles and weaving was at least in part inherited from her aunt, the aforementioned Ubonwanna, who was considered an expert in local textiles. Ubonwanna had directly managed the production of textiles at her household, where slave women could often be seen working at the looms on the front veranda of her house.[19]

Dara was also interested in maintaining the local patterns practiced in the rural villages scattered among the mountains near Chiang Mai, and she traveled to collect them as well. Her foster daughter Chatrsudha Wongtongsri claims Dara Rasami would ride miles to visit the village of Mae Chaem, where the highest-quality teen jok patterns could be found.[20] But it appears that she knew her way around a loom herself: Chatrsudha notes that Dara Rasami had woven a number of traditional Lan Na-style shoulder bags to donate to monks at her sixtieth birthday celebration only a few months before her death at the end of 1933.[21]

Most notable is Dara Rasami's gradual movement from performer to patron—or in this instance, matron. Whereas many women of both noble and common birth participated in music and dance as performers, there are few examples of women as sponsors of such activities; that role was typically reserved for male elites, the noblemen, or kings whose prestige was enhanced by performers' presence in their households. As a matron devoted to sponsoring—and not merely performing in—Lan Na arts, Dara's pattern of participation aligned more closely with those practiced by Siamese noblemen rather than those of Siamese elite women of her era.

Dara Rasami as Modern Matron of Medicine and Agriculture

In addition to supporting, maintaining, and preserving local traditions of Lan Na dance, Dara's matronage took other forms consistent with those practiced by her Siamese contemporaries, especially relating to Western medical practices and facilities. Siam's royals had experience with Western medicine beginning with the first Protestant missionaries who came to Bangkok in the 1830s, and they eagerly accepted vaccination and surgery as complements to traditional Thai medicinal practices. King Chulalongkorn founded Siriraj Hospital in 1888 and sponsored the British-founded Bangkok Nursing Hospital (now known as BNH) in 1897. The standard of royal medical patronage was feminized around the turn of the twentieth century, as Queen Saovabha initiated the first branch of the Red Cross in Siam, modeling elite women's support of medical enterprises as siwilai practice.

Dara Rasami's family had a similar history of exposure to Western medicine, also through Protestant Christian missionaries in Chiang Mai. Dara's parents had maintained their belief in the efficacy of Western medicine despite having lost a child to a failed vaccination attempt in 1868.[22] Nonetheless, Chiang Mai's royal family continued to have a close relationship with the missionaries, encouraging their activities by granting them funds and land for their residences, hospitals, and schools in Chiang Mai. When Dara Rasami's mother died in 1884, it was noted not only that missionary Dr. Peoples had been entirely in charge of her care, but also that "Mrs. McGilvary was with her at her death, and remained to see the body dressed for the coffin. We missed her very much as a friend."[23]

Following her return to Chiang Mai, Dara Rasami appears to have had a similarly close relationship with the missionaries of Chiang Mai, acting as a matron of their medical activities and facilities between 1915 and 1933. She built on her parents' legacy of support for the local Presbyterian missionaries, donating funds for the expansion of McCormick Hospital and the McKean Leper Colony.[24] When the latter opened new housing for its patients in 1923, she even enlisted the help of her old friend Prince Damrong to assist in the ribbon-cutting ceremonies. Dara Rasami represented Siamese royalty by giving a speech at the reception luncheon held for the hundred local Western and Lan Na elites who attended the occasion.[25]

Dara's siwilai orientation familiarized her with other contemporary sciences, particularly agriculture. Even before her retirement to Chiang Mai, Dara's agricultural bent was noted by King Chulalongkorn while she visited Chiang Mai in 1909; in two of his letters to Dara, he makes a point of updating her on the

condition of a lamduan tree she planted just before her departure.[26] During the same visit, local Chinese merchants allegedly presented Dara with five *lamyai* trees, two of which she brought back with her and planted in Bangkok. Dara's passion for growing things soon developed in a philanthropic direction, which was aided by several Siamese and Lan Na elites—most notably, *Mom Chao* Sithiphon Kridakorn (1883–1971), who came to be known as the "father of Thai agriculture." After a successful twenty-year career in the royal administration, Sithiphon resigned in 1921, moving to the rural village of Bang Berd approximately 250 miles south of Bangkok (near Hua Hin), where he and his wife set up an experimental farm and founded the agricultural journal *Kasikorn* (1927). After he was appointed director-general of the Agricultural Inspection Department in 1931, he expanded his agricultural project to establish three experimental agriculture stations to the north, northeast, and south of Siam.[27] Dara and Sithiphon shared several Lan Na connections. His father, Prince Boworadet (1877–1947), who had served as viceroy of monthon Payap from 1915 to 1926, had married Dara's former lady-in-waiting, Thipawaan, and lived for several years in a mountainside retreat next door to Dara Rasami's just outside Chiang Mai. Sithiphon himself was married to Mom Chao Siphroma, a Lan Na woman of the Nan royal family (who had also served in King Chulalongkorn's court).[28]

Dara Rasami shared an interest in agriculture with a number of other Lan Na elites. Chao Cheun Sirorote (1896–1996), one of the founding instructors of Chiang Mai's agricultural college, had knowledge of cultivating Virginia tobacco and other crops new to Siam.[29] Chao Thipawaan, Dara's former lady-in-waiting, made her fortune as the first to cultivate and cure Virginia tobacco in Chiang Mai following her divorce from Prince Borowadet in 1926.[30]

Like these elites, Dara Rasami saw both obstacles and opportunities for local farmers to adjust their practices to better meet the market realities of Siam's changing economy. To pursue this interest, however, Dara needed a bigger plot of land than the rose garden at Khum Chedi Kiu. Not long after her return to Chiang Mai, she began seeking a space of her own on which to build her own residence and farm.[31] She eventually found her ideal site about nine miles north of Chiang Mai near the village of Mae Rim, where the soil was fertile and there was an ample water source in the nearby Mae Sa River. Although the exact dates are not known, it is estimated that she broke ground on her new farm not long after her return to Chiang Mai in 1915, and that the residence—Dara Phirom Palace—was ready to move into by 1920.[32]

There Dara Rasami became a local matron of modern agriculture for Chiang Mai. The seventy *rai* of land surrounding the Dara Phirom residence, known

as *Suan Chao Sabai* (Garden of the Princess's Happiness), served as a kind of laboratory for experimenting with new agricultural techniques and crops.[33] On her new farm, Dara Rasami cultivated both native and foreign species of both ornamental and fruiting trees, flowers, and crops. Dara recognized the challenges local farmers faced as the local economy shifted away from subsistence farming toward the raising of cash crops. She used her farm to evaluate which fruits and vegetables farmers could easily grow to sell.[34] Through her connections to Lan Na and Siamese nobility, Dara Rasami brought several new crops to Chiang Mai which subsequently became economically important. Using seeds and agricultural knowledge obtained from the aforementioned Sithiphon Kridakorn, Dara introduced cabbage to northern farmers, who were able to sell their produce to Bangkok at a profit. She took a personal interest in these agricultural pursuits, as is evident in the account of a local farmer whom she encouraged to grow cantaloupe:

> I planted the "farang" melon using the special-formula fertilizer of Chao Sithiphon [Kridakorn], and the fruit looked very good. They were smaller than Thai melon, but sweeter. I took one to give to Dara, and she was very impressed by its sweetness. I sent one as an example to a hotel in Bangkok— the Hotel Trocadero. Their manager answered me that if I had any more like the one I'd sent, he'd buy them all at thirty satang a pound—around three pounds for a baht.[35]

Dara Rasami is also credited with the introduction of a new variety of lamyai tree to Chiang Mai, whose fruit became another important cash crop for northern Thai farmers.[36] In addition to cantaloupe and lamyai, Dara also planted Chinese cabbage, bamboo shoots, rambutan, lychee, purple cabbage, sweet and sour tamarind, mangosteen, coconuts, pomegranates, rose apples, and star apples in the fields at Mae Rim. Though she continued to grow her beloved roses at Suan Chao Sabai, her involvement in experimental agriculture demonstrates both her high esteem of scientific siwilai and her desire to benefit the people of Lan Na through agricultural knowledge. In the next form of matronage we will examine, Dara Rasami combined science with her concern for the survival of local culture to become a matron of a wholly new kind: a matron of historical knowledge.

Dara Rasami as Matron of Cultural History

In addition to her support of medical activities, Dara Rasami also became a well-known repository of local cultural history. Her interest in Chiang Mai's

local history can be traced to two distinct sources: first, her family's deep connection to and knowledge of Lan Na history; and second, her friendship with Prince Damrong, who is known as the father of Thai history.

Dara Rasami was steeped in Lan Na myth and history as she grew up and was raised by Lan Na elites who passed along their knowledge to her. According to British explorer Holt Hallett, who visited Chiang Mai in the early 1880s, Dara's aunt Ubonwanna shared with him the story of Lan Na's legendary Queen Chamathewi, prompting Hallett to call her "the historian of the Chiang Mai palace."[37] Other British officials of the time describe Ubonwanna as "the person who knows the story of Chiang Mai better than anyone else."[38] As Dara Rasami lived with her aunt for about two years following her mother's death in 1884, she would certainly have learned these and many other stories during her childhood. More importantly, Dara grew up amid royal women for whom family and local histories were both personally and historically meaningful.

Dara Rasami and Prince Damrong had become friends during her career in the Bangkok palace, a relationship they maintained after her return to Chiang Mai in 1915. Their connection during this period is evidenced both by Dara's numerous appearances in his (voluminous) collected correspondence, and by Damrong's repeated visits to Dara in Chiang Mai (often with a few of his daughters in tow). For our purposes, the most important link shared by Prince Damrong and Dara Rasami was their appreciation of learning and historical knowledge. Damrong, who had translated and published the corpus of Siamese royal chronicles in updated Thai language, traveled extensively to archaeological sites all over Southeast Asia in his later life, and wrote extensively on Thai history and antiquities. Dara Rasami appears to have shared his passion for knowledge, as she herself engaged in similar activities following her return to Chiang Mai. In a 1931 letter, Damrong responded to another scholar seeking information about the use of currency in old Lan Na that "I will ask [Dara Rasami], because she knows better than I do."[39] In their subsequent correspondence on the subject, Dara described to Damrong the evidence she had found in traveling around the area, and also explained that she had been reading the "ancient chronicles" to see if she could find any additional past references.[40] She subsequently set up the first central library in Chiang Mai, looking to the model of Damrong's recently-created National Library in Bangkok.[41] Damrong's daughter later said of Dara:

I once asked some Westerners in the timber trade who had come from living in the north about how the northern rulers really were. They told me

that the "stupid" rulers of Chiang Mai were really very smart. And "the Queen of Chiang Mai" was what they called [Dara Rasami].[42]

According to her foster daughter during that period, Chatrsudha Wong-tongsri, Dara traveled extensively throughout the region surrounding Chiang Mai to gather historical data from surviving members of the old nobility, as well as any artifacts she could find. These journeys through the thickly forested, mountainous terrain of the region often necessitated travel on horseback or by elephant, as paved roads had not yet been laid.[43] On these travels, Dara Rasami was usually accompanied by Chatrsudha herself, who—like her European-educated mother, Laddakham—was a skilled horsewoman.[44] Dara Rasami's horseback journeys to the village of Mae Chaem to collect samples of the beautiful teen jok textiles are still known to people living in Chiang Mai today.[45] Part of the impetus behind these activities appears to have been Dara's consciousness of the importance of the past in maintaining a people's cultural identity—and the potential for loss of Lan Na culture and/or history, as the Siamese became increasingly involved in the governance of Chiang Mai, and elite cultural expressions. Dara Rasami went to great lengths to ensure that her own generation of Chiang Mai's royal family was not forgotten. Not long after returning to Chiang Mai in 1914, she and her foster daughter Laddakham saddled horses and rode to the top of Doi Angkhan, the highest peak in Thailand, where she carried out her father's wishes to have his remains interred atop the mountain, which she subsequently re-named Doi Inthanon after him. Their timing was not the best, however: after burying the "gold-plated box containing [Inthawichyanon's] bones," the temperature dropped into the lower 40s and the women were stuck in their camp on the mountaintop for two days.[46]

Prince Damrong himself made several journeys to visit Dara Rasami in Chiang Mai, and recognized her expertise in the cultural history of Lan Na on several occasions. When approached by scholars seeking information on topics related to Lan Na's history, he often referred them to Dara Rasami. In August of 1923, Prince Damrong wrote to Dara Rasami to introduce a young Suzanne Karpeles, visiting on a scholarship from the French government to study the histories and customs of the countries of the Tonkin region:

> [Regarding] Miss Karbolet [sic], a French student who knows Pali, Sanskrit and Thai. . . . She would also like to go to Chiang Mai in order to see the country and study ancient history. She has told me that for knowledge of northern antiquities, your expertise is like no one else's in Payap province, and she has heard many praise your character. . . . In my view Miss Karbolet

is very proper, loves learning, and would get along well with you. Please accept this letter of introduction and help make Miss Karbolet comfortable when she comes to Chiang Mai so that she can study and seek knowledge as she wishes.[47]

The knowledge of her home region's history that Dara Rasami gained through travel, collecting oral history, and reading older texts earned her a reputation over time as a local historical expert among Western and Siamese scholars alike. But it also represents a marked departure from the practices of her female Siamese counterparts. Culturally, femaleness tended to be far more strongly associated with "inside" than the masculine, dangerous "outside" in mainland Southeast Asia.[48] In Siam, the careers of royal consorts within the palace would have habituated them to the luxury and security of life behind palace walls, and few would have considered undertaking the difficult and sometimes dangerous journeys that Dara Rasami and her foster daughter did—particularly without the accompaniment of elite males. In this respect, Dara's activities appear more consistent with those of Siamese male contemporaries such as Prince Damrong, rather than Siamese elite women, for whom such solo travels would have been quite unthinkable. Despite her own long years living within the confines of the palace, Dara Rasami's youthful experiences of the outside, while traveling between Chiang Mai and Bangkok with her parents, may have been a key factor that rendered possible the outdoor journeys she made later in life. Perhaps the proscription against the outside among elite women was weaker in the north, where women's status was higher and "traditions of female governance were stronger" than in Siam.[49] In any event, Dara Rasami's research travels represent a major divergence between the practice of cultural matronage in Lan Na and those of Siamese elite women of the same era.

Full Circle: Lan Na Style becomes Fashionable in Bangkok

As a strategy for maintaining distinctiveness from southern Siamese culture, Dara's activities were successful—sometimes in wholly unintentional ways. The 1920s saw the emergence of a fad for Lan Na textiles—particularly teen jok phasin—among Bangkok elite women. This fashion was sparked by the visits of two important Siamese elites to Chiang Mai: Prince Damrong in 1922 and King Prajadhipok in 1927. With the completion of the railway line all the way to Chiang Mai in 1921, the arduous journey to the north was reduced from several weeks to an overnight trip. The visits of Siamese nobles like Damrong and Prajadhipok

further served to raise the profile of Chiang Mai as a destination for domestic travel—nascent tourism—during this era. Prince Damrong's travels in particular made Lan Na dress more visible to Bangkok's elites through the photographs he took of his young daughter Phunpitsamai dressed in an ensemble of Lan Na and Shan textiles.

However, it was King Prajadhipok's royal visit to Chiang Mai in 1927 that gave the fad a renewed impetus. The king's two-week tour of Lan Na included both administrative activities such as meetings with local officials, and ritual elements such as visits to important local temples. The royal couple was also treated to classical Lan Na music and dance performances courtesy of Dara Rasami's dance troupe. After the king's return to Bangkok, teen jok phasin became all the rage in Bangkok in the late 1920s, particularly after Queen Rambai Barni was photographed wearing a phasin. According to British Resident Reginald LeMay in 1926, "Nearly all Siamese ladies of good social position are adopting the *sin* [i.e., phasin] instead of the *phanung* for daily wear."[50]

Whereas during the prior reign Dara Rasami's phasin had marked her as a less-than-siwilai woman among the Siamese elites, in the 1920s the phasin metamorphosed into an emblem of the modern Siamese elite traveler. As Daruni Somsri describes in her analysis of this period, Lan Na's new proximity by rail, coupled with its cultural distinction from Bangkok, gave it great appeal as a tourist destination to Bangkok's emergent middle class.[51] The royal visit bestowed a newfound cachet on the "domestic Other" of the north among Siam's first (elite) tourists, as an exotic locale within Siam, easily accessible from Bangkok.[52] Thus the phasin—especially one featuring a teen jok border—identified the wearer as an elite able to afford the expense of traveling outside the capital, making it a trophy of tourist consumption of the north. Thus Dara Rasami's strategic essentialism of Lan Na's uniqueness had come full circle.

Dara Rasami's Role in Contemporary Memory

Dara's post-palace life in Chiang Mai appears to have been relatively healthy and happy. She divided her time between the farm in Mae Rim and her summer residence on the mountainside at Doi Suthep, and by all accounts was kept very busy by her many interests and projects. She continued to include children in her household, as is evident from a number of photographs of the era. In one, Dara conducts a soul-tying ceremony with a relative's infant child; in another, she is shown working in her rose garden accompanied by her young foster daughter Chatrsudha Chatrchai. Even after her foster children left Dara's household, she

continued to support them, financing the education of several children abroad in Europe.[53]

Despite her return to her Chiang Mai roots, Dara Rasami did not allow her Bangkok connections to lapse. In fact, Dara made an annual visit to Bangkok every August around the time of her birthday. During her visits she stayed with Queen Savang Vadhana, one of Chulalongkorn's other highest-status queens, with whom she had become close friends.[54] During these visits, the women shared their mutual pastimes of sewing and needlework, and enjoyed playing cards as they had in the palace, sometimes gambling late into the night.[55]

Altogether, Dara lived in Chiang Mai for nineteen years following her retirement from palace life in Bangkok. The last year of her life, however, witnessed tumultuous times in Siam. On June 24, 1932, a group of civilian reformers brought the absolute monarchy to a sudden end with a change of government that introduced a constitution and body of elected representatives to the Thai state.[56] The change was anything but universally embraced among Siam's elites and commoners alike, who were at first mystified by the appearance of the radical new Khana Ratsadon party. Among those opposed was Dara's old friend—and former Chiang Mai resident—Prince Boworadet, who along with several other princes launched an unsuccessful rebellion in October of 1933. On the failure of his counterrevolution, Boworadet and his second wife escaped by airplane to live in exile in Vietnam and Cambodia.[57] The prince's son, Sithiphon, who had shared his agricultural know-how with Dara, was imprisoned for several years for taking part in his father's rebellion.[58] The events surrounding the change of government also swept up Dara's friend Prince Damrong, who was forced into exile in Penang, Malaysia, in the fall of 1933. In little more than a year, the familiar world in which Dara Rasami and her royal counterparts had lived was turned upside down: the course of history had irreversibly changed, taking with it a way of life.

Dara's old lung ailment returned in the spring of 1933. No doubt the difficult events of that summer and fall took their toll on Dara's already fragile health. Telegrams of the time show that King Prajadhipok sent 5,000 baht for her medical care, and Damrong wrote expressing great concern, promising to try to visit (even though his own situation at that point was politically precarious).[59] Although her half brother took her in to care for her at his residence at Khum Rinkaew, Dara Rasami died on December 9, only a few months after her sixtieth birthday.[60] Queen Savang Vadhana telegraphed Chao Kaew Nowarat to express her "great sadness at this unexpected tragedy."[61] Dara Rasami's funeral events in April of 1934 were attended by both members of the former Chiang

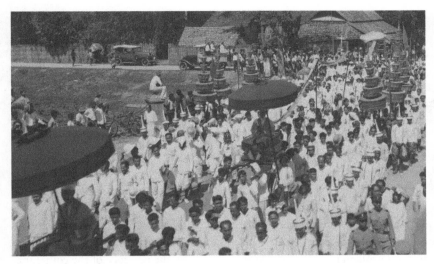

FIGURE 9. Thousands of local residents crowd into the street
for Dara Rasami's funeral procession (ca. 1933). Image courtesy of
Oliver Backhouse (grandson of Evelyn van Millingen of BBTC Siam).

Mai royal family (such as her half brother Major General Kaew Nowarat) and
Siamese administrators sent up to Chiang Mai from Bangkok—a total of 287
officials.[62] From photographs of the time, it appears most of Chiang Mai's pop-
ulation turned out to join the procession to Wat Suan Dok for her cremation
ceremony (see figure 9). Dara's ashes were divided and interred in two differ-
ent locations: half reside in Dara's monument in the royal cemetery at Wat
Suan Dok in Chiang Mai, while the other half are interred in her monument
at the women's cemetery adjacent to Wat Rajabophit in Bangkok, along with
her daughter's ashes.

Dara Rasami as an Ambiguous Symbol of Lan Na Identity

Given Dara Rasami's unique historical role in maintaining and preserving Lan
Na identity, one might wonder whether her memory could be considered threat-
ening to the Thai nation-state. After all, many elements of the Lan Na identity
as it is expressed in Chiang Mai today stem directly from the "invented tradi-
tions" Dara Rasami created following her return home in 1914. However, these
invented traditions, coupled with Dara Rasami's foothold in the central Thai
royal family, have created a uniquely ambiguous niche for her in local culture:

a figure whose memory is championed by localists and royalists alike, albeit in different moments.

Since her death, Dara Rasami has figured in Chiang Mai's local memory in unusual ways. At times, Dara's image appears alongside those of her male relatives as part of the greater lineage of Chiang Mai royalty, as in the display located in the *bot* (main hall) at Wat Phra Singh. Tourists and locals may know her through the museum at Dara Phirom Palace, the house Dara built at her experimental farm, Suan Chao Sabai in Mae Rim. The house, which fell into disuse after her death, was utilized from the 1940s to 1960s by the Thai military. Ownership of the property eventually fell to Chulalongkorn University, which undertook a complete restoration of the house in the late 1980s. The prominent role played by the current Thai royalty (late King Bhumibhol's older sister, Princess Kalyani Wattana [d. 2008], and daughter, Princess Sirindhorn) in the renovation and re-opening of Dara's house as a museum in 1990 additionally helped to revive Dara Rasami's role in local history. At the same time, the presence of the contemporary Thai royal family in this event served to reify the close—yet subordinate—relationship of both Dara Rasami and Chiang Mai itself to Bangkok royalty.

Local memory of Dara Rasami and her historical role is ambiguous, at times even problematic. After Dara Rasami's return to Chiang Mai in 1914, apocryphal stories attribute her move to Mae Rim to discomfort with the suspicion expressed toward her by local Chiang Mai residents, who felt she was an outsider, having lived in Bangkok for too long. This notion seems to have some traction, particularly in recent years as northern history, language, and cultural difference have experienced a renaissance in Chiang Mai. Although undoubtedly several local cultural forms benefited from Dara's patronage, there is some debate as to whether they became too "Siamized" in the process. Chiang Mai's local historians and proponents of Lan Na studies seem to have some difficulty deciding which side Dara Rasami was on, exactly. One local scholar described Dara Rasami to me as "the skeleton in the closet" of Chiang Mai's nobility.[63] Dara Rasami's status as both a Chiang Mai insider and Bangkok outsider makes it difficult to claim her as fully embodying either "authentic" Lan Na culture or history.

Yet Dara Rasami's status among regular Chiang Mai folk is not so difficult to parse. Mention of Dara Rasami to local people in Chiang Mai often elicits stories of ancestors with connections to her household.[64] The annual celebration of Dara's birthday, held at Dara Phirom Palace every August, features Buddhist ceremonies with chanting monks as well as dance performances, and appears to be very well attended by local people.[65] However, when compared to Siamese royals, her visibility as a famous figure is clearly not equal. For example, while

one can find any number of vendors selling amulets featuring the image of King Chulalongkorn in Chiang Mai's local markets, it is difficult to find images of Dara Rasami for sale—and sometimes the vendors do not recognize her name when asked.

In examining Dara's legacy in local memory, there is an interesting comparison to make between her and a contemporary local figure similarly important to Lan Na identity: Buddhist forest monk Khruba Srivichai (1878–1938), whose "statues, photographs and amulets can be found at Buddhist temples and homes throughout the region."[66] Born in Amphur Lii just north of Lamphun—allegedly in the middle of a thunderstorm—Khruba's controversial career overlapped Dara Rasami's later years in both Bangkok and Chiang Mai.[67] Like Dara Rasami, Khruba similarly lived through the era during which Siam solidified its control over the previously sovereign kingdoms of Lan Na. Unlike Dara, however, Khruba Srivichai became emblematic of resistance against Siamese domination, and the figurehead of a millenarian movement that blossomed throughout Lan Na from the 1910s to the 1930s. From early in his career, the monk had driven a number of several important temple restorations and construction projects—an unusual arena for monastic aspirations. His projects included rebuilding the reliquary at the Chamathewi temple in Lamphun, and building the road just outside Chiang Mai that leads up the side of Doi Suthep to the temple at the top. These he achieved through a combination of lay donations and volunteer labor (yet another finger in the eye of the Siamese), establishing the monk's reputation as a charismatic leader of people in addition to his religious leadership. Khruba Srivichai's "public works" approach to local modernization also drew a stark contrast to the exploitation and neglect many Lan Na people experienced at the hands of the Siamese authorities (and their tax collectors) in that turbulent era.

In addition to his massive popular following, Khruba Srivichai gained a passionate backing from local monks who chafed at Bangkok's attempts to extend spiritual authority over the local Buddhist sangha, preferring Khruba's charismatic ordination instead. The revered monk's practice of Lan Na-style "forest" Buddhism held great appeal to local laypeople and monastics alike, as it functioned as an expression of both cultural and religious resistance to incipient Siamese hegemony. To Siamese authorities, Khruba Srivichai's authority was dangerous for precisely the same reasons. The monk was detained and released several times by the Siamese authorities and ultimately stripped of his titles; he was even summoned to appear in Bangkok in both 1920 and 1935 to answer to Siam's Supreme Patriarch himself before being allowed to return to Lan Na.[68]

Khruba Srivichai's rise corresponded to the massive social and economic changes occurring in Lan Na communities as a direct result of Siam's new administrative and tax practices. The 1900 Ministry of the Interior Order, which established the *monthon tawan tok chiang nua* (northwest circle), completely overhauled the civil service structure in the north. Positions, salaries, and responsibilities were reorganized, and while northern nobles could still apply, "many were not invited since the King wanted . . . only the talented."[69] As taxation shifted from in-kind payments made to local rulers to a flat four baht "head-tax" by often extortive tax collectors, villagers and farmers felt increasingly oppressed by new Siamese systems. Although villagers unable to pay the tax were allowed to perform corvée labor instead, Siamese officials frequently abused the practice well beyond the legal twenty-day limit, deploying thousands of "free" local laborers in the building of roads, bridges, and canals.[70] Karen locals recalled that sometime between 1900 and 1910, "they and some Thai killed the first Nai Amphoe of Ping Tai (now Hot) district over taxation matters," which "prompted a Thai armed presence and the moving of the District seat to Chiang Khoeng village."[71] Droughts and famines throughout the 1910s compounded the situation, with moneylenders seizing fields from farmers whose crops had failed, and rice shortages forcing many families to leave.[72] In 1912, a Lampang observer reported that "I have heard a lot about the wholesale removal of households from some parts of Monthon Phayab. . . . Some of the people have gone over to the Burma side, others have only changed into another Quang. The reason is partly scarcity of rice or good land for cultivation, partly the taxes and the forced labour, making of roads, etc."[73] Chiang Mai suffered flooding in 1909, violent hailstorms that damaged homes and injured villagers in 1913 and 1914, and earthquakes that shook the region in 1912 and 1914. As if these tribulations were not enough, epidemics of malaria and smallpox also ravaged the region from 1912 to 1913, anthrax and rinderpest devastated villagers' working animals in 1914 and 1915, and influenza swept through in 1918.[74] The vector for these maladies was frequently identified as traffic coming from Bangkok by boat or train, which, as Bowie notes, "may describe a fact, or instead reveal anti-Bangkok sentiments."[75]

As the social fabric that had held Lan Na together for centuries seemed to unravel, the region became fertile ground for millenarian social movements—and figures like Khruba Srivichai—that promised the return of cosmic order. The mythology of Khruba Srivichai in particular locates the monk in a lineage of Lan Na *tonbun* (which translates to "having merit" or, roughly, "saint"), and sees him as Maitreya, an incarnation of the future Buddha. Lan Na Buddhist legend privileged the magical future Buddha over the original Gautama Buddha, and

predicted that Maitreya's return would follow a series of disastrous events, which included "kings oppressing the populace, rampant unrestrained warfare, crop failure, natural disasters, famine and the unleashing of evil spirits."[76] Khruba Srivichai's construction and renovation activities—restoring significant religious monuments as well as creating important new overland arteries for transportation and communication—represented a positive response to the devastating changes of the era. By 1920, Khruba Srivichai was, according to Sommai, "attracting huge crowds wherever he went, and rumors of his magical protective powers (*waetmon khathaa*) mushroomed. People spread turmeric on his feet and saved the white cloth on which he had walked for worship and protection."[77] During his detention in Chiang Mai prior to being sent to Bangkok in 1920, "there were nearly a thousand and on hardly any day was [sic] there less than a hundred to see him."[78] When Khruba Srivichai returned to the north later that year, his journey was accompanied by throngs of thousands along the way, much as Dara Rasami's 1909 visit was—except that Khruba Srivichai had neither the royal financial support nor official arrangements that had smoothed the way for Dara's journey.

In today's northern Thai politics, the memories of Khruba Srivichai and Phra Rachaya Chao Dara Rasami stake out opposite ends of the political spectrum. The persistence of Khruba Srivichai's memory as a champion of the people has proved to be an important Lan Na touchstone for the campaigns of both Thaksin Shinawatra and his sister, Yingluck, who launched her successful 2011 bid for the office of prime minister at Khruba Srivichai's shrine. The intentional alignment of such regional populists with the rebel monk's memory makes sense, given the Red Shirt movement's appeal to the people at the peripheries over the traditional bureaucratic politicians in the center of Bangkok.

Dara Rasami's place in local memory, alternatively, sits at the more conservative, royalist end of the spectrum. Contemporary fans romanticize her fabled commitment to "duty over love," and celebrate her alignment with cultural tropes of successful motherhood and matronage. The positive historical associations with her 1909 visit and the massive economic boost it brought to Chiang Mai compete with problematic activities like her relocation of Chiang Mai's royal remains from the riverside to a new cemetery at Wat Suan Dok. That Dara achieved a queenly rank and maintained close relationships with Siamese royals in Bangkok continues to provide local elites—particularly the "na Chiang Mai" and other "city" families—with an insider figure that links them directly to the central Thai royal family. Dara's internalization of the siwilai worldview and associated cultural practices form the foundation of local elites' notions of

their role in both creating and maintaining "*ur*-Lan Na" culture, tradition, and history—even though Dara's is essentially a story of Lan Na's submission to Siamese domination.

Yet, at the same time, Dara's contributions to cultural preservation open avenues to proponents of Lan Na identity that resist the domination of central Thai identity in the region—particularly via local textile traditions. Wearing the phasin on Fridays has become accepted practice in Chiang Mai and its environs, and various Lan Na communities have found economic advantage in reviving the local weaving industry.[79] Thus Dara Rasami's legacy—and memory—remain ambiguous and open to appropriation at either end of the Thai political spectrum. By embodying an alternative—possibly elitist—approach to "Lan Na-ism" when compared to that of Khruba Srivichai, Dara Rasami serves simultaneously as an insider and outsider figure to both Chiang Mai's local identity and Bangkok royalty. At the same time, her status reveals how the construction of Lan Na identity remains a focal point of local resistance to projects that attempt to impose hegemonic central Thai politics and identity.

Dara Rasami's position as a "Siamized" member of the Bangkok elite—and her adoption of the Siamese siwilai worldview—alerted her to the value of Lan Na's ethnic difference, and provided her the tools with which to actively preserve and promote it. The Siamese adaptation of *Madame Butterfly*, *Sao Khrua Fa*, serves as an exemplar of how Bangkok crypto-colonially exoticized Dara Rasami's native culture; yet its wild popularity also demonstrated to Dara Rasami the potential value of self-orientalizing her Lan Na-ness as a means of preserving local culture and traditions in her home region. Her promotion of dance, music, and textile arts in particular reflects the keen awareness she gained from the popularity of *Sao Khrua Fa* as to which Lan Na cultural elements central-plains Thai considered unique. At the same time, Dara Rasami's matronage of practices like medicine, agriculture, and historical research demonstrated her desire to preserve valuable aspects of Lan Na's cultural difference in anticipation of future economic and social change. In addition to reflecting Dara Rasami's enculturation to the siwilai worldview, it is also emblematic of the particularly modern form of matronage that she practiced.

Intertwined Fates

Monarchy, Women's Bodies, and the Thai State

A S WITH SO MUCH of history, the timing of events sometimes outweighs all else. (Perhaps this historian's perspective is influenced by the current state of affairs dictated by the COVID-19 crisis of 2020.) Reflecting on the progression of Thai history since Dara Rasami's death, the shaping of Thailand's monarchy, gender relations, and nation-building reveal themselves to be intertwined in ways that demonstrate her story's ongoing relevance to Thai culture and politics. The abdication of the Thai monarch in 1933 began a long period of kinglessness in Thailand, during which new marriage laws were enacted, and authoritarian leaders began to formulate new ways of imagining the Thai state that depended on particular ideas of gender relations. In the present moment, King Vajiralongkorn's appointment of the first royal concubine in nearly a century[1] sparked a renewed global interest in royal Thai concubinage, and points once again to the ways in which gender, nation, and the monarchy continue to be interwoven in the Thai context. Allow me to trace a few historical points that will make that relationship clear.

Polygyny, Women's Bodies, and the Thai Nation

During King Chulalongkorn's reign (1868–1910), Thai royal concubinage reached its zenith—153 consorts—despite the fact that polygyny itself had become a bone of contention between Siam and the West. While the interested reader can look to the scholarship of Tamara Loos (*Subject Siam*) and Scot Barmé (*Woman, Man, Bangkok*) for much more nuanced and in-depth analysis than is possible here, I will attempt to provide a brief sketch of how the polygyny debate played out in Siam, particularly as it related to royal concubines.

Siamese elites first became aware of polygyny's potential to be "ideologically deployed by foreign powers as evidence of Siam's uncivilized status"[2] during the reign of King Mongkut (r. 1853–68). Although Mongkut considered abolishing

polygyny as he negotiated unequal treaties with various Western powers in the 1850s, he ultimately declined, defending polygyny as part of a royal practice he saw as intrinsic to Buddhist monarchy, and culturally distinct—but morally parallel—to European practices. At the same time, Mongkut relaxed some of the rules that made palace consorts appear to be "enslaved for life" to Anna Leonowens, allowing unhappy consorts to exit palace life if they so desired (provided they had not yet borne any children to the king). Both Mongkut and his son, Chulalongkorn, ultimately maintained royal polygyny for its "integrative, alliance-making, and legitimating functions."[3] Thus the practices of royal Siamese polygyny continued on, much as they had for centuries, up until the end of King Chulalongkorn's reign in 1910.

During the latter part of Chulalongkorn's reign, however, royal concubines' political currency declined precipitously in the 1890s as he fundamentally reshaped the Thai state through a host of administrative reforms that centralized Bangkok's control over the kingdom's peripheral territories. These policies effectively eliminated the need for political marital alliances, redefining Thai territories by the drawing of maps (see Thongchai Winichakul's brilliant *Siam Mapped* for an exploration), and assigning Siamese administrators to govern each and every province according to Bangkok's guidance. Besides these administrative changes, monarchs themselves came out against polygyny on moral grounds. Chulalongkorn's his son and successor, Vajiravudh (r. 1910–25), was outspoken in his criticism of polygyny and resisted taking more than one wife until near the end of his reign, though he ultimately took three more consorts in an attempt to produce a male heir. Nonetheless, a definition of legal marriage continued to elude the ministers charged with fleshing out Siam's new legal system. Meanwhile, as Bangkok's market economy and middle class began to flourish in the first decades of the twentieth century, the debate about marriage and polygyny moved from elite circles into the popular press. There, concerns ranged from anxiety over the rise of prostitution to worries about the potential problems posed by new monogamy laws (i.e., illegitimacy of children, the erosion of women's rights, etc.).

The growing Thai middle class viewed elite polygyny in particular as reflecting "the abuses of officialdom and the backwardness of the state."[4] As Barmé notes, Thai writers of the 1910s and 1920s mirrored Western critiques of polygyny as a decadent and illegitimate practice, castigating elite polygynous men as "living an idle, licentious existence, immersed in pleasure while contributing nothing to the wider community."[5] But despite these popular debates and efforts at reform—which included instituting marriage regulations for state officials—a new national marriage law was never formulated while an absolute monarch occupied

the Thai throne. It was only after the change of government in 1932—followed by the abdication of King Prajadhiphok in 1933—that the new constitutional government put a national marriage law in place. In the long period during which Thailand had no monarch on the throne in Bangkok (1933–46), various military and civilian leaders vied for power as much of the Thai populace struggled to understand what the term "constitutional monarchy" really meant. This vacuum opened the way for "strong man" politicians like Field Marshal Phibun Songkram and his public relations minister Luang Wichit Wathakan, who embarked on a massive campaign of nation-building activities and public relations initiatives.[6] The Phibun regime of the middle 1930s and early 1940s explicitly promoted a nuclear, heteronormative family model among Thai bureaucrats, encouraging them to "kiss their wives goodbye at the door" as they went off to work in the morning. In 1935, the new government finally enacted a national marriage law: only one marriage could be legally registered. Under the new law, it was still technically legal for a man to keep other wives (even if they were not legally recognized). But only the first wife held any rights to property in the event of divorce, and the offspring of lesser wives could only be legally recognized if the father opted to do so. Interestingly, royal polygyny was not mentioned—perhaps due to the fact that prior kings had already become monogamous, or perhaps because there was no king on the throne in that moment to whom it would apply. In any case, we can now see the significance of this omission in the present.

While the place of palace women like Dara Rasami in Thai society was assured, the end of royal polygyny spelled the end of significant political power for Thai women. Although women never disappeared entirely from Thai politics, their roles changed significantly—from actors to supporting players. As the Thai struggled to compete successfully in the global race to define their nationhood in the 1930s to mid-1940s, elite women faded from the political center even as much of the work of embodying the new nation fell to its female citizens.[7] In 1939 Phibun instituted a broad set of cultural mandates intended to bring the mass population—not just the elites—into line with the requirements of Western modernity. If, as Maurizio Peleggi has noted, "embodying modernity and nationality was a self-improvement task for fin de siècle Siamese monarchs,"[8] the "self-improvement" efforts of Phibun's tenure devolved instead onto the bodies of common women during the middle twentieth century. Among the twelve total cultural mandates Phibun instituted, women's participation was particularly important to Mandate Ten, which prescribed "modernizing" the dress of the general Thai populace as part of establishing Thailand's nationhood.[9] More concrete instructions for carrying out Mandate Ten's edicts were provided in eight

supplements issued in the spring and summer of 1941 addressed to "Thai Sisters" and "Esteemed Ladies Everywhere."[10] These edicts directed Thai women to grow out their hair in more feminine styles; stop wearing trouser-like chongkrabaen in favor of wrap skirts; and don blouses or shirts instead of wearing a simple wrapped upper garment or going bare-chested.[11] A few months later, additional measures—wearing hats and gloves—were also added to the list. Thus the task of "embodying the nation" was shifted from the bodies of elite palace women to the bodies of all Thai women, regardless of location, age, or class.[12]

Unsurprisingly, changing the daily dress of the mass populace proved more difficult to enforce than to mandate. While the new policies shifted the burden of culturally representing the nation from elites to commoners, leaders put on a series of elite events at Suan Amphon modeled on King Chulalongkorn's 1905 winter festival, which was itself a fundraising event for the construction of Wat Benchamabophit. These events emphasized the new dress mandates and required attendees to wear modern dress or else be denied entry and accused of "non-Thai" behavior.[13] They also turned to former palace women of Dara Rasami's generation to model the new styles in an attempt to harness their remaining power as cultural elites. For example, Chao Khun Phra Prayoon Wong—then nearly ninety years old—was happy to serve as an ambassador of the modern style, "presid[ing] over many social functions and prize-giving ceremonies."[14] Other women, however, were somewhat less than enthusiastic. When they asked Dara Rasami's old friend Queen Savang Vadhana to be photographed wearing a hat, she replied, "Today I am hardly myself anymore, now you are even interfering with my head. No! If you really want me to put on a hat then cut my head off and put the hat on it yourself."[15]

The mandates ultimately took root more deeply in Thailand's center than at its peripheries—but especially in the capital city, where the growing number of government workers and bureaucrats swelled the ranks of Bangkok's nascent middle class. At the same time, expanding capitalism, which put a wider range of goods within the reach of the middle-class consumer, elided Siamese sumptuary laws. Indeed, the more luxury consumer markers became available, the more eager middle-class Bangkokians became to obtain and display them as markers of their own membership among the modern Thai elite.

Nonetheless, these attempts by the state to forge a modern Thai nation on the compliant bodies of its citizens never succeeded in erasing the significance of royal blood from Thai society. While many material markers of class—handbags, designer clothes, expensive cars—can be purchased, lineage cannot. Even today, the high society pages of newspapers and magazines are full of Kridakorns, Amatyakuns, and Na Ayutthayas—familiar surnames that denote noble bloodlines.

The social (and inherently political) significance of these family lineages persists in Thai society, in a manner analogous to the persistent prestige of the British royal family (an alignment many Thais see as unambiguous). In contrast to the British example, however, the level of prestige afforded these families by virtue of their links of royal blood with the Thai king himself has no strict analog in Western societies. Though the intervening decades of capitalism have served to create new wealth, particularly among Sino-Thai trading families, the tightly interlocking circles of elite patrons and clients at the top of Thai society continue to persist, rendering contemporary Thai society in many ways nearly as hierarchical today as it was in the past. Indeed, the royalist "yellow shirts"—whether of royal descent or merely aspiring to it—now impart their legitimacy to the ruling military elite. In a striking contrast to Phibun's policies, the political discourse of today's Thai royalists often falls back on a classist critique in which the non-eliteness of populist ("red shirt") activists and politicians—their not-quite-siwilai—is cited as the reason for their unfitness to participate in democratic self-rule. Western critique of these discourses is often met with an exceptionalist counter-narrative that asserts the existence of a unique, Thai-style democracy whose authoritarian orientation is simply unintelligible to culturally clueless outside observers.[16]

Reforming Polygyny and Its Unintentional Consequences

Following on the heels of his father's long, monogamous reign (1946–2017), King Vajiralongkorn's 2019 appointment of the first royal consort in nearly a century sparked surprise and curiosity both inside and outside Thailand.[17] Given that phasing out royal polygyny was once seen as an important way to demonstrate Thailand's arrival in the global category of siwilai, what could the present-day reinstitution of palace polygyny signify? Once again, I suggest that the answer reflects the interwoven fates of gender, monarchy, and the Thai nation.

Part of the answer can be found in Thailand's crypto-colonial history. In places where ruling elites became aligned with colonial overlords, polygyny made an easy target for anticolonial sentiment. Many neighboring Asian nations that had traditionally practiced royal polygyny either lost their monarchs (for example, the 1885 exile of Burma's King Thibaw and Queen Supayalat to India by the British) or ousted them during anticolonial movements (as happened in China, etc.). The fact that Siam never had a foreign colonial power to throw off prevented polygyny from being deployed "as part of a 'tradition' used by local indigenous elites against a colonial overlord."[18] Quite the opposite: if (royal) polygyny was a legitimate cultural practice sanctioned by Thai Buddhism, Thai

elites felt that jettisoning the practice would amount to an admission that Christianity is superior to Buddhism.[19] Among the growing Thai middle class, vigorous public debate on the topic in the 1910s and 1920s encompassed both critique and defense of polygynous practices. But the marriage law finally enacted in 1935 managed to duck the issue. Rather than outlawing polygynous relationships, the law merely limited recognition of marital relationships to the first wife registered in a polygynous household, leaving the welfare and inheritance rights of subsequent consorts and their children to the whims of their male patrons. As the market economy picked up momentum in Thai society, it also encouraged the mapping of polygyny onto eliteness: any man with enough money could keep multiple women in their households to demonstrate their financial wherewithal and ability to participate in a lifestyle previously available only to noble elites.

In the intervening decades, both Western feminism and sex tourism have greatly affected Thailand's gender landscape. In "respectable" society, middle-and upper-class Thai women aspire to find a husband uninterested in engaging in multiple relationships, while at the lower economic rungs of society, being a *mia noi* (lesser wife) or a Bangkok sex worker is seen as a lucrative life choice. The polygynous practices of today have become ever more transactional, as economically disadvantaged women seek out "sugar daddies" who are happy to rent them apartments and buy them cars—but not bring them into their household. (And the trope of the suspicious wife who is horrified to discover her husband's mia noi has become a staple of Thai soap operas.) The disposable nature of these extramarital relationships has created a spatially distributed form of polygyny, whereby men can keep multiple women under multiple roofs with no formal social or financial obligations to the women involved (much less any offspring of said relationships). Despite the best intentions of feminists and reformers, the legal emphasis on monogamy has not improved the position of women in Thai society.

Bringing Royal Polygyny Back

Why has the practice of royal polygyny resurfaced at this particular historical moment? After years of rumors surrounding the former prince's personal life, his multiple consorts have recently begun to emerge into the public eye. One eyewitness described to me how one of the new king's current "harem" openly introduced herself as one of a dozen of his "concubines" who participated in the royal coronation ceremonies in May of 2019.[20] I suggest that the new monarch's reintroduction of royal concubinage constitutes an assertion of Thai-style monarchy, and a return to traditionalist notions of absolute monarchy as the foundation of the nation.

This throwback to absolutism makes a neat parallel to the notion of Thai-style de-mocracy, a favorite deflection technique utilized by ultraroyalists against Western critics of elite-driven Thai politics, particularly the multiple military coups and "astroturf" protests that have riven the country since 2006. Whereas Chulalong-korn himself was intensely concerned with Western perceptions of Thai siwilai, the current revival of royal polygyny reflects a lack of concern about international reaction; rather, the government's focus appears to be on shaping the perceptions of the monarchy by the Thai populace at large. The restoration of royal polygyny is entirely consistent with the current attempts on the part of the military ruling class to both appease the current monarch and make royal absolutism fashionable again.

In the same vein, a related effort to reinvigorate a peculiarly retrograde form of Thai-ness harkens back to Phibun's cultural dress mandates: the current gov-ernment has updated and reprised King Chulalongkorn's 1905 winter festival once again. Entitled "Love and Warmth at Winter's End" (a direct reference to Chulalongkorn's 1905 "Winter's End" celebration rather than the Phibun-era events), the 2018 festival utilized the theme of "Return to Traditional Cloth-ing."[21] The current king, Rama X, himself opened the events clothed in the raja pattern style of dress fashionable during Chulalongkorn's later reign. Holding the event at the central complex of Suan Amphon and Ananta Samakhom Hall additionally reaffirmed the link between the past(s) and present. The National Council for Peace and Order (NCPO), the euphemism for the military junta in power since the 2014 military coup, announced that participants were encour-aged—but not required—to wear "polite" Fifth Reign–era outfits to attend (and rentable clothes were available at the door).[22] The event simultaneously fulfilled the military government's stated goal of encouraging "happiness" while also al-lowing the new king literally to clothe himself in the garb of King Chulalong-korn's era. The popularity of the event was expanded across the nation as local businesses and attractions offered discounts to citizens who showed up in Fifth Reign outfits.[23] The event was so successful that it was reprised nine months later, from December 2018 to January 2019. Selfies and photographs of event participants filled up Instagram and Pinterest accounts, showcasing fun-loving young elites resplendent in luxuriantly updated versions of traditional Thai garb.[24] Such cultural events attempt to fuse together the Thai monarchy and the contemporary nation, making *ratta niyom* (the Phibun-era term for "official state customs") an elite cultural preoccupation by referencing a traditional elite version of Thai-ness drawn unironically from the late nineteenth century.[25]

A possible goal of these events is to obtain buy-in from the middle and elite classes to an opulent, after-party image of "happiness" (an updated version of

siwilai?) available to the compliant subjects of a paternalistic Thai monarch in the mold of "tradition," however nominal. The purpose of such events is less to attempt to redefine the monarch, than it is to broaden the appeal of the conditions of subjecthood: to gild the cage, so to speak, in an era when economic growth (for some) occurs in parallel with tightly restricted political expression.

The reintroduction of royal polygyny at this historical moment speaks to the contemporary way in which women's bodies are central to formulations of the Thai state. Whereas royal consorts once embodied political ties between the center and peripheries, they now embody the personal prerogatives of an absolute ruler, and the military government's interest in emphasizing the absolutist parallels between the eras and practices of Rama V and Rama X. To outsiders, royal polygyny demonstrates to a global audience that outsiders' opinions of monarchic practice matter far less than the Thai monarch's freedom to exercise his royal prerogative to make his polygynous lifestyle public. In that sense, the brazen revival of these practices signals the king's aspiration to membership in the same autocrats' league as Kim Jong Un and Donald Trump—leaders famous for their "do as I say, not as I do" modes of rule.

The rehabilitation and reinstatement of Rama X's newest consort, coming a year after her very public removal, stands in stark contrast to the fates of his previous wives and children.[26] Yet the risks to today's royal consorts and spouses are even greater than in the past, when palace women could at least continue to live in the palace after a disgrace, even if only in chains. Nonetheless, royal polygyny still presents risks to its practitioners, whether from without or within, palace or nation. In describing the popular Thai debate about elite polygyny of the early twentieth century, Loos presciently commented that "polygyny's former political function of integrating the kingdom was drastically flipped: now it served to dis-integrate the nation."[27] It is possible that royal polygyny will serve that purpose anew, depending on how the practice is perceived by the increasingly dissatisfied youth of the nation now demanding reform of the monarchy, reviving and reaffirming Thailand's democratic past.[28] As of this writing (September 2020), young Thais had taken to the streets of Bangkok yet again for fresh rounds of protest, but this time without the tell-tale "colors" typically flown by either the royalist or populist factions, and with nary but memes and signs bearing the nonobjectionable slang term "chai" (street speak for "yup") as their armor.[29] In the current battle to define Thai-ness, the fusion of past, present, gender, and nation remain central forces—but whose version of siwilai will triumph remains far from certain.

Chapter 1. Introducing Lan Na, Siam, and the Inland Constellation

1. Born in 1838, Duleep Singh was crowned the ruler of the Punjab at the age of five and taken from his mother to be raised by British missionaries at age ten, after which he converted to Christianity. He was brought to London in 1854 bearing the Koh-I-Noor diamond and Golden Throne as gifts for Queen Victoria. You can learn more about him and his descendants here: http://www.duleepsingh.com/Biography.

2. Lysa, "Palace Women at the Margins of Social Change," 310–24.

3. Prince Damrong, one of King Chulalongkorn's many half brothers, maintained a total of eleven wives and consorts in his household, ultimately producing thirty-three children. See Finestone, *A Royal Album*, particularly chapter 12 on Damrong's descendants, who bear the surname "Diskul."

4. These works include Wyatt, *The Politics of Reform in Thailand*; Vella and Vella, *Chaiyo!*; Bunnag, *The Provincial Administration of Siam*; Greene, *Absolute Dreams*; and Peleggi, *Lords of Things*.

5. Scott, *Gender and the Politics of History*.

6. See Alfred Habegger, *Masked: The Life of Anna Leonowens, Schoolmistress at the Court of Siam* (Madison, WI: University of Wisconsin Press, 2014); and Susan Morgan, *Bombay Anna: The Real Story and Remarkable Adventures of the King and I Governess* (Berkeley, CA: University of California Press, 2008). Anna went to great lengths to obscure the facts of her birth, which occurred in India, not—as she claimed—in England; while she was employed by King Mongkut to tutor his children part-time in the English language, she was never resident inside the palace as a governess would have been. In fact, Anna also socialized mainly with American residents of Bangkok rather than Britons, as they would have found the flaws in her claims as to her English birthplace and schooling in short order.

7. See Grewal, *Home and Harem*.

8. The well-known musical *The King and I* was adapted from Margaret Landon's 1944 *Anna and the King of Siam*, which was in turn a novelization of Leonowens's *English Governess* text. Both the musical and all film versions have been banned in Thailand, including the 2000 film version starring Jodie Foster and Chow Yun Fat.

9. While Hong Lysa and Tamara Loos have fruitfully mined the documents on palace judicial cases, there is undoubtedly enough information in the archival files on illness

and death among palace women of the Fifth Reign to provide a scholar of medical history enough material for a fascinating thesis or book. See National Archives of Thailand, Bangkok (NAT) R.5, Krasuang Wang, R.5 W.99, Bettalet.

10. Sulak, *Samphat Mom Chao Jongjitrathanom Diskul.*

11. See Thongchai, *Siam Mapped.*

12. I borrow this term from Thongchai's 2000 article, "The Others Within."

13. Gayatri Chakravorty Spivak's concept of "strategic essentialism" first appeared in her 1985 essay "Subaltern Studies: Deconstructing Historiography."

14. Current King Vajiralongkorn (r. 2018–) appointed the first royal consort in nearly a century—former nurse and bodyguard Sineenat Wongvajirapakdi, age thirty-four—in August 2019. Though she was stripped of the rank just three months later on grounds of "misbehavior and disloyalty," she was reinstated in August 2020. For more, see https://www.dailymail.co.uk/news/article-7313849/Thai-king-anoints-army-nurse-mistress-official-concubine-ceremony-wife.html, https://www.cbsnews.com/news/king-maha-vajiralongkorn-of-thailand-strips-his-consort-of-royal-titles-disloyalty-today-2019-10-21/, and https://www.bbc.com/news/world-asia-53994198.

15. Sarassawadee, *History of Lan Na.*

16. Stanley Jeyaraja Tambiah elaborates on the concept of the "galactic polity," in which the traditional Southeast Asian city-state model, called a *mandala*, focuses on the power of the ruler as it radiates from the capital at its center, rather than the state's outermost boundaries (which were often loosely defined and could even overlap with those of neighboring mandala states). See Tambiah, *World Conqueror and World Renouncer.*

17. I will follow Tambiah's usage of the term *muang*, which "refers to centered or center-oriented space (as opposed to bounded space) and typically stands for a capital or town or settlement with the surrounding territory over which it exercised jurisdiction" (*World Conqueror and World Renouncer*, 112).

18. At the same time, while Lan Na made up part of the Inland Constellation, it should not be read as identical to it. The Inland Constellation I propose has included at various times Lan Na, Lan Xang, the Shan States, and parts of Sipsòng Panna in southern China.

19. These rivers include the Nan, Yom, Wang, and Ping rivers, which provide a continuous waterway between Chiang Mai and Bangkok (during the rainy season). The Ping River was used by the Chiang Mai nobles (and Dara Rasami) in their semiannual travels between Chiang Mai and Bangkok.

20. See also Bowie, "Unraveling the Myth of the Subsistence Economy," 797–823.

21. This route was known as *senthang baicha* (the way of tea). See Foon Ming, Grabowsky, and Renoo, *Chronicle of Sipsòng Panna*, 34; see also Freeman and Ahmed, *Tea Horse Road.*

22. Forbes and Henley, *The Haw: Traders of the Golden Triangle.*

23. Chinese chronicles even referred to Lan Na as the "land of the sticky-rice eaters." See Foon Ming, Grabowsky, and Renoo, *Chronicle of Sipsòng Panna*; and Ratana, "Social Strategies in Creating Roles for Women in Lan Na and Lan Sang." See also the excellent Sithu, *Zinme Yazawin*—a chronicle that details the role of cosmology in the siting of several ancient cities in the region.

24. Reid, *Southeast Asia in the Age of Commerce.*

25. This pattern of out-marriage of royal sons to the daughters of local nobles is consistent with Lan Na's cultural pattern of matrilocality, and would be utilized later by Lan Na rulers as well (which will be seen later in this chapter). Also see Wijeyewardene, "Northern Thai Succession," 285–92.

26. Lan Na maintained this nickname until it was colonized by the Burmese in the sixteenth century, after which it became known as the "land of 800 stockades." See Foon Ming and Grabowsky (in collaboration with Aroonrut), *Lan Na in Chinese Historiography*, 102.

27. Elements of Burmese culture that are still visible in Lan Na's culture today include the use of *luntaya acheik* textiles in local dress; the wearing of a flower behind one ear in both men's and women's hairstyles; foodways including *mieng,* curry, and certain noodle dishes such as *khao soi*; and the orthography of local language (which shifted from more rectangular characters to more circular ones following the arrival of the Burmese).

28. Grabowsky notes that Prince Damrong's *Our Wars with the Burmese* (Bangkok, Thailand: White Lotus, 1977) ignores Kawila's role in the victories, instead crediting *Phraya* Chakri's troops and leadership. Thus the reestablishment of Lan Na was co-opted to become part of the founding narrative of the Siamese nation-state. See Grabowsky, "Forced Resettlement Campaigns," 56.

29. From the *Thamnan Sipha Rachawong (Chronicle of the Fifteen Kingdoms),* as cited in and translated by Grabowsky, "Forced Resettlement Campaigns."

30. See Kraisri, "Put Vegetables Into Baskets, and People Into Towns."

31. Grabowsky, "Forced Resettlement Campaigns," 59.

32. See Sarassawadee, *History of Lan Na*, and Grabowksy, "Forced Resettlement Campaigns," for slightly different periodizations of these waves.

33. Sarassawadee, *History of Lan Na*, 133.

34. See Grabowsky, "Forced Resettlement Campaigns."

35. Sipsòng Panna's lowland peoples were ethnically Tai Lüe. See Foon Ming, Grabowsky, and Renoo, *Chronicle of Sipsòng Panna.*

36. Grabowksy, "Forced Resettlement Campaigns," 74.

37. Grabowksy, "Forced Resettlement Campaigns," 74.

38. Grabowksy, "Forced Resettlement Campaigns," 76.

39. The language of the Yuan ruling elite was shared by the multiethnic khon muang. Today it is known by local residents as *phasaa muang* (muang language) or *kham muang* (muang words), and it is still widely spoken, although central Thai has been the official language in the region since the 1930s.

40. See Grabowsky and Turton, *The Gold and Silver Road of Trade and Friendship*, 5.

41. See Maha Sila Viravong's *History of Laos* (New York: Paragon Book Reprint Corp., 1964) for a persuasive argument that it was the Siamese preoccupation with a possible British intervention that encouraged Chao Anou to make his attempt; Mayuri and Pheuiphanh argue that there was never a Chao Anou rebellion, but only a "war between Bangkok and the Lao." More recently, Grant Evans cast the episode as part of an ongoing "competition for resources in the Mekong basin" between Siam, Laos,

Cambodia, and Vietnam in his *A Short History of Laos*. See Mayuri and Pheuiphanh's *Chao Anou (1767–1829): Pasason Lao lae Asia Akhane*, Vientiane, [n.p.]: 2010; and *Paths to Conflagration: Fifty Years of Diplomacy and Warfare in Laos, Thailand, and Vietnam, 1778-1828*, Ithaca, NY: Southeast Asia Program Publications, Cornell University, 1998.

42. Evans, *A Short History of Laos*, 28–29.

43. According to Sarassawadee, *History of Lan Na*, even though Chiang Mai had supplied troops to the Siamese to fight against Chao Anou, there were still nobles in eastern Lan Na who sympathized with the Lao ruler.

44. Sarassawadee, *History of Lan Na*, 8. The earliest letter, arriving in March of 1825, could have come from either the ailing Khamfan or his successor, Phuttawong, who was known for his more conciliatory attitude toward Ava (see Brailey, "The Origins of the Siamese Forward Movement").

45. Figures from British annual reports, as cited in Grabowsky and Turton, eds., *The Gold and Silver Road of Trade and Friendship*.

46. Grabowsky and Turton, eds., *The Gold and Silver Road of Trade and Friendship*, 78.

47. For an in-depth exploration of this and the subsequent era in Burma, and the ecological exploitation of Burmese forests that also occurred under British imperialism there, see Charles Lee Keeton, *King Thebaw and the Ecological Rape of Burma: The Political and Commercial Struggle between British India and French Indo-China in Burma, 1878–1886*. Delhi: Manohar Book Service, 1974.

48. See Sarassawadee, *History of Lan Na*, 157–59.

49. Thipakorawong, *Phongsawadan Ratanakosin Rachakan thi 3*, 140–43.

50. According to Sarassawadee, the conflict arose because the *rajabut*'s troops reached the city first and attacked immediately in a bid for glory; when this attempt failed, the *uparat* deliberately delayed sending reinforcements due to his antagonism toward the rajabut. Lan Na's King Mahotraprathet even complained to Bangkok about the situation, which led to King Mongkut's 1856 participation in the selection of the next Lan Na king—ostensibly to prevent such problems in the future. Sarassawadee, *History of Lan Na*, 144–45.

51. Sarassawadee, *History of Lan Na*, 163.

52. Sarassawadee, *History of Lan Na*, 163.

53. Sarassawadee, *History of Lan Na*, 7.

54. Sarassawadee, *History of Lan Na*, 164.

55. National Archive of Thailand (NAT), Bangkok, Thailand: R.5, M 16/10: Report of Phra Ong Pen's Journey to Review Forestry, November R.S. 112 (A.D. 1893).

56. Sarassawadee, *History of Lan Na*, 169.

57. Sarassawadee, *History of Lan Na*, 169.

58. Brailey, "The Origins of the Siamese Forward Movement," 141.

59. Brailey, "The Origins of the Siamese Forward Movement," 141.

60. Brailey, "The Origins of the Siamese Forward Movement," 201.

61. British National Archives (BNA), Kew, United Kingdom, Foreign Office Records (FO) 69/55: Journal Kept by Captain Lowndes, Superintendent of Police, British Burma, Whilst on a Mission to the Zimme Court (Lowndes's Journal), March 27 to May 30, 1871.

62. While it is not within the scope of this chapter to explore these events fully, the interested reader may find a complete account of the British-Siamese diplomatic affairs surrounding the Chiang Mai treaties in Brailey, "The Origins of the Siamese Forward Movement," and also Ratanaporn, "Political, Social, and Economic Changes."

63. Ratanaporn, "Political, Social, and Economic Changes," 182.

64. Ratanaporn explains that the British Indian government had "long considered Thailand as part of its sphere of interest particularly since problems there mostly concerned British subjects. [And since] they also frequently disagreed with [Bangkok consul] Knox's actions... the Calcutta officials responded delightedly" to the opportunity to refer unresolved or contested legal cases from Chiang Mai to Burma. Ratanaporn, "Political, Social, and Economic Changes," 174.

65. Brailey, "The Origins of the Siamese Forward Movement," 215.

66. BNA, FO 628/157, Memo on Taxes and Monopolies by Gould, April 9, 1885. As we will see later in this chapter, the rice whisky monopoly was quickly rescinded through the efforts of the spirit-medium sister of the queen, Chao Ubonwanna—but such spirit-induced interventions were quickly outlawed by the Siamese.

67. Ratanaporn, "Political, Social, and Economic Changes," 207.

68. Ratanaporn, "Political, Social, and Economic Changes," 205.

69. Ratanaporn, "Political, Social, and Economic Changes," 205.

70. BNA, FO 69/55, Lowndes's Journal, 1871.

71. BNA, FO 628/10/157, Hildebrand's Report, 1875, 19.

72. Ratanaporn, "Political, Social, and Economic Changes," 210.

73. BNA, FO 628/10/157: Progs. No. 25-12. From the Commissioner of the Tenasserim Division, May 31, 1875.

74. Ratanaporn, "Political, Social, and Economic Changes," 212.

75. Ratanaporn, citing Sinlapakon, *Prachum Phongsawadan*, 127–29. *Phra* Narin made sure these envoys also reported to Bangkok on their return in January 1875. See Brailey, "The Origins of the Siamese Forward Movement."

76. Ratanaporn, 213, citing *Siam Repository*, 461–62; Edwardes's report of June 17, 1875 in BNA, FO 69/62.

77. See Sarassawadee, *History of Lan Na*, 171.

78. Brailey, "The Origins of the Siamese Forward Movement," 216.

79. Engel and Reynolds, *Code and Custom in a Thai Provincial Court*, 32.

80. Ratana Pakdeekul notes, "It is remarkable that Tai peoples who had a culture of consuming glutinous rice (Sipsòng Panna, Chiang Tung, Chiang Rung, Lan Na, and Lan Sang) all shared the characteristic of being matriarchal societies." Ratana, "Social Strategies in Creating Roles for Women," 43.

81. Foon Ming, Grabowsky, and Renoo, *Chronicle of Sipsòng Panna*.

82. Wijeyewardene, "Northern Thai Succession," 285–92.

83. Interestingly, under the Chao Chet Ton dynasty of Lan Na, there were no queens. From that perspective, Thipkraisorn—given her choice of a "weak" spouse to take the Chiang Mai throne—was the nearest example.

84. Brailey, "The Origins of the Siamese Forward Movement," 168.

85. Inthanon had a total of eleven children by six women: 1. Chao Noi Mahawan, born to a "saw" musician [name unrecorded]; 2. Chao Noi Tone, son by Chao Duang Thep na Lampang; 3. Chao Kaew Praba Muang, son by Chao Thep na Lampang; 4. Chao Noi Khattiyawong (who later became Chao Rachabut and Chao Rachawong of Chiang Mai), son by Mom Khab Kham; 5. Chao Noi Suriya, son by Mae Chao Ringkham, who later became the eighth ruler of Chiang Mai, Chao Inthawarorot Suryawong; 6. Chao Kaew Nowarat, son born to Mom Kieow, who later became the ninth and last ruler of Chiang Mai; 7. Chao Chomjan, another son by Mom Kieow; 8. Chao Kham Khai, daughter by Mom Kham; 9. Chao Kham Thong, daughter by Mom Phom; 10. Chao Jantrasopha, daughter by Thipkraisorn; 11. Chao Dara Rasami, daughter by Thipkraisorn. Following Inthanon's death, his successors were drawn from among his male children by wives previous to Thipkraisorn. See Saengdao, *Phra Prawathi*, 62–63; and Prani, *Petch Lan Na,* 103.

86. The "yellow cloth" refers to the saffron-dyed robes of Buddhist monks. Bock, *Temples and Elephants*, 226.

87. Wijeyewardene, "Northern Thai Succession," 285–92. Relative to this practice, there was also a general expectation that the youngest daughter would take on the care of her parents in their old age.

88. Wijeyewardene, "Northern Thai Succession," 288.

89. BNA, FO 30/33, E. B. Gould, the British Vice-Consul in Chiang Mai, to Ernest M. Satow, May 2, 1884.

90. Wijeyewardene, "Northern Thai Succession," 263.

91. See Davis, "Muang Matrifocality," 264.

92. See Cohen and Wijeyewardene, "Introduction to Special Issue No. 3," 249–62.

93. See Emilie McGilvary's letter of May 5, 1883, in *Woman's Work for Woman and Our Mission Field,* Vol. XIII, 1883, Presbyterian Historical Society, Philadelphia, 310.

94. Colquhoun, *Amongst the Shans*, 244–45.

95. Brailey, "The Origins of the Siamese Forward Movement," 167.

96. McGilvary, *A Half Century Among the Siamese and the Lao,* 145.

97. McGilvary, *A Half Century Among the Siamese and the Lao,* 136.

98. See especially Holt S. Hallett's accounts of several conversations with Chao Ubonwanna in *A Thousand Miles on an Elephant.*

99. Hallett, *A Thousand Miles on an Elephant,* 117.

100. Hallett, *A Thousand Miles on an Elephant,* 105.

101. Bock, *Temples and Elephants,* 340.

102. Sarassawadee, *History of Lan Na,* 185.

103. Saengdao, *Phra Prawathi.*

104. BNA, FO 69/117, November 12, 1888.

105. Saengdao, *Phra Prawathi,* k.

106. BNA, FO 69/55, Lowndes's Journal, 1871, 12.

107. Indeed, Holt Hallett notes the Western utensils used at a dinner party hosted by Ubonwanna in 1885. Hallett, *A Thousand Miles on an Elephant,* 125.

108. Prince Phichit Prichagon is also known as "Gagananga Yukala" in his Wikipedia entry. See https://en.wikipedia.org/wiki/Gagananga_Yukala.

109. Lawaan, *Kaew Ching Duang* (n.d.), citing the *Royal Daily Record*, 332–34.

110. See Saengdao, *Phra Prawathi*, 178.

111. Saengdao, *Phra Prawathi*, 178.

112. Saengdao, *Phra Prawathi*, 179.

113. Nattakhan, "Phra Rachaya Chao Dara Rasami: Phra Prawathi," in Wongsak, ed., *Khattiyani Sri Lanna*, 128.

114. Lawaan, *Kaew Ching Duang*, 334–35.

115. Sarassawadee, *History of Lan Na*, 182; her translation of R.5 B.1.1 K/8, "From Rama 5 to Racha Samparakorn," Eighth month, Minor Era Year 1245 [1883], National Archive of Thailand.

116. See Sarassawadee, *History of Lan Na*, 195, quoting a letter from Songsuradet (An Bunnag) to Prince Damrong Rajanubhab in 1900.

117. NAT, R.5 M.58/88, Report of Krommuen Phichit Prichagon (May 1884).

118. See Benchawan's essay, "Chao Ubonwanna," in Wongsak na Chiang Mai, ed., *Chao Luang Chiang Mai*, 238–40.

119. Arun, *Phra Rachaya*, 72.

120. Arun, *Phra Rachaya*, 268–78.

121. Arun, Phra Rachaya, 240.

Chapter 2. Dara Rasami's Career in the Siamese Royal Palace

1. See Herzfeld, "The Absent Presence," 899–926.

2. See Chula, *Lords of Life*, 224.

3. Mongkut's democratic attitude towards his subjects was well-known: during his rule, royal prostration was abolished, and Mongkut held public audiences at 4pm daily in the Middle Palace, where he "received people informally . . . [it] was the time when *farang* friends usually called to see him." Chakrabongse, 192.

4. Prani, *Petch Lan Na*, 9; Saengdao, *Phra Prawathi*, 68.

5. Prani, *Petch Lan Na*, 9–10.

6. Prani, *Petch Lan Na*, 10.

7. Saengdao, *Phra Prawathi*, 68–72.

8. Saengdao, *Phra Prawathi*, 68; also Phonsiri, "Nang Nai," 150. King Chulalongkorn also raised the status of Dara Rasami's mother, Thipkraisorn, who had been deceased since 1884.

9. After Inthawichyanon's reign, there were only two more local rulers of the Chiang Mai royal line, but the Siamese greatly reduced their political status from kings—*chao chiwit*, or lords of life, with a salary of 80,000 rupees per year—to the rank of governors, who then ruled alongside the Siamese provincial administrator (at the reduced salary of 30,000 rupees per year; see Sarassawadee, *History of Lan Na*, 198).

10. Definition of *polygyny* from New Oxford American Dictionary, 2018.

11. Akin, *The Organization of Thai Society in the Early Bangkok Period*, 27.

12. The chief minister of the south was known as the *samuha kalahom*, while the chief minister of the northern region was the *samuha nayok*.

13. See Sara, "Satri nai Rachasamnak Siam," 23.

14. In contrast, Siamese administrators sent to govern provinces at the kingdom's peripheries were forbidden to marry the daughters of provincial noble families, lest they align together against the Siamese king. See the 1873 *Phra Racha Banya Samrap Khaluang chamra khwan hua mueang* (Act of Provincial Commissioner Justice).

15. Sara, "Satri nai Rachasamnak Siam," 23.

16. With the victory of the British in the First Anglo-Burmese War of 1825, Siam recognized the decreased military might of its former rival, Burma, as Western imperialism began to impinge on Siam's boundaries. See Ni, *Burma's Struggle Against British Imperialism* and Furnivall's *The Fashioning of Leviathan* for excellent accounts of British involvement in Burma in the nineteenth century.

17. Finestone, *A Royal Album*, 18–40. Although Mongkut had 56 consorts during his reign, he complained that he was not gifted as many women as the *uparat* (second king), who was perceived as younger and more virile. See Seni and Kukrit, *Mongkut*, 213.

18. Sara, "Satri nai Rachasamnak Siam," 54.

19. Mongkut's son by Queen Thepsirin was Chulalongkorn, who succeeded the throne to become Rama V. Mongkut's three daughters by Chao Chom Manda Phiyama Wadi were Saovabha Phongsri, Savang Vadhana, and Sunanta Kumarirat, who were Chulalongkorn's three highest-status queens.

20. Mongkut had two daughters with Princess Numan of Vientiane, Laos; however, neither became a consort of the next king (Chulalongkorn). See Finestone, *The Royal Family of Thailand*.

21. Finestone, *A Royal Album*, 64–73.

22. Naengnoi and Freeman, *Palaces of Bangkok*. As Naengnoi notes, every prior Chakri king had built his own *prasat* in the palace, tearing down the structures of his predecessor and rearranging the layout of palace grounds to suit his own tastes. After Chulalongkorn relocated his palace to the Dusit district in 1902, subsequent Thai kings have also continued to build their residences outside the old Royal Palace grounds. The women's quarters of the old Inner Palace fell into disrepair until the late 1950s, when Rama IX renovated several buildings, razing some that were beyond hope.

23. Naengnoi and Freeman, *Palaces of Bangkok*, 100.

24. The public/private divide as understood in Western cultures, however, has limited utility for understanding these spaces. See Rosaldo, Lamphere, and Bamberger, *Woman, Culture, and Society*.

25. She was not, however, free to marry again. See Wales, *Siamese State Ceremonies*.

26. See Tambiah, *World Conqueror and World Renouncer*.

27. See Tambiah's notion of the "galactic polity" and the role of the capital as the sacred center of the Southeast Asian "mandala" kingdom, from which political power

radiated outward, diminishing as it reached the peripheries. Tambiah, *World Conqueror and World Renouncer.*

28. Tambiah, *World Conqueror and World Renouncer.*

29. These three sisters were the daughters of the prior king, Mongkut, and consort-mother Piam; Chulalongkorn was Mongkut's son by Queen Thepsirin. Thus Chulalongkorn's highest-ranking queens were actually his half sisters.

30 Damrong Rajanubhab (1862–1943), one of King Chulalongkorn's many younger half brothers, was also one of his talented and most trusted ministers, heading up the Ministry of Education and the Mahat Thai (Ministry of the Interior, 1884–1915) over the course of his long career.

31. Thipawaan, "Phra Rachaya: Phra Sri Ming Mueang Nakhorn Chiang Mai," 54; this is also described in Sarassawadee, *History of Lan Na,* 16.

32. Prani, *Petch Lanna,* 11.

33. *Mom Chao Ying* Phunpitsamai Diskul as quoted in Sansani, *Luk kaew, Mia khwan,* 309.

34. Prani, *Petch Lanna,* 11.

35. Prani, *Petch Lanna,* 11.

36. Phonsiri, "Nang Nai," 59.

37. In a letter to Ernest Satow, the British consul to Siam, American missionary Dr. Cheek claims Ubonwanna died by poisoning in his note of February 11, 1886 (Public Records Office File 30/33/17/14), and Volker Grabowsky notes that the name Ubonwanna does not appear again after 1886 in either Siamese or Western documents of the time (Wongsak, ed., *Khattiyani Sri Lanna,* 269). On that date, Dara Rasami and her father were in Bangkok presenting Dara to the king as a consort.

38. See Chunlada, *Loh Wang,* 149–50, and Nattakhan's chapter on Dara Rasami's life, "Phra Rachaya Chao Dara Rasami," in Wongsak, *Khattiyani Sri Lanna,* 129. These sources are problematic, however, as they do not cite proper source material, and no other supporting primary documents have yet been found to either support or refute the story.

39. Nattakhan, "Phra Rachaya Chao Dara Rasami," 129.

40. See Hallett, *A Thousand Miles on an Elephant,* 444; McGilvary, Swanson, and Brown, *A Half-Century Among the Siamese and Lao,* 71–76.

41. Contemporary photographs of the interiors of this residence are featured in Nongyao Kanchanachari's official biography, *Dara Rasami,* 44–48.

42. Nongyao, *Dara Rasami,* 44–48. King Inthawichyanon had several other wives before he was chosen by Chao Thipkraisorn, King Kawilorot's daughter, to be her husband sometime in the 1870s—at which time she forced him to set them aside in favor of her and her children. See also Bock, *Temples and Elephants,* 226.

43. Phongsuwan, *Autobiography of Sipromma Kridakorn,* 49–50.

44. Leonowens, *The English Governess at the Siamese Court.*

45. See Naengnoi, *Satthabattyakam Phra Boromma Rachawang,* 316.

46. *Sakdi na,* as defined by David Wyatt in his *Thailand: A Short History,* is a system of law created under Sukhothai's King Boromma Trailokanat (1448–88), which

"delineated an enormously complex hierarchical society in which the place and position of every individual was carefully specified. The laws assigned to everyone a number of units of sakdi na, literally 'field power.' Although at first this may have at least symbolically represented actual measured rice fields, ... by the fifteenth century it did not carry this meaning, for even Buddhist monks, housewives, slaves, and Chinese merchants were assigned sakdi na. Ordinary peasant freemen were given a sakdi na of 25, slaves were ranked five, craftsmen employed in government service 50, and petty officials, from 50 to 400. ... In the exhaustive laws of [this era], which read like a directory of the entire society, every possible position and status is ranked and assigned a designation of sakdi na, thus specifying everyone's relative position." Wyatt, *Thailand: A Short History*, 73.

47. A noblewoman could be promoted even after her death; thus many other high-ranking women, both living and dead, were promoted again by later kings (as Queen Saovabha was by her son, Rama VI, King Vajiravudh). See Finestone's 1989 and 2000 genealogies (*The Royal Family of Thailand* and *A Royal Album*, respectively), which track many of these promotions.

48. During Chulalongkorn's reign, the keeper of the royal wardrobe was Chao Chom Manda Waat, and Chao Chom Manda Hem (a close friend of Dara Rasami) was the keeper of royal perfumes. Phonsiri, "Nang Nai," 62–63.

49. *Mom Chao Ying* Phunpitsamai Diskul, quoted in Sansani, *Luk kaew, Mia khwan*, 132–33.

50. Again, see the example of Phloi in Kukrit's *Four Reigns*. Though fictional, Phloi's career trajectory reflects the real-life opportunities for social advancement, which opened to lower-status women of the Inner Palace. In Kukrit's story, Phloi progresses from the daughter of a wealthy commoner to junior lady-in-waiting in the Inner Palace, to wife of a former royal page who becomes a prominent member of the king's staff. This progression reflects the real-life opportunities for social advancement that palace service opened to lower-status women.

51. Phonsiri, "Nang Nai," 59.

52. Phonsiri, "Nang Nai," 59.

53. Hanks, "Merit and Power in the Thai Social Order," 1247–61.

54. Consanguineous relationships—that is, those between the king and his own half sisters—were reserved for the king alone. See Wales, *Siamese State Ceremonies*, 117.

55. See Thipawaan, "Chao Dara Rasami Thamnaeng Phra Rachaya," 69–77.

56. See this page for a complete listing of all Chulalongkorn's children: https://en.wikipedia.org/wiki/List_of_children_of_Chulalongkorn.

57. But this effort was to no avail. Apparently, the girls—aged fourteen—were considered too young to be accepted to the English medical program to which they had been sent, and they eventually returned to Siam empty-handed (Smith, *A Physician at the Court of Siam*). However, Queen Saovabha founded her own school for midwifery in Bangkok in 1897. See Chula, 230.

58. Saengdao, *Phra Prawathi*, 80.

59. While Dara Rasami's parents had submitted her to the Siamese custom of topknot-cutting as a requirement for her engagement to King Chulalongkorn, the

custom of cutting a child's topknot was otherwise not practiced in Lan Na. It is mentioned several times in various biographies of Dara Rasami that she was unique among Lan Na royalty for having undergone the ceremony.

60. Saengdao, *Phra Prawathi*, 79.

61. Phonsiri, "Nang Nai," 105.

62. *Mom Chao Ying* Phunphitsamai Diskul, *Phra Brawati Somdet Boromma Wongtoe Krom Phraya Damrong Rachanubhab, P.S. 2405–2486.*

63. See Leonowens, *The Romance of the Harem.*

64. See Naengnoi, *Satthabattyakam Phra Boromma Rachawang*, 310.

65. Naengnoi, *Satthabattyakam Phra Boromma Rachawang*, 311.

66. Naengnoi, *Satthabattyakam Phra Boromma Rachawang*, 311.

67. The interior of the umong is described as a long aisle running between two facing rows of seat-height brick "stalls." It is unclear whether these stalls were partitioned or not, but it seems there was little privacy between the umong's users. Naengnoi, *Satthabattyakam Phra Boromma Rachawang*, 311.

68. Kukrit, *Four Reigns*, 36.

69. Naengnoi, *Satthabattyakam Phra Boromma Rachawang*, 314.

70. Prani, *Petch Lanna*, 31–32.

71. Nongyao, *Dara Rasami*, 50, quoting Omrot Runaraks' *Wang Luang*, 120.

72. See Naengnoi, *Satthabattyakam Phra Boromma Rachawang*, 314.

73. Naengnoi, *Satthabattyakam Phra Boromma Rachawang*, 106. This passage quotes Sri Prahoma Kridakorn's memoir of her life in Queen Saovabha's entourage between 1899 and 1902. For more about Sri Prahoma, see Phongsuwan, *The Autobiography of Lady Sri Prahoma Kridakorn.*

74. Kukrit, *Four Reigns.*

75. Sulak, *Samphat Mom Chao Jong Jitrathanom Diskul*, 70.

76. Sulak, *Samphat Mom Chao Jong Jitrathanom Diskul*, 70.

77. Chula, *Lords of Life.*

78. Wannaphon, *Chom Nang Haeng Siam.*

79. National Library of Thailand, Bangkok (NLT), "Kho Kamnot Fai Nai Phu Praprythi Mi Chob J.S. 1247," letter of R.5, group 142, #4.

80. Loos, "Sex in the Inner City," 886.

81. Loos, "Sex in the Inner City," 886.

82. Loos, "Sex in the Inner City," 884.

83. Wales, *Siamese State Ceremonies*, 193.

84. NLT, "Kho Kamnot Fai Nai Phu Praprythi Mi Chob J.S. 1247," letter of R.5, group 142, number 4.

85. Prani, *Petch Lan Na*, 11.

86. Prani, *Petch Lan Na*, 21.

87. Anna Leonowens depicted the abuse of palace slaves by royal women in her writings about palace life. Though the veracity of her account is questionable, a palace slave suffering abuse would have found it difficult to complain or find a new master, as doing so would put have been politically risky to the new owner. Hong Lysa details one such

case, that of Khun Wad, the director of the Inner Palace, in "Of Consorts and Harlots in Thai Popular History," 333–53. According to Lysa, Wad "had the slave chained and whipped for over six months, until the woman died." Though Wad and two of her servants were found guilty of causing the woman's death, King Chulalongkorn pardoned her on account of her high rank (340).

88. See Nawa, *Nithan Chao Rai*, 71.

89. Nawa, *Nithan Chao Rai*, 71.

90. Cort, *Siam*, 51.

91. Smith, *A Physician at the Court of Siam*, 56.

92. Smith, *A Physician at the Court of Siam*, 56.

93. In nineteenth-century Siam, a child was considered to have come of age at the onset of puberty, at which time the tuft of hair coiled on the crown of the head was cut in a special ceremony, the topknot-cutting. This usually occurred around the age of eleven or twelve. Following their tonsure, boys of royal birth who had lived in the Inner Palace had to move out, either into the household of a relative (i.e., a princely uncle) or a household of their own outside the palace. According to H. G. Quaritch Wales, the tonsure of royal princes was carried out differently from those of noblemen and commoners. For more information, see Chapter X of Wales's seminal work, *Siamese State Ceremonies*, 126–36.

94. This edict outlining acceptable practices for royal pages of the Mahat Lek is reprinted in *Ruang Mahatlek khong Krom Sinlapakorn*, a cremation volume for Phon Ek Nai Worakhan Buncha (Kanbuncha Sutuntanon), Wat Thepsirin, 8 November 2517: 5, 46, & 80. (Translation my own.)

95. Naengnoi and Freeman, *Palaces of Bangkok*, 313.

96. Saengdao, *Phra Prawathi*, 84–87.

97. NAT R.5 Krasuang Wang (microfilm) M.R.5 W/18 26 Mokharakhom 121 (Symptoms/condition of Chao Chom Manda Thipkesorn, Nov. 28–Jan. 26, year R.S. 121 [1902–03]).

98. NAT R.5 Krasuang Wang (microfilm) M.R.5 W/18 26 Mokharakhom 121 (Symptoms/condition of Chao Chom Manda Thipkesorn, Nov. 28–Jan. 26, year R.S. 121 [1902–03]).

99. Though he refused to allow her to leave at that time, King Chulalongkorn essentially deferred her request, saying it would be arranged. He gave Dara Rasami permission to adopt children from her relatives' families and raise them in her residence. See Saengdao, *Phra Prawathi*, 84–87.

100. Wongsak, *Khattiyani Sri Lanna*, 126.

101. Saengdao, *Phra Prawathi*, 84–87.

102. Quoted by Nattakhan, "Phra Rachaya Chao Dara Rasami," in Wongsak, *Khattiyani Sri Lanna*, 131.

103. The 1893 Paknam Crisis, in which the French blockaded the mouth of the Chao Phraya River and sailed gunboats upstream to Bangkok, forced Siam to cede their Lao and Cambodian tributaries east of the Mekong River to the French. According to Wyatt, it also resulted in King Chulalongkorn experiencing a breakdown the following year. Wyatt, *Thailand: A Short History*, 204.

104. Finestone, *The Royal Family of Thailand*, 64.

105. This could be due to Dara Rasami's promotion to the rank of high queen (*phra rajajaya*) in 1909, which would mean that her children would automatically have been born with chao fa status. Finestone, *The Royal Family of Thailand*, 64.

106. The boy and girl—Kawilowong and Renuwanna, respectively—can be seen in photographs of Dara Rasami and her entourage at the royal residence at Bang Pa-In (Ayutthaya) circa 1906. Later accounts state that Dara Rasami requested that Laddakham allow her daughter to be raised by Dara Rasami as well. She complied, sending her daughter Chatrsudha to live with Dara in Chiang Mai in the 1920s following her retirement to Chiang Mai (Prani, *Petch Lan Na*, 20).

107. Prani, *Petch Lan Na*, 20.

108. Thipawaan, "Chao Dara Rasami Thamnaeng Phra Rachaya," 69–76, 77.

109. For more information on the royal women's cemetery, see Krom Sinlapakon, *Prawati Wat Rachabophit Sathit Maha Simaram*. According to Hiram Woodward, the remains of Siamese kings Rama I–III and their chief consorts were interred in a columbarium inside the Ho Phrathat Montien, outside the Temple of the Emerald Buddha in the Outer Palace. See Woodward, "Monastery, Palace, and City Plans," 23–60.

110. The other half of Dara Rasami's (and her daughter's) ashes are interred in a funerary monument in the royal cemetery she built in Chiang Mai, at Wat Suan Dok (Flower Garden Temple, which will be discussed further in the next chapter.

111. Chao Chom Manda Thipkesorn entered service in the palace in 1883, in the household of *Chao Khun Manda* Phae (of the Bunnag family). Her son, Dilok Nopparat, was born the following year. (Prani, *Petch Lan Na*, 130–31.)

112. Thipkesorn was the daughter of Chao Suriya and Lady Bua Nam. Chao Suriya's father was Chao Naan Mahawong, son of *Phra Chao* Kawila, the first ruler of Chiang Mai's Chao Chet Ton dynasty. Thipkesorn's mother, Lady Bua Nam, was the daughter of *Chao Luang* Sretthi Kham Fan, the third Chao Chet Ton king of Chiang Mai. Prani, *Petch Lan Na*.

113. Finestone, *The Royal Family of Thailand*, 66.

114. Prince Dilok Nopparat earned a PhD in economics from Tubinggen University in Germany in 1905. See Wichitwong's *Sethakit Siam* for a full account of Prince Dilok's life and career.

115. Though she did not appear to suffer ill treatment. In one of the only archival sources where she appears, Thipkesorn's illnesses were treated with extensive medical care. See NAT R.5 Krasuang Wang M.R.5, W 99.

116. Her son, Dilok Nopparat, had not yet returned from studying for his PhD in economics at the Tubinggen University in Germany (which he completed in 1905). Letter from Chulalongkorn to Noppaphon (undated), reprinted in Prani, 131.

117. Cunningham, "Thailand's Supatra Dynasty," https://www.forbes.com/sites/susan-cunningham/2018/07/24/thailands-supatra-dynasty-4-generations-of-women-running-the-chao-phraya-river/.

118. Chao "Noi" Sukkasem, however, was deeply unhappy having been forced to renounce his love for a young Burmese woman, Ma Mia, whom he met during his

schooling in Moulmein. After battling heartbreak, depression, and alcohol for several years, he died prematurely at age thirty-three. (The Ma Mia story—and its relationship to Dara Rasami—will be discussed in greater detail in the next chapter.)

119. Prani, *Petch Lan Na*, 23. During their marriage, Boworadet and Thipawaan had maintained an interest in agriculture; following their divorce, Thipawaan launched her own new agricultural venture, becoming the first to cultivate Virginia tobacco in the region. Thipawaan remained close to Dara Rasami and prominent in Chiang Mai's cultural life; in addition to being promoted by Rama VI, she was also instrumental in arranging the traditional Lan Na-style performances for the visit of Rama VII in 1926. See Chiang Mai University's repository of information about important Lan Na women at http://www.sri.cmu.ac.th/%7Emaeyinglanna/main2/main9.php. Following the change of government that changed Siam to a constitutional monarchy in 1932, her former husband, Prince Boworadet, led the unsuccessful uprising that still bears his name, the Boworadet Rebellion. See https://en.wikipedia.org/wiki/Boworadet_rebellion#Prince_Boworadet.

120. Prani, *Petch Lan Na*, 32–33.

121. Prani, *Petch Lan Na*, 28.

122. See Loos, "Sex in the Inner City," 142.

123. Chunlada, Sri Mahawaan (Mom Luang), *Lao Wang*.

124. Though there is a historical and cultural distinction to be made between the Lan Na and Lan Xang kingdoms, the difference was not well understood by Bangkok Siamese, who tended to lump all northerners into the category of Lao. Thus whenever Dara Rasami and her entourage are referred to as Chao Lao, it should be read not as Lao Ladies, but rather as Lan Na Ladies.

125. Chao Khun Manda Pae was titled chao khun because she was a royal granddaughter, although her mother was not a member of the Chakri royal family. See Chunlada, *Lao Wang*, 148; Wannaphon, *Chom Nang Haeng Siam*, 299.

126. Definition of *ai* taken from (Thai-English) Lexitron Electronic Dictionary, a publication of the Thai National Dictionary Foundation, 2005.

127. Arun, *Phra Rachaya Chao Dara Rasami*, 76–77.

128. Arun, *Phra Rachaya Chao Dara Rasami*, 77–78.

129. See Tuck, *The French Wolf and the Siamese Lamb*.

130. According to Dr. Malcolm Smith, no more children were born to King Chulalongkorn after his fortieth birthday (in September of 1893), which corresponds to the royal genealogy compiled by Finestone (*A Royal Album*).

Chapter 3. Performing Identity and Ethnicity in the Siamese Court

1. Samnak Phra Rachawang, *Phra Rachawang Dusit Moo Phra Tamnak*.

2. NAT, R.5, N.18.1K/28, dated February 19, 1898.

3. Naengnoi mentions that funds from the privy purse were used so as to render the land the personal property of the king, which he could leave to his children and consorts after his death. Naengnoi and Freeman, *Palaces of Bangkok*, 195, 230.

4. Samnak Phra Rachawang, *Phra Rachawang Dusit*, 17.

5. The new Inner Palace grounds at Dusit were named for one of Chulalongkorn's favorite wives, Queen Sunanta Kumarirat, who had drowned in a boating accident early in his reign (1880).

6. As Naengnoi reminds us, "It will be recalled that consorts with sons could [go to] live with them in their own palaces" after the king's death. Otherwise, a woman would have had to return to her parents' home or live in straitened circumstances. Naengnoi and Freeman, *Palaces of Bangkok*, 230.

7. Samnak Phra Rachawang, *Phra Rachawang Dusit*, 17.

8. Vimanmek Mansion is purported to be the largest structure in the world made entirely from golden teak wood. Originally begun as the Mundhat Ratanarot Palace on Koh Si Chang Island, just off Siam's coast in the Gulf of Thailand, it was abandoned after the Paknam Crisis of 1893. After Chulalongkorn's brief visit to the island in May 1901, the structure was disassembled and moved to Dusit Park, where it was rebuilt into Vimanmek Mansion, which opened nineteen months later in 1903. Samnak Phra Rachawang, *Phra Rachawang Dusit*, 30. First restored to its former grandeur in the 1980s, it has been completely dismantled for foundation work and will likely not reopen to the public. See https://www.khaosodenglish.com/news/2019/07/25/khaosod-english-visits-demolished-vimanmek-palace/.

9. It was also the location where the famous photo of Chulalongkorn—pictured sitting in a chair, shirtless and smoking a cigar, while stirring a large wok—was taken by Erb Bunnag. This image can be spotted frequently in the royal shrines displayed in restaurants in Thailand and beyond.

10. See Nattakhan Limsathaphon's essay, "Phra Rachaya Chao Dara Rasami: Phra Prawati," in Wongsak, ed., *Khattiyani Sri Lanna*, 127. This decoration was the same one awarded to her father, King Inthawichyanon of Chiang Mai, on Dara's entry into palace service in Siam in 1886.

11. Letter of Chulalongkorn to Dara Rasami dated February 13, 1909, quoted in Phonsiri, "Nang Nai," 106.

12. Thongchai, "The Quest for 'Siwilai,'" 528–49.

13. Peleggi, *Lords of Things*, 90–93.

14. See Brydon and Niessen, *Consuming Fashion*; and Roces and Edwards, *The Politics of Dress in Asia and the Americas*.

15. See Gittinger and Lefferts, *Textiles and the Tai Experience*; Cheesman, *Lao Tai Textiles*; Songsak and Cheesman, *Pha Lan Na*; and Susan Conway's works *Thai Textiles*; *Silken Threads Lacquer Thrones*; and *Power Dressing*.

16. Conway, *Silken Threads, Lacquer Thrones*, 92.

17. Conway, *Silken Threads, Lacquer Thrones*, 93.

18. Gittinger and Lefferts, *Textiles and the Tai Experience*, 69.

19. Gittinger and Lefferts, *Textiles and the Tai Experience*, 69.

20. Conway, *Silken Threads, Lacquer Thrones*, 126.

21. See particularly Songsak and Cheesman, *Pha Lan Na*, 12: "In the past every woman could weave."

22. Bowie, "Unraveling the Myth of the Subsistence Economy," 797–823.

23. Conway, *Silken Threads, Lacquer Thrones*, 94–95.

24. Bock, *Temples and Elephants*, 322.

25. Hallett, *A Thousand Miles on an Elephant.*

26. Colquhoun also mentions the large number of slaves owned by Ubonwanna: eight hundred, which ranked her just below Chiang Mai's king and *uparat* (second king), who owned 1,500 and 1,000 slaves, respectively. See Colquhoun, *Amongst the Shans*, 257.

27. This request was part of an exchange of textiles Hallett facilitated between Ubonwanna and his sister in England in the late 1880s. See Hallett, *A Thousand Miles on an Elephant*, 386–87.

28. Conway, *Silken Threads, Lacquer Thrones*, 93.

29. *Hua sin* translates literally as head of the skirt; *dtua sin* translates to body of the skirt; *teen sin* translates to skirt edge or hem. See Appendix III in Cheesman, *Lao-Tai Textiles*, 284–94, for a full glossary of terms related to various weaving patterns and textiles.

30. Bock, *Temples and Elephants*, 327.

31. See Ratanaporn, "Political, Social, and Economic Changes," for a description of King Kawilorot's persecution of Christian missionaries and his execution of several converts in 1869. In contrast, as I noted in chapter 1, Kawilorot's daughters, Thipkraisorn and Ubonwanna, were friendly with the missionaries and other Western visitors to Chiang Mai, including Carl Bock, Archibald Colquhoun, and Holt Hallett.

32. Conway, *Silken Threads, Lacquer Thrones*, 91.

33. See Guy, *Indian Textiles in the East.*

34. It is unclear whether the patterns originated in Siam and were copied by Indian weavers, or vice versa. Guy, *Indian Textiles in the East*, 98.

35. Krom Sinlapakon, *Phra Racha Phongsawadan Krung Ratanakosin Rachakan tee 4*, 377–78.

36. Damrong, *Phra Sanom Ek*, 18.

37. Lawaan, *Kaew Ching Duang*, 114–15.

38. Wannaphon, *Chom Nang Haeng Siam*, 133.

39. Damrong, *Phra Sanom Ek*, 41–42.

40. Faris Yothasamuth explores this phenomenon in his recent *New Mandala* article, "Disappearing Japan: Vajiravudh's Translations of the Mikado and the Thai Elite's Admiration of Japan," August 16, 2019, https://www.newmandala.org/disappearing-japan/.

41. Conway makes this claim in *Silken Threads, Lacquer Thrones* (155), but it is unsupported by either historical data or photographic evidence. The Thai cultural historian Anucha Thirakanont was also adamant in his efforts to disabuse me of this notion. (Woodhouse research notes on personal conversation with Anucha Thirakanont, Bangkok, July 2007.)

42. Wannaphon describes the formulation of this policy in relation to "aryatham," or civilization, in *Chom Nang Haeng Siam*, 130–41.

43. Conway, *Silken Threads, Lacquer Thrones*, 152.

44. This system of colors was dictated by the Brahmin-Hindu notion associating a different god with each day of the week, making particular colors auspicious to wear on different days. Some middle-to upper-class Thais still endeavor to wear the color of the day as a means of improving their popularity and prosperity.

45. Wannaphon, *Chom Nang Haeng Siam*, 133.

46. King Chulalongkorn directed that the various palace ministries wear jackets of different colors. The Mahat Thai (Interior Ministry) was to wear dark green, the Foreign Ministry was to wear dark blue, and Royal Pages were to wear gray. See Rataphatri Chandavij, *Pha Phim Lai Boran nai Phiphitaphan Satan Haeng Chat*, 65–66.

47. See Sulak, *Samphat Mom Chao Jong Jitrathanom Diskul*, 75. Thipkesorn had arrived in Bangkok in 1880 several years before Dara Rasami to serve as a consort in the Siamese palace.

48. Chunlada, *Lao Wang*, 318–20. Translation mine.

49. Sulak, *Samphat*, 75.

50. That Queen Saovabha and other high consorts expressed jealousy and other hard feelings toward Dara is mentioned in Nongyao's biography of Dara Rasami, as well as several of the palace memoirs left by women like Phunphitsamai Diskul (*Prachum Phra Niphan; Phra Prawati Somdet Phrachao Boromawongtoe Phra Ong Chao Ditsaworakuman Krom Phraya Damrong Rachanuphap*) and her sister, Jong Jitra Thanom Diskul (Sulak, *Samphat*).

51. Phunphit, *Ueng Ngern*, 48–49.

52. Anake, *Phrawatikan thay rup yuk raek khong Thai*, 745-757. I have also analyzed these photographs in greater depth in my 2013 article, "Concubines with Cameras," which can be found at http://hdl.handle.net/2027/spo.7977573.0002.202.

53. Anake, *Phrawatikan thay rup*, 747.

54. From Thongchai, "The Quest for 'Siwilai,'" 528–49. The *Latthi Thamniam Tang* article from which the quote is taken was originally published in the Siamese journal *Wachirayanwiset* in 1896.

55. Thongchai, "The Quest for 'Siwilai,'" 528–49.

56. See the "Phrakat wa duay Lakhon Phuying," as quoted in Damrong, *Thamnan Phrakat Ruang Lakhon Inao*, 170–71.

57. *Phrachum Prakat Rachakan tee 4*, 161–63.

58. Mattani, *Dance, Drama, and Theater in Thailand*, 83.

59. Damrong, *Thamnan Phrakat Ruang Lakhon Inao*, 175, 177.

60. Mattani, *Dance, Drama, and Theater in Thailand*, 105.

61. Mattani, *Dance, Drama, and Theater in Thailand*, 105.

62. Damrong, *Thamnan Phrakat Ruang Lakhon Inao*, 199.

63. The best English-language source on the history of Thai dance-drama is Mattani's 1993 *Dance, Drama, and Theater in Thailand*.

64. Mattani, *Dance, Drama, and Theater in Thailand*, 103.

65. Here the author notes that in 1899 lakhon dukdamban performances were held to welcome Prince Phitsanulok home from a visit to Europe and in honor of the royal visit of Prince Henry, brother of the King of Prussia (December 27), and that the king

ordered a lakhon rong performance for the visit of the Duke of Brunswick in late 1909. Mattani, *Dance, Drama, and Theater in Thailand*, 126–27, 146.

66. Letter from King Chulalongkorn to Dara Rasami, April 24, 1909. Chulalongkorn, *Samnao Phra Rachahatalekha Rawang Phrabat Somdet Phra Chula Chom Klao Chao You Hua Mi Phra Rachathan Krom Narathip Phraphanphong*, 306–07.

67. Nongyao, *Dara Rasami*; Mattani also notes that a senior dancer of Mongkut's reign, Lady Sa-ngiam, was sent to teach dance in the court of Chiang Mai's Chao Intawarorot, who reigned from 1897 to 1910 (Mattani, *Dance, Drama, and Theater in Thailand*, 102).

68. Phunphit, *Ueng Ngern*, 48–49.

69. Prani, *Petch Lanna*, 33.

70. Phunphit, *Ueng Ngern*, 67. Dara's lady-in-waiting, Chao Bua Choom, exhibited so much talent that Dara sent her to take lessons from a European lady by the name of Ma'am Bella at a Bangkok hotel. Prani, *Petch Lanna*, 55–56.

71. Kaewgiriya, *Dara Rasami*, 88.

72. Mattani, *Dance, Drama, and Theater in Thailand*, 120.

73. From King Chulalongkorn's personal letter to Dara Rasami dated July 2, 1909, collected in Prayut, *Rak Nai Racha Samnak Rachakan tee 5*, 302.

74. Mattani, *Dance, Drama, and Theater in Thailand*, 221–22.

75. Chulalongkorn, *Samnao Phra Rachahatalekha . . . kap Krom Narathip Phraphanphong*, 92.

76. King Chulalongkorn wrote about *Madame Butterfly* in his letters home from Europe in 1906–07, which were collected and published in the volume *Klai Baan [Far from Home]*.

77. Letter from King Chulalongkorn to Dara Rasami, quoted in Chulalongkorn, *Samnao Phra Rachahatalekha ... kap Krom Narathip Phraphanphong*, 306.

78. Mattani, *Dance, Drama, and Theater in Thailand*, 143.

79. Mattani helpfully notes that the term "wik" comes from the English "week," which was the average length of most theater showings; over time wik came to denote a show's run. Mattani, *Dance, Drama, and Theater in Thailand*, 141, 269. Letter to Dara Rasami from Chulalongkorn dated June 29, 1909, Chulalongkorn, *Samnao Phra Rachahatalekha Rawang Phrabat Somdet Phra Jula Jom Klao Chao Yu Hua kap Phra Rachathan Krom Narathip Phraphanphong*, 311.

80. Letter to Dara Rasami dated July 2, 1909, Chulalongkorn, *Samnao Phra Rachahatalekha . . .*, 310–11.

81. Mattani, *Dance, Drama, and Theater in Thailand*, 140.

82. Letters to Dara Rasami, dated March 17 and July 2, 1909, Chulalongkorn, *Samnao Phra Rachahatalekha . . . kap Narathip Phraphanphong*, 310–11.

83. Mattani, *Dance, Drama, and Theater in Thailand*, 140.

84. See Ratana's essay, "Botbat khong Phra Rachaya Chao Dara Rasami Nai Khaansang Phaplak 'Phuying Muen,'" in Wongsak, *Khattiyani Sri Lanna*, 135–46.

85. See Grabowsky's (Thai-language) article, also in Wongsak, *Khattiyani Sri Lanna*, 268–78; Holt Hallet's description in *A Thousand Miles on an Elephant in the Shan*

States, 117-118; and Carl Bock's reference to Ubonwanna's many lovers in *Temples and Elephants,* 364–65.

86. And there it remains to this day, thanks to repeated iterations of *Sao Khrua Fa* on film and television. See the Thai Wikipedia entry for *Sao Khrua Fa* at http://th.wikipedia.org/wiki/สาวเครือฟ้า (accessed Feb. 12, 2020).

87. Mattani, *Dance, Drama, and Theater in Thailand,* 118.

88. Phunphitsamai, *Phrachum Phra Niphon,* 132.

89. Mattani, *Dance, Drama, and Theater in Thailand,* 115.

90. From Chulalongkorn's introduction to *Bot Lakhon Ruang Ngo Pa lae Prachum Khlong Supasit,* 1–2.

91. Mattani, *Dance, Drama, and Theater in Thailand,* 115.

92 Khun Pracha Khadikit, "Waduai praphet khonpa ru kha fainua," *Wachirayanwiset* 1(9), 1885: 164–66. (As cited in Thongchai, "The Others Within: Travels and Ethno-Spatial Differentiation of Siamese Subjects, 1885–1910," in *Civility and Savagery,* Turton, ed., 38-62, 2000.)

93. I've written about Khanung in greater depth in my 2017 article, "Picturing Siwilai," 141–57.

94. Sulak, *Samphat,* 76.

95. This fact would not have been lost on the British either. However, there is no evidence that they sent any officers to accompany the Shan princess, or that the British were in any way involved in this audience.

96. *Mom Chao* Jongjitrathanom Diskul, as quoted in Phonsiri, "Nang Nai," 151.

97. Chunlada, *Lao Wang,* 66–67.

98. Phonsiri, "Nang Nai," 151.

99. Nongyao, *Dara Rasami,* 32.

100. Archive of the Royal Secretariat, Bangkok (SRL), *Phra Racha Kitcha Ray Wan (Royal Daily Journal),* February 6, 1909, 37.

101. As Damrong made this journey several times during his tenure as Minister of the Mahat Thai, he was encouraged by a certain "historian"—Dara Rasami herself—to record the details of the journey for posterity. He did, publishing *Atibai Raya Than Long Lam Nam Pho Tang Tae Chiang Mai Teung Phak Nam Pho* in 1931.

102. Saengdao, *Phra Prawathi,* 88–92.

103. Saengdao, *Phra Prawathi,* 88–92.

104. See Sulak, *Samphat,* 73.

105. For more about the *Lilit Phra Law,* see Bickner, *An Introduction to the Thai Poem "Lilit Phra Law."*

106. Jirijan, *Ma Mia Jak Wan Nan tueng Wan Ni 100 Pee 2446-2546.*

107. Jirijan, *Ma Mia Jak Wan Nan tueng Wan Ni 100 Pee 2446-2546,* 93. Archival documents also suggest that timing was at least part of the issue here, since King Chulalongkorn was abroad visiting Europe when Inthawichyanon died.

108. Arun, *Phra Rachaya Chao Dara kap Kan Ruam Mueang Phak Nuea,* 85. Italics mine.

109. He married one of Dara Rasami's own kinswomen and ladies-in-waiting, Bua Choom. Unfortunately, his heartbreak turned into alcoholism, resulting in his death at the age of just thirty-three. After Chao Noi Sukkasem's death seven years later in 1910, she married Chao Chai Worachat na Chiang Mai, the governor of *amphoe* Sankhampheng. See Jirijan, *Ma Mia Jak Wan Nan tueng Wan Ni 100 Pee 2446-2546*, 114–15; Arun, *Phra Rachaya Chao Dara Rasami Kap Kanruam Hua Mueang Phak Neua*, 86.

110. See Finestone, *The Royal Family of Thailand*, 66.

111. Although the other queens did not have to *krab* (prostrate themselves) before Dara before her 1909 journey, they (and all other palace folk) had to do so on her return. Sulak, *Samphat*, 76.

112. Phonsiri, "Nang Nai," 59.

113. According to Saengdao, this photo was taken by *Luang Anusan* Sunthon, a Siamese noble sent up along with Dara's entourage for the journey. Saengdao, *Phra Prawathi*, 178.

114. Nongyao, *Dara Rasami*, 67. These letters and telegrams are collected and reprinted in full in Nongyao's biography of Dara Rasami, as well as Prayut, *Rak Nai Rachasamnak*. Dara left Bangkok on February 12 and arrived in Chiang Mai March 3; she returned to Bangkok on November 23 of that year.

115. Prani, *Petch Lanna*, 4.

116. Prani, *Petch Lanna*, 4–5.

117. Wijeyewardene, "Northern Thai Succession and the Search for Matriliny," 285–92.

118. See SRL Ray Ngan Krasuang Mahat Thai ruang Chao Dara Rasami khuen Pai Chiang Mai, Rahat Ekasan R.5 K.6, klong 5, phaen 7 [Report of the Mahat Thai re: Chao Dara Rasami's Visit to Chiang Mai], Letter from Surasri to Bangkok, dated October 22, 1909.

119. This manuscript is in the personal collection of *Ajaan* Kreuk Akornchinaret, curator of the Huen Derm (Original House) manuscript library at Chiang Mai University. It comes from Wat Phra Phaeng (formerly Wat Chieng Mun), a temple in the Thammayut Nikai (Theravada Buddhist) tradition. The notes in question date from between July 29, 1909, and January 5, 1910, and are located on the end pages of the forty-eight-page manuscript.

120. Sulak, *Samphat*, 73.

121. This building still stands today and is publicly accessible as part of the Vimanmek Mansion park. The house was abandoned after 1932 and today contains exhibits of royal objects and regalia.

122. Sulak, *Samphat*, 72.

123. NAT R.W., Rahat Ekasan 2450809, Phra Racha Hattalekha Somdet Phra Rachathan Chao Phra Yao Woraphong Phiphitaphan, wan tee 9 Pruetsajikayon, Ratanakosin 128 [document no. 2450809, Letter from King Chulalongkorn to Chao Phraya Woraphong Phiphat, November 9, 1909].

Chapter 4. Inventing Lan Na Tradition and Dara Rasami's Legacy

1. See Renard, "The Differential Integration of Hill People into the Thai State," 63–83.

2. These administrative reforms have been well covered elsewhere. See Wyatt, *The Politics of Reform in Thailand*, and Tej, *The Provincial Administration of Siam*.

3. The northern rail line finally reached Chiang Mai—its northern terminal point— in 1921. See Kakizaki, *Laying the Tracks*, 106.

4. Such scholars include Deborah Cherry, *Painting Women: Victorian Women Artists,* (Abingdon: Routledge, 1993), and Heidi Strobel, *The Artistic Matronage of Queen Charlotte - 1744–1818: How a Queen Promoted Both Art and Female Artists in English Society,* (New York: Edwin Mellon, 2011). See my chapter ("A Very 'Modern' Matron") in Belli Bose, *Women, Gender and Art in Asia*, 91–121.

5. Linda Nochlin, "Why Have There Been No Great Women Artists?" *ARTnews*, January 1971, 22–39, 67–71.

6. See Belli-Bose, ed., *Women, Gender and Art in Asia, C. 1500-1900* (London, New York: Routledge [An Ashgate Book]), 2016, 3.

7. See my chapter, "A Very 'Modern' Matron," in Belli Bose, *Women, Gender and Art in Asia*, 91–121.

8. Rujaphon, *Nattasin Lanna*, 27.

9. Rujaphon, *Nattasin Lanna*, 27.

10. The Thai term "kru" denotes a highly skilled instructor or trainer.

11. Rujaphon, *Nattasin Lanna*, 28.

12. Kaewgiriya, *Sai Yai Rak nai Rachagan thi 5*, 190.

13. Kaewgiriya, *Sai Yai Rak*, 190.

14. According to Witthi Panichphun, professor of performing arts at Chiang Mai University, the song is still performed locally quite often, and can also be found on many sound recordings of contemporary Lan Na music. Woodhouse research notes, 2012.

15. As in Siam, dancers frequently became concubines of Lan Na's kings and noblemen, making the boundary between palace lakhon troupes and royal/noble households a very permeable one. Protestant missionaries in Chiang Mai in the 1880s believed that "the theatre girls belong in the main to the king's harem," resulting in attempts to "rescue" local girls from being recruited as court dancers. (Letter of Dr. Daniel McGilvary to Cornelia McGilvary, September 24, 1886, McGilvary Family Papers, accessed at the Payap University Archive, July 2012.)

16. Rujaphon, *Nattasin Lanna*, 27.

17. Thipawaan, "Chao Dara Rasami nai thamnaeng Phra Rachaya," 73.

18. Woodhouse research notes from visit to Dara Phirom Palace, Mae Rim, Thailand, August 2, 2006.

19. See Hallett, *A Thousand Miles on an Elephant*, 103.

20. Aroonrut Wichienkieow says her mother used to tell her this story about Dara Rasami. Woodhouse research notes, January 10, 2008. Incidentally, Mae Chaem is still well known today for the beauty and quality of its intricate teen jok textiles, which frequently can be found for sale at Chiang Mai markets and festivals.

21. Dara's sixtieth birthday—which marked the completion of her fifth "twelve-year" cycle in Tai/Yuan astrology—was August 26, 1933. Thipawaan, "Chao Dara Rasami nai Thamnaeng Phra Rachaya: Phra sri ming muang Nakhon Chiang Mai," 52.

22. Though the missionaries describe the dead child as a son, I suspect that it was actually Dara Rasami's elder sister, Jantrasopha, who died around that time, though no date of death was recorded. See McGilvary, Swanson, and Brown, *A Half Century among the Siamese and the Lao*, 89–91.

23. McGilvary, Swanson, and Brown, *A Half Century among the Siamese and the Lao*, 257.

24. Nongyao, Dara Rasami. The McKean facility, which once functioned as a haven for leprosy patients, is now named the McKean Senior Center and has shifted its focus of service to the care of (largely expat) seniors, including patients with dementia. For more information, see their website: https://mckean.or.th/history/.

25. It is not clear whether Dara made the address in *kham muang*, Siamese, or English—though the speech was reported upon in English in the missionary journal *Siam Outlook* in October 1923. See Gillies, Dr. R. M., D.D. "The Dedication of the James. M. Patton Village," 292.

26. See Narint, "Phra Rachaya Chao Dara Rasami kap kaseton," 200.

27. See "Obituary of Sithiporn Kridakara," *Journal of the Siam Society*, 1970, http://www.siamese-heritage.org/jsspdf/1971/JSS_060_1r_ObituaryPrinceSithipornKridakara.pdf.

28. Mom Chao Siphroma was a princess from the royal family of Nan, another city of Lan Na's Inland Constellation. Siphroma was famous for refusing to become a consort of King Chulalongkorn in the early twentieth century, rejecting his request via a letter written in English so as to avoid causing a loss of face to the king. See Pongsuwan, trans., *The Autobiography of Lady Siphroma Kridakon*, 88.

29. Established in 1924, the school became Chiang Mai Teachers' College in 1948—the first institution of higher education in Chiang Mai, as Chiang Mai University was not established until 1964. Today the Teachers' College is a branch of Rajabhat University.

30. Lady Thipawaan was a modern matron in her own right. Not only did she continue to dance—she was one of the two dancers at the head of the procession during King Prajadhipok's visit to Chiang Mai in 1927—but she also served as the president of Chiang Mai's Sri Lanna Thai women's club for the advancement of women and Lan Na culture. See her page at Chiang Mai University's Social Science Research Institute's online repository of local Lan Na historical information, *Mae Ying Lanna:* http://www.sri.cmu.ac.th/~maeyinglanna/main2/main9.php (accessed January 30, 2019).

31. After Dara Rasami moved to her new house in Mae Rim, her half brother Chao Kaew Nowarat moved into the residence she had vacated. Today, the original teak house is gone, but the Khum Chedi Kiu compound still stands and is home to the US Consulate in Chiang Mai. See details at the consulate's website: https://th.usembassy.gov/wp-content/uploads/sites/90/2016/07/consul-general-residence.pdf.

32. See Narint, "Phra Rachaya Chao Dara Rasami kap Kan Kasetr," 201.

33. A rai is equal to an area of 0.4 acre, making seventy rai equal to roughly twenty-eight acres.

34. See Narint, "Phra Rachaya Chao Dara Rasami kap Kan Kasetr," 204.

35. Narint, "Phra Rachaya Chao Dara Rasami kap Kan Kasetr," 207–8.

36. Narint, "Phra Rachaya Chao Dara Rasami kap Kan Kasetr," 205–6.

37. The legend of Queen Chamathewi originated in the thirteenth century in the ancient kingdom of Hariphunchai in the Lan Na region. See Swearer and Premchit, *The Legend of Queen Cama*, and Hallett, *A Thousand Miles on an Elephant*, 49.

38. Report respecting the Central and Northern Provinces of Siam, Inclosure Mr. McCarthy: DE to Mr. Palgrave (Private and Confidential), 30/33, 1/8. Public Records Office, Kew, UK.

39. Nuachanok, "Botbat dan kanmuang lae sangkhom khong Phra Rachaya Chao Dara Rasami," 104.

40. Thipawaan, "Chao Dara Rasami nai Thamnaeng Phra Rachaya," 106.

41. See Nongyao, Dara Rasami, 99.

42. Sulak, *Samphat M. C. Jongjitrathanom Diskul*, 72.

43. Thipawaan, "Phra Rachaya," 49–56. It appears that Dara Rasami also kept a stable of her own elephants. According to Chiang Mai native Dr. Ratana Pakdeekul, her grandfather worked as an elephant mahout in Dara Rasami's household. Woodhouse research notes, 2008.

44. Thipawaan, "Chao Dara Rasami nai Thamnaeng Phra Rachaya," 53. Chatrsudha's excellent horseback-riding skills are attributed to time spent in England.

45. Woodhouse research notes of an interview with *Ajaan* Aroonrut Wichienkieow, Chiang Mai, Thailand, January 10, 2008.

46. See Thipawaan, "Phra Rachaya," 49–56. Doi Intanon is the highest mountain in Thailand at 8,415 feet tall. Today a monument to former King Inthawichyanon and Dara Rasami still stands near the mountaintop, where people continue to leave offerings regularly.

47. Nuachanok, "Botbat dan kanmuang lae sangkhom khong Phra Rachaya Chao Dara Rasami," 107. Damrong was likely referring to Suzanne Karpeles, a French woman who served as the director of the Cambodian Royal Library from 1925 to 1941, and also founded the Buddhist Institutes in French colonial Vientiane, Laos, and Phnom Penh, Cambodia. See Edwards, *Cambodge*, 186–94.

48. Andaya, *The Flaming Womb*, 173.

49. Andaya, *The Flaming Womb*, 166.

50. LeMay, *An Asian Arcady*, 102.

51. See Daruni, "The Construction of Chiang Mai's Beautiful Image."

52. See Renard, "The Image of Chiang Mai," and Ratana, "Phaplak 'Phuying Nuea' thang thae play phuttasathawat 25 tueng don phuttasathawat tee 26," which analyzes the depiction of Chiang Mai women as "exotic beauties" in central Thai discourse.

53. Dara Rasami sponsored the European studies of at least two female relatives: her niece, Renuwanna, and Laddawan Chatrchai, Chatrsudha's mother. This was supposedly why Laddawan and her daughter were skilled equestrians.

54. Queen Savang was a full sister to Saovabha and Sunanta Kumarirat (d. 1880), who were the three highest-ranking queens of Chulalongkorn's reign, and their sons were in line for the throne. After Saovabha's sons Vajiravudh (r. 1910–25) and Prajadhipok (r. 1925–33) ruled the kingdom, the Chakri line of succession passed over to Sawang's sons, Ananta Mahidol and Bhumibhol Adulyadet. Savang's residence, Sraphatum Palace, still stands on its original lot behind today's Siam Paragon shopping mall in central Bangkok, and serves as Princess Sirindhorn's residence.

55. This apocryphal story was related to me by M. L. Pattaratorn Chirapravati, a descendant of Queen Savang, in 2013.

56. See Batson, *The End of Absolute Monarchy in Siam*, and Baker and Pasuk, *A History of Thailand*. More about the Boworadet Rebellion can be found at https://en.wikipedia.org/wiki/Boworadet_rebellion.

57. See Ferrara, "The Legend of King Prajadhipok," 4–31.

58. For an excellent profile of Lady Sripromma's biography created by Chiang Mai University's Social Research Institute, see http://www.sri.cmu.ac.th/~maeyinglanna/main2/main15.php.

59. Saengdao, *Phra Prawathi*, 212, 214.

60. See Nathakhan's essay in Wongsak, ed., *Khattiyani Sri Lanna*, 133.

61. Saengdao, *Phra Prawathi*, 216.

62. NAT S.B. 2.11/14, Phra Rachaya Plerngsop Chao Dara Rasami, Phra Rachaya (8-23 Metsayon, P.S. 2477).

63. Personal conversations with Kreuk Akornchinaret, curator of the Huen Derm manuscript collection at Chiang Mai University. Woodhouse research notes, January 12, 2008, and July 15, 2017.

64. Aroonrut Wichienkieow says her mother used to tell her this story about Dara Rasami. Woodhouse research notes, January 10, 2008.

65. The last time I attended this celebration, on August 25, 2007, nearly every seat inside Dara Phirom Palace was filled—approximately seventy-five to eighty people attended the ceremonies. I was one of only two non-Thais present.

66. See Bowie, "The Saint with Indra's Sword: Khruba Srivichai and Buddhist Millenarianism in Northern Thailand," 682. "Khru ba" literally means "forest monk" and is used as an honorific for a respected monk, while "sri vichai" translates to "venerated victorious one."

67. See Bowie, "The Saint with Indra's Sword," 687.

68. See Bowie, "The Saint with Indra's Sword," 683–84.

69. Renard, "The Differential Integration of Hill People into the Thai State," 76.

70. Renard, "The Differential Integration of Hill People into the Thai State," 76.

71. Renard, "The Differential Integration of Hill People into the Thai State," 76.

72. Bowie, "The Saint with Indra's Sword," 699.

73. *Bangkok Times,* August 26, 1912, as quoted in Bowie, "The Saint with Indra's Sword."

74. Bowie, "The Saint with Indra's Sword," 699–701.

75. Bowie, "The Saint with Indra's Sword," 700.

76. See Nguyen, "A Sangha without a King," 1.

77. Sommai, *Thamnan sipha rachawang chabap sop chamra*, 19.

78. *Bangkok Times*, June 7, 1920, as quoted in Bowie, "The Saint with Indra's Sword," 690. One wonders whether Dara Rasami herself was among the visitors.

79. See Phitsanu Thepthong, "Pushing 'Phasin' to the Fore," Bangkok Post, February 17, 2020: https://www.bangkokpost.com/thailand/special-reports/1858929/pushing-phasin-to-the-fore.

Chapter 5. Intertwined Fates

1. See the July 30, 2019 story in local Bangkok media: http://www.khaosodenglish.com/news/2019/07/30/rama-x-names-first-royal-consort-in-almost-a-century/.

2. See Tamara Loos, *Subject Siam* (Ithaca, NY: Cornell University Press, 2006), 100.

3. Loos, *Subject Siam*, 119.

4. Loos, *Subject Siam*, 125.

5. Barmé, *Woman, Man, Bangkok*, 125.

6. Barmé, *Luang Wichit Wathakan and the Creation of a Thai Identity*.

7. Thamsook, "Pibulsongkram's Thai Nation-Building Programme," 237.

8. Peleggi, *Lord of Things*, and Peleggi, "Refashioning Civilization."

9. Kanjana, "Dear Thai Sisters," 233–58.

10. Kanjana, "Dear Thai Sisters," 239.

11. Kanjana, "Dear Thai Sisters," 241.

12. Nonetheless, the authorities experienced a good bit of resistance to these measures, as reflected in the repeated efforts via print, posters, and radio addresses to popularize the new practices throughout the land.

13. See Kanjana, "Dressing Thai," 12.

14. Quoted in Thamsook, "Pibulsongkram's Thai Nation-Building Programme," 239.

15. Thamsook, "Pibulsongkram's Thai Nation-Building Programme," 239.

16. See the entry for "Thai exceptionalism" in Fry, Nieminen, and Smith, *Historical Dictionary of Thailand*, 405–06.

17. The consort, Sineenat Wongvajirapakdi, was thirty-four years of age at that time, and had been in the king's service since before his 2019 coronation. According to the BBC article published at the time, traffic to the official palace website that posted photographs of the new consort was so great that it caused the site to crash. See https://www.bbc.com/news/world-asia-49474422.

18. Loos, *Subject Siam*, 129.

19. This according to King Vajiravudh himself, as stated in Loos, *Subject Siam*. However, as Loos notes, Vajiravudh contradicted himself on the subject of polygyny on several occasions, sometimes vilifying and other times supporting the practice. See Loos, *Subject Siam*, 128–29.

20. From a 2019 conversation with a Thai royal descendant who prefers to remain anonymous.

21. See Kanjana, "Dressing Thai," 12.

22. Kanjana, "Dressing Thai," 12.

23. Kanjana, "Dressing Thai," note 43, 13.

24. I have saved a dozen or more images from these events on my personal Pinterest board, accessible at https://www.pinterest.com/LeslieCastroWoodhouse/_saved/.

25. See Kanjana, "Dressing Thai."

26. See https://www.newmandala.org/thailands-king-vajiralongkorn-turning-back-time/ for a rundown of the King's previous spouses and children.

27. Loos, *Subject Siam*, 129.

28. Protesters have even attempted to re-install the historical marker for the country's 1932 transition to a constitutional monarchy, which was disappeared in 2017. See https://www.bangkokpost.com/thailand/politics/1988567/protesters-install-new-plaque-at-sanam-luang.

29. See Thammachart Kri-aksorn's March 9, 2020, article in Prachathai, "Thai Political Slang Explained: *Chai* or 'Yup,'" https://prachatai.com/english/node/8395.

SELECTED BIBLIOGRAPHY

Archival Sources Consulted

BL British Library, London, UK
BNA British National Archives, Kew, UK
FO Foreign Office Records (subset of the BNA or BL)
L/P&S Political & Secret Documents (subset of BL/FO documents)
NAT National Archives of Thailand, Bangkok
NLT National Library of Thailand, Bangkok
PUA Payap University Archive, Chiang Mai, Thailand
SRL Archive of the Royal Secretariat, Bangkok

Published English-Language Sources

Akin Rabibhadana. *The Organization of Thai Society in the Early Bangkok Period, 1782–1873*. Ithaca, NY: Southeast Asia Program, Cornell University, 1969.

Anan Ganjanapan. "The Idiom of 'Phii Ka': Peasant Conception of Class Differentiation in Northern Thailand." *Mankind* 14, no. 4 (1984): 325–29.

Andaya, Barbara Watson. *Other Pasts: Women, Gender and History in Early Modern Southeast Asia*. Honolulu: Center for Southeast Asian Studies, University of Hawai'i at Mânoa, 2000.

——. *The Flaming Womb: Repositioning Women in Early Modern Southeast Asia*. Honolulu: University of Hawai'i Press, 2006.

Aye Chan. "Burma: Shan Domination in the Ava Period (ca. AD 1310–1555)." *Journal of the Siam Society* 94 (2006): 27–49, https://thesiamsociety.org/wp-content/uploads/2006/03/JSS_094_0d_AyeChan_BurmaShanDominationInAvaPeriod.pdf.

Bacon, George B. *Siam: The Land of the White Elephant as It Was and Is*. Vol. VIII of *Itineraria Asiatica. Thailand*. Bangkok: White Orchid Press, 2000.

Baker, Christopher John, and Pasuk Phongpaichit. *A History of Thailand*. Port Melbourne, Vic., Australia, and New York: Cambridge University Press, 2005.

Barmé, Scott. *Woman, Man, Bangkok: Love, Sex, and Popular Culture in Thailand*. Lanham, MD: Rowman & Littlefield, 2002.

——. *Luang Wichit Wathakan and the Creation of a Thai Identity: Social Issues in Southeast Asia*. Singapore: Institute of Southeast Asian Studies, 1983.

Batson, Benjamin. *The End of Absolute Monarchy in Siam*. Singapore: Oxford University Press, 1984.

Belli Bose, Melia, ed. *Women, Gender and Art in Asia, 1500–1900*. London and New York: Routledge, 2016.

Bhabha, Homi K. *The Location of Culture*. London and New York: Routledge, 2004.

Bickner, Robert J. *An Introduction to the Thai Poem "Lilit Phra Law" (the Story of King Law)*. DeKalb, IL: Center for Southeast Asian Studies Monograph Series on Southeast Asia, Northern Illinois University, 1991.

Bock, Carl. *Temples and Elephants: The Narrative of a Journey of Exploration through Upper Siam and Laos*. Bangkok: White Orchid Press, 1985.

Bowie, Katherine. "The Saint with Indra's Sword: Khruubaa Srivichai and Buddhist Millenarianism in Northern Thailand." *Comparative Studies in Society and History* 56, no. 3 (2014): 681–713, https://www.jstor.org/stable/43908304.

——. "Standing in the Shadows: Of Matrilocality and the Role of Women in a Village Election in Northern Thailand." *American Ethnologist* 35, no. 1 (2008): 136–53, https://www.jstor.org/stable/27667478.

——. "Slavery in Nineteenth Century Northern Thailand: Archival Anecdotes and Village Voices." In *State Power and Culture in Thailand*, edited by E. Paul Durrenberger. New Haven, CT: Yale Southeast Asia Studies, 1996.

——. "Assessing the Early Observers: Cloth and the Fabric of Society in 19th-Century Northern Thai Kingdoms." *American Ethnologist* 20, no. 1 (1993): 138–58, https://www.jstor.org/stable/645416.

——. "Unraveling the Myth of the Subsistence Economy: Textile Production in 19th Century Thailand." *Journal of Asian Studies*, no. 4 (November 1992): 797–823, https://doi.org/10.2307/2059037.

Breckenridge, Carol. "The Aesthetics and Politics of Colonial Collecting: India at World Fairs." *Comparative Studies in Society and History* 31 (1989): 195–216.

Bristowe, W. S. *Louis and the King of Siam*. New York: Thai-American Publishers, 1976.

Brydon, Anne, and S. A. Niessen. *Consuming Fashion: Adorning the Transnational Body*. Oxford, UK, and New York: Berg, 1998.

Camp, Beatrice, Plai-auw Thongsawat, Supattra Suttilagsana, eds. *American Threads in the Lanna Fabric: U.S. Involvement in Northern Thailand, 1867–2007*. Chiang Mai, Thailand: US Consulate General, 2007.

Cheesman, Patricia. *Lao-Tai Textiles: The Textiles of Xam Nuea and Muang Phuan*. Chiang Mai, Thailand: Studio Naenna, 2004.

Chiranan Prasertkul. *Yunnan Trade in the Nineteenth Century: Southwest China's Cross Boundaries Function System*. Bangkok: Institute of Asian Studies, Chulalongkorn University, 1989.

Chula Chakrabongse. *Lords of Life: A History of the Kings of Thailand*. 2nd rev. ed. Bangkok: DD Books, 1982.

Chulalongkorn, and Jones, Robert B. *Thai Titles and Ranks. Including a Translation of Traditions of Royal Lineage in Siam by King Chulalongkorn*. Ithaca, NY: Southeast Asia Program, Department of Asian Studies, Cornell University, 1971.

Cohen, Paul. "Are the Spirit Cults of Northern Thailand Descent Groups?" *Mankind* 14, no. 4 (1984): 293–99.

Cohen, Paul T., and Gehan Wijeyewardene. "Introduction to Special Issue No. 3: Spirit Cults and the Position of Women in Northern Thailand." *Mankind* 14, no. 4 (1984): 249–62.

Cohen, Paul T., and Gehan Wijeyewardene, guest eds., and Peter Hinton, ed. *Spirit Cults and the Position of Women in Northern Thailand*. Sydney: Anthropological Society of New South Wales, Australia, 1984.

Colquhoun, Archibald Ross. *Amongst the Shans*. London: Field & Tuer, 1885.

Conway, Susan. *Power Dressing: Lanna Shan Siam 19th Century Court Dress*. Bangkok: James H. W. Thompson Foundation, distributed in Thailand by River Books, 2003.

——. *Silken Threads, Lacquer Thrones: Lan Na Court Textiles*. Bangkok: River Books, 2002.

——. "Power Dressing: Female Court Dress and Marital Alliances in Lan Na, the Shan States and Siam." *Orientations* 32, no. 4 (2001): 42–49.

——. *Thai Textiles*. Bangkok: Asia Books, 1992.

Cort, Mary Lovina. *Siam; Or, the Heart of Farther India*. New York: A. D. F. Randolph & Company, 1886.

Cunningham, Susan. "Thailand's Supatra Dynasty—4 Generations of Women Running the Chao Phraya River." *Forbes*, August 2018, https://www.forbes.com/sites/susan-cunningham/2018/07/24/thailands-supatra-dynasty-4-generations-of-women-runni ng-the-chao-phraya-river/.

Curtis, Lillian Johnson, and Walter E. J. Tips. *The Laos of North Siam: Seen through the Eyes of a Missionary*. New York: Revell, 1903. Rev. ed., Bangkok: White Lotus Press, 1998.

Damrong Rajanubhab. *Our Wars with the Burmese*. Bangkok, Thailand: White Lotus, 2001.

Davis, Richard. "Muang Matrifocality." *Mankind* 14, no. 4 (1984): 263–71.

——. *Muang Metaphysics: A Study of Northern Thai Myth and Ritual*. Bangkok: Pandora, 1984.

Davis, Sara. "Premodern Flows in Postmodern China: Globalization and the Sipsongpanna Tais." *Modern China* 29, no. 2 (2003): 176–203, https://doi.org/10.1177/0097700402250738.

Day, Anthony. "Ties that (Un)Bind: Families and States in Premodern Southeast Asia." *Journal of Asian Studies* 55, no. 2 (1996): 384–409, https://www.jstor.org/stable/2943364?seq=1.

Disch, Hilary A. "A New Vision: Chamari, Chamadewi, and Female Sovereignty in Northern Thailand." *Studies on Asia* Series IV, 2, no. 2 (October 2012): 1–60.

Dodd, William Clifton. *The Tai Race: Elder Brother of the Chinese*. Bangkok: White Lotus, 1996.

Easum, Taylor M. "A Thorn in Bangkok's Side: Khruba Sriwichai, Sacred Space and the Last Stand of the Pre-Modern Chiang Mai State." *South East Asia Research* 21, no. 2 (2013): 211–36, https://www.jstor.org/stable/23752549.

———. "Imagining the 'Laos Mission': On the Usage of 'Lao' in Northern Siam and Beyond." *Journal of Lao Studies, Special Issue* 1 (2015): 6–23.

———. "Sculpting and Casting Memory and History in a Northern Thai City." *Kyoto Review of Southeast Asia* 20 (September 2016), https://kyotoreview.org/issue-20/casting-memory-northern-thai-city/.

———. "Local Identity, National Politics, and World Heritage in Northern Thailand." *Kyoto Review of Southeast Asia* 27 (March 2020), https://kyotoreview.org/issue-27/thai-national-identity-lanna-identity-northern-thailand-2/.

Edwards, Penny. "Restyling Colonial Cambodia (1860–1954): French Dressing, Indigenous Customs and National Costume." *Fashion Theory* 5, no. 4 (2001): 389–416.

———. *Cambodge: The Cultivation of a Nation, 1860–1944.* Honolulu: University of Hawai'i Press, 2007.

Engel, David M., and Frank Reynolds. *Code and Custom in a Thai Provincial Court: The Interaction of Formal and Informal Systems of Justice.* Tucson: University of Arizona Press, 1978.

Evans, Grant. *A Short History of Laos: The Land In Between.* Crows Nest, New South Wales, Australia: Allen & Unwin, 2002.

Faris Yothasamuth. "Disappearing Japan: Vajiravudh's Translations of the Mikado and the Thai Elite's Admiration of Japan." *New Mandala*, 16 August, 2019, https://www.newmandala.org/disappearing-japan/.

Ferrara, Federico. "The Legend of King Prajadhipok: Tall Tales and Stubborn Facts on the Seventh Reign in Siam." *Journal of Southeast Asian Studies* 43, no. 1 (2012): 4–31.

Finestone, Jeffrey. *A Royal Album: The Children and Grandchildren of King Mongkut (Rama IV) of Siam.* Bangkok: Loma Holding, 2000.

———. *The Royal Family of Thailand: The Descendants of King Chulalongkorn.* Bangkok: Phitsanulok Publishing Co., Ltd, 1989.

Foon Ming Liew-Herres and Volker Grabowsky (in collaboration with Aroonrut Wichienkieow). *Lan Na in Chinese Historiography: Sino-Tai Relations as Reflected in the Yuan and Ming Sources (13th to 17th Centuries).* Bangkok: Institute of Asian Studies, Chulalongkorn University, 2008.

Foon Ming Liew-Herres, Volker Grabowsky, and Renoo Wichasin. *Chronicle of Sipsòng Panna: History and Society of a Tai Lü Kingdom, Twelfth to Twentieth Century.* Chiang Mai, Thailand: Mekong Press, 2012.

Forbes, Andrew, and David Henley (Photographer). *Khon Muang: People and Principalities of North Thailand.* [N.p.]: Sollo Development, 1997.

Forbes, Andrew, and David Henley (Photographer). *The Haw: Traders of the Golden Triangle: People and Cultures of Southeast Asia.* Chiang Mai, Thailand: Asia Film House, 1997.

Freeman, Michael. *A Guide to Northern Thailand and the Ancient Kingdom of Lanna.* Trumbull, CT: Weatherhill, 2001.

Freeman, Michael, and Selena Ahmed. *Tea Horse Road: China's Ancient Trade Road to Tibet.* Bangkok: River Books, 2011.

Fry, Gerald W., Gayla S. Nieminen, and Harold E. Smith. *Historical Dictionary of Thailand*. Lanham, MD: Scarecrow Press, 2013.

Furnivall, J. S., and Gehan Wijeyewardene. *The Fashioning of Leviathan: The Beginnings of British Rule in Burma*. Canberra, Australia: Economic History of Southeast Asia Project and the Thai-Yunnan Project, 1991.

Gehan Wijeyewardene. "Northern Thai Succession and the Search for Matriliny." *Mankind* 14, no. 4 (1984): 285–92.

———. "The Prince and the Moulmein Market Girl." *Thai-Yunnan Newsletter* 5 (1989): 26–27.

———. "More on the Princess Dara Rasmi." *Thai-Yunnan Newsletter* 7 (1989): 25.

Gillies, Dr. R. M., D.D. "The Dedication of the James. M. Patton Village." *Siam Outlook* III, No. 2 (1921): 291–93.

Gittinger, Mattiebelle, and H. Leedom Lefferts. *Textiles and the Tai Experience in Southeast Asia*. Washington, DC: Textile Museum, 1992.

Grabowsky, Volker. "Forced Resettlement Campaigns in Northern Thailand during the Early Bangkok Period." *Oriens Extremus* 37 (1994): 45–116, http://oriens-extremus.org/wp-content/uploads/2014/06/OE-37-1-02.pdf.

———. "The Northern Tai Polity of Lan Na (Babai-Dadian) between the Late 13th to Mid-16th Centuries: Internal Dynamics and Relations with Her Neighbours." Singapore: Asia Research Institute, National University of Singapore, 2004. Asia Research Institute Working Paper Series no. 17, https://ari.nus.edu.sg/wp-content/uploads/2018/10/wps04_017.pdf.

———. "Population and State in Lan Na Prior to the Mid-Sixteenth Century." *Journal of the Siam Society* 93 (2005): 1–68.

Grabowsky, Volker, and Andrew Turton. *The Gold and Silver Road of Trade and Friendship: The McLeod and Richardson Diplomatic Missions to Tai States in 1837*. Chiang Mai, Thailand: Silkworm Books, 2003.

Gray, Christine. "Hegemonic Images: Language and Silence in the Thai Polity." *Man*, vol. 26, no. 1 (March 1991): 43–65, http://www.jstor.org/stable/2803474.

Greene, Steven Lyon Wakeman. *Absolute Dreams: Thai Government under Rama VI, 1910–1925*. Bangkok: White Lotus Press, 1999.

Grewal, Inderpal. *Home and Harem: Nation, Gender, Empire, and the Cultures of Travel*. Durham, NC: Duke University Press, 1996.

Guy, John. *Indian Textiles in the East: From Southeast Asia to Japan*. London: Thames & Hudson, 2009.

Hale, Ann. "The Search for Jural Rule: Women in Southeast Asia—The Northern Thai Cults in Perspective." *Mankind* 14, no. 4 (1984): 330–38.

Hall, D. G. E. *Henry Burney: A Political Biography*. London and New York: Oxford University Press, 1974.

Hallett, Holt S. *A Thousand Miles on an Elephant in the Shan States*. Edinborough and London: William Blackwood and Sons, 1890.

Hanks, Jane Richardson, and Lucien Mason Hanks. *Tribes of the North Thailand Frontier*. New Haven, CT: Yale University Southeast Asia Studies, 2001.

Hanks, Lucien M. "Merit and Power in the Thai Social Order." *American Anthropologist* 64, no. 6 (1962): 1247–61.

Hayashi Yukio. *Practical Buddhism among the Thai-Lao: Religion in the Making of a Region*. Kyoto and Melbourne, Australia: Kyoto University Press and Trans Pacific Press, 2003.

Herzfeld, Michael. "The Absent Presence: Discourses of Crypto-Colonialism." *South Atlantic Quarterly* 101, no. 4 (2002): 899–926.

Heywood, Denise. *Ancient Luang Prabang*. Bangkok: River Books, 2006.

Higham, Charles. *Early Cultures of Mainland Southeast Asia*. Bangkok and London: Distributed by River Thames & Hudson, 2002.

Hunter, Eileen, and Narisa Chakrabongse. *Katya & the Prince of Siam*. Bangkok: River Books, distributed by APA Publications (Thailand), 1994.

Irvine, Walter. "Decline of Village Spirit Cults and Growth of Urban Spirit Mediumship: The Persistence of Spirit Beliefs, the Position of Women and Modernization." *Mankind* 14, no. 4 (1984): 315–24.

Jackson, Peter. "Performative Genders, Perverse Desires: A Bio-History of Thailand's Same-Sex and Transgender Cultures." *Intersections: Gender and Sexuality in Asia and the Pacific*, no. 9 (2003), http://intersections.anu.edu.au/issue9/jackson.html.

Jacobsen, Trudy. *Lost Goddesses: Denial of Female Power in Cambodian History*. Copenhagen: Nordic Institute of Asian Studies, 2008.

Jedamski, Doris. "Madame Butterfly in a Robinson-Reading: A Note of Discord in Colonial Indonesia." *IIAS Journal*, no. 27 (2001): 28–29.

Kakizaki Ichiro. *Laying the Tracks: The Thai Economy and Its Railways, 1885–1935*. Kyoto and Melbourne, Vic., Australia: Kyoto University Press and Trans Pacific Press, 2005.

Kamala Tiyavanich. *Forest Recollections: Wandering Monks in Twentieth-Century Thailand*. Honolulu: University of Hawai'i Press, 1997.

Kanjana Hubik Thepboriruk. "Dear Thai Sisters: Propaganda, Fashion, and the Corporeal Nation under Phibunsongkhram." *Southeast Asian Studies* 8, no. 2 (2019): 233–58.

——. "Dressing Thai: Fashion, Nation, and the Construction of Thainess, 19th Century–Present." *Journal of Applied History* 1 (September 2020): 1–17, https://doi.org/10.1163/25895893-bja10007.

Keyes, Charles F. "Buddhism and National Integration in Thailand." *Journal of Asian Studies* 30, no. 3 (1971): 551–67.

——. "Buddhist Pilgrimage Centers and the Twelve-Year Cycle: Northern Thai Moral Orders in Space and Time." *History of Religions* 15, no. 1 (1975): 71–89.

——. "Ethnicity and the Nation-State: Asian Perspectives." Paper presented at the Spring 2003 Symposium of the Center for International Ethnicity Studies at North Carolina State University's College of Humanities and Social Sciences, Raleigh, NC, 2003.

——. "'The Peoples of Asia': Science and Politics in the Classification of Ethnic Groups in Thailand, China, and Vietnam." *Journal of Asian Studies* 61, no. 4 (2002): 1163–1203.

Koenig, William J. *The Burmese Polity, 1752–1819: Politics, Administration, and Social Organization in the Early Kon-Baung Period*. Ann Arbor, MI: Center for South and Southeast Asian Studies, University of Michigan, 1990.

Kraisri Nimanhaemin. "Put Vegetables into Baskets, and People into Towns." In *Ethnographic Notes on Northern Thailand*, edited by Lucien M. Hanks, Jane Richardson Hanks, and Lauriston Sharp. Ithaca, NY: Southeast Asia Program, Department of Asian Studies, Cornell University, 1965.

Kukrit Pramoj. *Four Reigns*. Translated by Tulachandra. Chiang Mai, Thailand: Silkworm Books, 1998.

LeMay, Reginald. *An Asian Arcady: The Land and Peoples of Siam*. Cambridge, UK: W. Heffer & Sons, 1926.

Leonowens, Anna Harriette. *The English Governess at the Siamese Court: Being Recollections of Six Years in the Royal Palace at Bangkok*. Singapore: Oxford University Press, 1988.

Leonowens, Anna Harriette, and Susan Morgan. *The Romance of the Harem*. Charlottesville, VA: University of Virginia Press, 1991.

Lewis, Paul W., and Elaine Lewis. *Peoples of the Golden Triangle: Six Tribes in Thailand*. London and New York: Thames and Hudson, 1998.

Likhit Dhiravegin. *Siam and Colonialism, 1855–1909: An Analysis of Diplomatic Relations*. Bangkok: Thai Wattana Panich, 1974.

Loos, Tamara. "Sex in the Inner City: The Fidelity between Sex and Politics in Siam." *Journal of Asian Studies* 64, no. 4 (2005): 881–909.

——. *Subject Siam. Family, Law, and Colonial Modernity in Thailand*. Ithaca, NY: Cornell University Press, 2006.

Lysa Hong. "Of Consorts and Harlots in Thai Popular History." *Journal of Asian Studies* 57, no. 2 (1998): 333–53.

——. "Palace Women at the Margins of Social Change: An Aspect of the Politics of Social History in the Reign of King Chulalongkorn." *Journal of Southeast Asian History* 30, no. 2 (1999): 310–24.

Manich Jumsai. *History of Laos Including the History of Lannathai, Chiengmai*. 4th ed. Bangkok: Chalermnit, 2000.

Manich Jumsai and Chamsai Jotisalikorn. *History of Anglo-Thai Relations*. 6th ed. Bangkok: Chalermnit, 2000.

Mattani Mojdara Rutnin. *Dance, Drama, and Theatre in Thailand: The Process of Development and Modernization*. Tokyo: The Centre for East Asian Cultural Studies for UNESCO, 1993.

McCarthy, James Fitzroy. *Surveying and Exploring in Siam: With Descriptions of Lao Dependencies and of Battles against the Chinese Haws*. Bangkok: White Lotus Press, 1994.

McDonald, N. A. *A Missionary in Siam (1860–1870)*. Reprint ed. of *Siam: Its Government, Manners, Customs, &c.* (Philadelphia: Alfred Martien, 1871). Bangkok: White Lotus Press, 1999.

McGilvary, Daniel, Herbert R. Swanson, and Arthur Judson Brown. *A Half Century among the Siamese and the Lao: An Autobiography*. Reprint ed. (original ed. 1912). Bangkok: White Lotus Press, 2002.

McMorran, M. V. "Northern Thai Ancestral Cults: Authority and Aggression." *Mankind* 14, no. 4 (1984): 308–14.

Moerman, Michael. "Ethnic Identification in a Complex Civilization: Who Are the Lue?" *American Anthropologist* 67, no. 5, Part 1 (1965): 1215–30.

———. "Kinship and Commerce in a Thai-Lue Village." *Ethnology* 5, no. 4 (1966): 360–64.

Morris, Rosalind C. *In the Place of Origins: Modernity and Its Mediums in Northern Thailand*. Durham, NC: Duke University Press, 2000.

Mouhot, Henri. *Travels in Siam, Cambodia, Laos and Annam*. Bangkok: White Lotus Press, 2000.

Naengnoi Saksi, *Mom Racha Wong*, and Michael Freeman. *Palaces of Bangkok: Royal Residences of the Chakri Dynasty*. Bangkok: Asia Books, 1996.

Nguyen, Betty. "A Sangha without a King: A Buddhist Millenarian Response to the Collapse of Lanna Buddhist Kingdoms." Paper presented at the Informal Northern Thai Group, Chiang Mai, Thailand, March 7, 2011.

Ni Ni Myint. *Burma's Struggle against British Imperialism, 1885–1895*. Rangoon, Burma: Universities Press, 1983.

Ockey, James. "God Mothers, Good Mothers, Good Lovers, Godmothers: Gender Images in Thailand." *Journal of Asian Studies* 58, no. 4 (1999): 1033–58.

Pasuk Phongphaichit. "Cultural Factors that Shape Governance in South-East Asia." Paper presented at the 1999 Meeting of UNESCO EFA Assessment, Bangkok, May 17–20, 1999.

Peirce, Leslie Penn. *The Imperial Harem: Women and Sovereignty in the Ottoman Empire*. New York: Oxford University Press, 1993.

Peleggi, Maurizio. *Lords of Things: The Fashioning of the Siamese Monarchy's Modern Image*. Honolulu: University of Hawai'i Press, 2002.

———. "Refashioning Civilization: Dress and Bodily Practice in Thai Nation-Building." In *The Politics of Dress in Asia and the Americas*, edited by Mina Roces and Louise P. Edwards. Brighton, UK, and Portland, OR: Sussex Academic, 2007.

Penth, Hans. *A Brief History of Lan Na: Civilizations of North Thailand*. Chiang Mai, Thailand: Silkworm Books, 1994.

Phitsanu Thepthong. "Pushing 'Phasin' to the Fore." *Bangkok Post,* February 17, 2020, https://www.bangkokpost.com/thailand/special-reports/1858929/pushing-phasin-to-the-fore.

Pirasri Povatong. "Transformation of Bangkok in the Press During the Reign of Rama V (1868–1910)." *Manusya* 6, no. 1 (2003): 47–53.

Pongsuwan T. Bilmes. *The Autobiography of Lady Siphroma Kridakon*. Southeast Asia Paper No. 22, Southeast Asian Studies, Center for Asian and Pacific Studies, University of Hawai'i at Mânoa, 1982.

Presbyterian Historical Society. *Woman's Work for Woman and Our Mission Field*. Vol. XIII. Philadelphia: Presbyterian Historical Society, 1883.

Puranananda, Jane, ed. *Through the Thread of Time: Southeast Asian Textiles*. Bangkok: River Books, James W. Thompson Foundation, 2004.

Ramsay, Ansil. "Modernization and Reactionary Rebellions in Northern Siam." *Journal of Asian Studies* 38, no. 2 (1979): 283–97.

Reid, Anthony. *Southeast Asia in the Age of Commerce, 1450–1680*. New Haven, CT: Yale University Press, 1988.

Renard, Ronald D. "The Differential Integration of Hill People into the Thai State," In *Civility and Savagery: Social Identity in Tai States*, edited by Andrew Turton, 63–83. London and New York: Routledge, 2000.

——. "The Image of Chiang Mai: The Making of a Beautiful City." *Journal of the Siam Society* 87, no. 1 & 2 (1999): 87–98.

——. "Geography and Peoples of Jengtung in the Pre-Colonial Period." *Proceedings of the 1995 Conference, Myanmar towards the 21st Century: Dynamics of Continuity and Change, June 1–3, 1995*: 17.

——. "Social Change in the Shan States under the British, 1886–1942." *Report Number 1 of the Annual Conference of the Institute of Southeast Asian Studies, Pasir Panjang, Singapore, 1988*: 109–147.

Renard, Ronald D., trans. *A History of Khrūbā Sriwichai (the Buddhist Saint of Northern Thailand), the Story of Making the Road Up Doi Suthep, and a Historical Chronicle of Wat Phrathat Doi Suthep*. Chiang Mai, Thailand: Sutin Press, 2006.

Reynolds, Craig J. *Seditious Histories: Contesting Thai and Southeast Asian Pasts*. Seattle and Singapore: University of Washington Press, in association with Singapore University Press, 2006.

Rhum, Michael. "The Cosmology of Power in Lanna." *Journal of the Siam Society* 75 (1987): 91–107.

Roces, Mina, and Louise P. Edwards. *The Politics of Dress in Asia and the Americas*. Brighton, England, and Portland, OR: Sussex Academic, 2007.

Rosaldo, Michelle Zimbalist, Louise Lamphere, and Joan Bamberger. *Woman, Culture, and Society*. Stanford, CA: Stanford University Press, 1974.

Rujaya Abhakorn, *Mom Rachawong*. "Changes in the Administrative System of Northern Siam, 1884–1933." Paper presented at *Changes in Northern Thailand and the Shan States, 1886–1940*, Pasir Panjang, Singapore, 1988.

Sao Saimong Mangrai. *The Shan States and the British Annexation*. Ithaca, NY: Department of Asian Studies, Cornell University, 1965.

——. *The Paòdaeng Chronicle and the Jengtung State Chronicle Translated*. Ann Arbor, MI: University of Michigan, Center for South and Southeast Asian Studies, 1981.

Sarassawadee Ongsakul. *History of Lan Na*. Translated by Chitraporn Tanratanakul. Edited by Dolina W. Millar and Sandy Barron. Chiang Mai, Thailand: Silkworm Books, 2005.

Scott, Joan Wallach. *Gender and the Politics of History*. Rev. ed. New York: Columbia University Press, 1999.

Selway, Joel Sawat. "Thai National Identity and Lanna Identity in Northern Thailand." *Kyoto Review of Southeast Asia* 27 (March 2020), https://kyotoreview.org/issue-27/thai-national-identity-lanna-identity-northern-thailand-2/.

Seni Pramoj and Kukrit Pramoj, *Mom Rachwong. Mongkut: A King of Siam Speaks*. Bangkok: Siam Society, 1987.

Sithu Gamani Thingyan. *Zinme Yazawin. Chronicle of Chiang Mai*. Translated by Ni Myint Thaw Kaung. Yangon, Myanmar: Universities Historical Research Center, 2003.

Skinner, G. William, and A. Thomas Kirsch, eds. *Change and Persistence in Thai Society: Essays in Honor of Lauriston Sharp*. Ithaca, NY: Cornell University Press, 1975.

Smith, Malcolm Arthur. *A Physician at the Court of Siam*. Kuala Lumpur, Malaysia, and New York: Oxford University Press, 1982.

Somboon Punsuwan, trans. *A History of Kruba Sriwichai (the Buddhist Saint of Northern Thailand) a Story of Making Way Up to Doi Suthep, and a Historical Chronicle of Wat Phra That Doi Suthep*. Chiang Mai, Thailand: Wat Phrathat Doi Suthep Rajwara Wiharn, 2005.

Spiro, Melford E. *Kinship and Marriage in Burma: A Cultural and Psychodynamic Analysis*. Berkeley, CA: University of California Press, 1977.

Spivak, Gayatri Chakravorty. *The Spivak Reader: Selected Works of Gayatri Chakravorty Spivak*. New York and London: Routledge, 2013.

Stewart, Anthony Terence Quincey. *The Pagoda War: Lord Dufferin and the Fall of the Kingdom of Ava, 1885–6*. 2nd edition. London: Faber and Faber, 1972.

Swearer, Donald K., Sommai Premchit, and Bodhiraṃ si. *The Legend of Queen Cama: Bodhiraṃ si's Camadevivamsa, a Translation and Commentary*. Albany, NY: State University of New York Press, 1998.

Tambiah, Stanley Jeyaraja. *World Conqueror and World Renouncer: A Study of Buddhism and Polity in Thailand against a Historical Background*. Cambridge, UK, and New York: Cambridge University Press, 1976.

Tanabe Shigeharu. "Autochthony and the Inthakhin Cult of Chiang Mai." In *Civility and Savagery: Social Identity in Tai States*, edited by Andrew Turton, 294–318. Richmond, Surrey, UK: Curzon, 2000.

Tarling, Nicholas, ed. *The Cambridge History of Southeast Asia*. Vol. 2, pt. 1. Cambridge, UK: Cambridge University Press, 1999.

Taylor, Robert H. "British Policy and the Shan States, 1886–1942." Paper presented at Changes in Northern Thailand and the Shan States, 1886–1940, Pasir Panjang, Singapore, 1988.

Tej Bunnag. *The Provincial Administration of Siam, 1892–1915: The Ministry of the Interior under Prince Damrong Rajanubhab*. Kuala Lumpur, Malaysia, and New York: Oxford University Press, 1977.

Thamsook Numnonda. "Pibulsongkram's Thai Nation-Building Programme during the Japanese Military Presence, 1941–1945." *Journal of Southeast Asian Studies* 9, no. 2 (1978): 234–47.

Thompson, P. A. *Siam, an Account of the Country and the People*. Bangkok: White Orchid Press, 1987.

Thongchai Winichakul. *Siam Mapped: A History of the Geo-Body of a Nation*. Chiang Mai, Honolulu: University of Hawai'i Press, 1994.

——. "The Quest for 'Siwilai': A Geographical Discourse of Civilizational Thinking in the Late Nineteenth and Early Twentieth-Century Siam." *Journal of Asian Studies* 59, no. 3 (2000): 528–49.

——. "The Others Within: Travels and Ethno-Spatial Differentiation of Siamese Subjects, 1885–1910." In *Civility and Savagery: Social Identity in Tai States*, edited by Andrew Turton, 38–62. London: Curzon, 2000.

Trinh T. Minh-Ha. "Writing Postcoloniality and Feminism." In *The Post-Colonial Studies Reader*, edited by Gareth Griffiths, Bill Ashcroft, and Helen Tiffin, 264–268. London and New York: Routledge, 1995.

Turton, Andrew G. W. "Remembering Local History: Kuba Wajiraphanya (C. 1853–1928), Phra Thongthip and the *Muang* Way of Life." *Journal of the Siam Society* 94 (2006): 147–76.

——. "People of the Same Spirit: Local Matrikin Groups and Their Cults." *Mankind* 14, no. 4 (1984): 272–85.

——. "Matrilineal Descent Groups and Spirit-Cults of the Thai-Yuan in Northern Thailand." *Journal of the Siam Society* 60 (1972): 171–256.

Turton, Andrew G. W., ed. *Civility and Savagery: Social Identity in Tai States*. London and New York: Routledge, 2000.

Van Esterik, Penny. *Women of Southeast Asia*. Rev. ed. DeKalb, IL: Northern Illinois University, Center for Southeast Asian Studies, 1996.

——. "The Politics of Beauty in Thailand." In *Beauty Queens on the Global Stage: Gender, Contests and Power*, edited by Richard Wilk, Colleen Ballerino Cohen, and Beverly Stoeltje, 203–16. London and New York: Routledge, 1996.

Vella, Walter F., and Dorothy B. Vella. *Chaiyo! King Vajiravudh and the Development of Thai Nationalism*. Honolulu: University of Hawai'i Press, 1978.

Wales, H. G. Quaritch. *Siamese State Ceremonies; Their History and Function*. London: B. Quaritch, 1931, https://archive.org/details/siamesestatecere03066 1mbp/page/n8/mode/2up.

Walker, Andrew. "Women, Space, and History: Long-Distance Trading in Northwestern Laos." In *Laos: Culture and Society*, edited by Grant Evans, 79–99. Chiang Mai, Thailand: Silkworm Books, 1999.

——. "Matrilineal Spirits, Descent and Territorial Power in Northern Thailand." *The Australian Journal of Anthropology* 17, no. 2 (2006): 196–215.

Walthall, Anne. *Servants of the Dynasty: Palace Women in World History (California World History Library).* Berkeley and Los Angeles, CA, and London: University of California Press, 2008.

Wilson, Constance M., and Lucien M. Hanks. *The Burma-Thailand Frontier over Sixteen Decades: Three Descriptive Documents.* Athens, OH: Ohio University, Center for International Studies, 1985.

Wolters, O. W. *History, Culture, and Region in Southeast Asian Perspectives.* Ithaca, NY: Southeast Asia Program Publications, Southeast Asia Program, Cornell University, 1999.

Wood, W. A. R. *Consul in Paradise. Sixty-Eight Years in Siam.* Chiang Mai, Thailand: Silkworm Books, 1965.

Woodhouse, Leslie Ann. "Concubines with Cameras: Royal Siamese Consorts Picturing Femininity and Ethnic Difference in Early 20th Century Siam." *Trans-Asia Photography Review* 2, no. 2 (2012), http://hdl.handle.net/2027/spo.7977573.0002.202.

——. "A Very 'Modern' Matron: Phra Rachaya Dara Rasami as Promoter and Preserver of Lan Na Culture in Early 20th Century Siam." In *Women, Gender and Art in Asia, C. 1500–1900,* edited by Melia Belli Bose, 91–121. London and New York: Routledge, 2016.

——. "Picturing Siwilai: Colonial Anxiety and Ethnic Difference in Elite Photography during Siam's Fifth Reign (1868–1910)." *Amerasia Journal* 43, no. 2 (2017): 141–57, https://doi.org/10.17953/aj.43.2.141-157.

Woodward, Hiram. "Monastery, Palace, and City Plans: Ayutthaya and Bangkok." *Crossroads* vol. 2, no. 2, 23–60.

Wyatt, David K. *The Nan Chronicle.* Studies on Southeast Asia, no. 16. Ithaca, NY: Southeast Asia Program, Cornell University, 1994.

——. *The Politics of Reform in Thailand: Education in the Reign of King Chulalongkorn.* New Haven, CT: Yale University Press, 1969.

——. *Thailand: A Short History.* New Haven, CT: Yale University Press, 1984.

Wyatt, David K., ed. *The Trans-Salwin Shan State of Kiang Tung.* Reprint ed. (original Calcutta: Superintendent of Government Printing, 1888). Chiang Mai, Thailand: Silkworm Books, 2005.

Wyatt, David K., and Aroonrut Wichienkieow. *The Chiang Mai Chronicle.* 2nd ed., vol. 1. Chiang Mai, Thailand: Silkworm Books, 1998.

Unpublished English-Language Sources

Bee Melanie Ontrakarn. "Servitude of the Ladies of the Royal Inner Court during the Reigns of King Rama IV, V and VI." Master's thesis, Chulalongkorn University, 2005.

Brailey, Nigel J. "The Origins of the Siamese Forward Movement in Western Laos, 1850–1892." PhD diss., University of London, 1968.

Easum, Taylor M. "Urban Transformation in the Colonial Margins: Chiang Mai from Lanna to Siam." PhD diss., University of Wisconsin at Madison, 2012.

Gray, Christine. "Thailand: The Soteriological State in the 1970s." PhD diss., University of Chicago, 1987.

Ratana Pakdeekul. "Social Strategies in Creating Roles for Women in Lan Na and Lan Sang from the Thirteenth to the Nineteenth Centuries." PhD diss., Westfalische Wilhelms-Universitat Muenster, 2009.

Ratanaporn Sethakul. "Political, Social, and Economic Changes in the Northern States of Thailand Resulting from the Chiang Mai Treaties of 1874 and 1883." PhD diss., Northern Illinois University, 1989.

Renard, Ronald D. "Prince Sithiphon Kridakara and the Control of Opium." Centre for Ethnic Studies and Development, Chiang Mai University, Thailand, June 2014.

Woodhouse, Leslie Ann. "A 'Foreign' Princess in the Siamese Court: Princess Dara Rasami, the Politics of Gender and Ethnic Difference in Nineteenth-Century Siam." PhD diss., University of California, 2009.

Published Thai-Language Sources

120 Phii Phra Rachaya Chao Dara Rasami. Wun waan thii Khan Khay. Chatrsudha Wongtongsri, editor. Chiang Mai, Thailand: Kad Suan Kaew Printing, 1997.

Amphan Chaiyaworasing. *Lao Rueang Mueang Nuea duay Prawati Bukkhon Samkhan.* Bangkok: Khurutsapha, 1981.

Anake Nawigamune. *Phrawathikan Thay Rup Yuk Raek Khong Thai.* Bangkok: Sarakhadi Phap, 2004.

———. *Kanthaengkay Samay Ratanakosin.* Bangkok: Muang Boran, 2004.

Arun Wetsuwan. *Phra Rachaya Chao Dara Rasami kap Kan Ruam Hua Mueang Phak Nuea.* Bangkok: Arunwithya Printing, 2000.

Aroonrut Wichienkieow. *Lanna Thai Sueksa.* Chiang Mai, Thailand: [n.p.], 1982.

———, ed. *Chiwit nai Adit.* Vol. 1. *Khomun jaak kansamphat.* [An Academic Collaboration Between the Kingdom of Thailand and the State of Bavaria, Federal Republic of Germany.] Sathabun Phasa, Sinlapa lae Wattanatham, Mahawittyalai Rajabhat, Chiang Mai, Thailand: [n.p.], 2008.

———. *Sangkhom lae wattanatham Lan Na jaak kham bok lao.* Chiang Mai, Thailand: [n.p.], 2011.

Banjop Phantmetha. *Kalemanthai.* Bangkok: Ongkan kha khong Khrutsapha, Suksa phan phanit, 1960.

Boonserm Rytthaphirom. *Nai Khanang Ngo Semang Phak Tai.* Bangkok: Borisat Samnakphim Bannakit, 1991.

Boonserm Sattraphai. *Sadet Lanna.* Krung Thep: Borisat Aksaraphiphat, 1989.

Chawali Na Thalang, Charnvit Kasetsiri, and Kanchani La-ongsri. *Prathetsarat Khong Siam*. Krung Thep: Samnakngan Khongthun Sanapsanun Kanwichai: Munlanithi Khrongkan Tamra Sangkhommasat lae Manutsayasat, 1998.

Chomrom Say Sakhun Bunnag. *Sakun Bunnag*. Bangkok: Sakun Bunnag, 1999.

Chulalongkorn. *Samnao Phraratchahattaleka Phrabat Somdet Phra Chula Chom Klao Chao Yu Hua Mi Phra Ratchathan Krom Phra Narathip Phraphanphong*. Bangkok: Sophon Phiphithaphan Thanakon, 1931.

——. *Bot Lakhon Ruang Ngo Pa lae Prachum Khlong Suphasit*. Bangkok: Khurutsapa, 1968.

——. *Klai Baan = Far from Home = Fern von zuhause = Loin des siens*. Otrakul Ampha, trans. Bangkok: Chulalongkorn University European Studies Programme, 1997.

Chunlada Phakdiphumin, *Sri Mahawaan (Mom Luang)*. *Loh Wang*. Bangkok: Chokchai Thewet, 2535.

Damrong Rachanubhab, *Somdet Phrachao Boromawongtoe, Phra Ong Chao Ditsaworakuman, Krom Phraya. Somdet Phra Phuttachao Luang kap Phra Sanom Ek*. Bangkok: Phrathat, 1900.

——. *Tamnan Phrakat Ruang Lakhon Inao*. Krung Thep: Thai: 1921.

——. *Atibai Raya Thang Long Lam Nam Pho Tang Tae Chiang Mai Teung Phak Nam Pho*. Bangkok: [n.p.], 1931.

Grabowsky, Volker. "Chao Ubonwanna." In *Khattiyani Sri Lanna*, edited by Wongsak na Chiang Mai, 268–78. Chiang Mai, Thailand: Within Design, 2004.

Kaew Nowarat, Chao. *Phra Prawati Phra Rachaya Chao Dara Rasami*. Bangkok: Bamrung Kunlakit, 1935.

Jirachat Santayot. *Phra Rachachaya Chao Dara Rasami: Prawatisat Chabap "Reu Sang" Tang Tee "Jing" Lad "Sang Kuen Mai."* Bangkok: Samnakphim Matichon, 2008.

Jirijan Prathipsen. *Ma Mia ja nan tueng wan nee 100 phii 2446-2546*. Chiang Mai, Thailand: Tonaban kanphim, 2004.

Kaewgiriya, Romaniyachat, ed. *Dara Rasami: Say Yai Rak Song Phaendin*. Bangkok: Chulalongkorn University, 1999.

Kalayani Watthana, *Somdet Phrachao Phee Nang Thoe Chaofa*, Krom Luang Narathiwat Sarason Karint. *Song ruap ruam Chulalongkorn rachasanthiwong, Phranam Phra Racha Orote, Phra racha thida, lae Phra rachnadda*. Bangkok: Samnakphim Bannakit, 1997.

Kanthathip Singhanet, Dr. *Yon roy Chao Chom Kok Oh*. Bangkok: Wiraya Turakit, 2006.

Kitthiphong Wirottamakon. *Rueang rao nai racha samay Praphutha Chao Luang*. Bangkok: Samnakphim Namfon, 1998.

——. *Nai Wang Kaew*. Bangkok: Samnakphim Dok Ya, 2002.

Krom Sinlapakon. *Prachum Phongsawadan Phak tee 61. Phim pen anuson nai ngan Prarachathan Phlengsop Phontri Chao Rachabutr (Wongsak na Chiang Mai) na Meru*

Wat Suan Dok, Changwat Chiang Mai, 12 Mokarakhom 2516. Bangkok: Rongphim Chuanphim, 1973.

———. Ruap ruam lae riep rieng. *Prawati Wat Rachabophit Sathit Maha Simaram*. Bangkok: Krom Sinlapakon, 1988.

Laddawan Saesieow. *200 Phii Phama nai Lanna. Wichakan chut "Khrongkan anaboriwen Sueksa 5 phumiphak, lamdap tee 7."* Bangkok: [n.p.], 2002.

Lamjoon, Huapcharoen. *Mua Ngao Chakkrawatniyom Pokkhlum Siam Lae Lanna Nai Khwamsong Jam*. Bangkok, Thailand: Samnakphim The Knowledge Center, 2008.

Lawaan Chotamra. *Phra Mahesi Thewi*. Bangkok: Odeon Store, 1989.

———. *Kaew Ching Duang*. Bangkok: [n.p., n.d.].

Naengnoi Saksri, M. R. W. [lae khon uen uen]. *Satthabattyakam Phra Boromma Rachawang*. Bangkok: Samnak Racha Lekhathikan, 1988.

Narint Thongsiri. "Phra Rachaya Chao Dara Rasami kap Kan Kasetr." In *Khattiyani Sri Lanna*, edited by Wongsak na Chiang Mai. Chiang Mai, Thailand: Within Design, 2004.

Naritsaranoo Wathiwong, *Somdet Chaofa Krom Phraya*, lae *Somdet Krom Phraya* Damrong Rachanubhab. *Saan Somdet*. Bangkok: Munlanithi Somdet Chaofa Krom Phraya Naritsaranoo Wathiwong, 1991.

Nattakhan Limsathaphon. *Chiang Mai, Hua Jai Lanna*. Bangkok: Phak That, 2001.

———. "Phra Rachaya Chao Dara Rasami: Phra Prawati." In *Khattiyani Sri Lanna*, edited by Wongsak na Chiang Mai. Chiang Mai, Thailand: Within Design, 2004.

Nawa Eksawat Jontani. *Nithan Chao Rai, Vol. 4* Bangkok: Kurutsapha, 1966.

Nidhi Aieusiwong. "Sao Khrua Fa: Fun tee pen jing." *Sinlapa Wattanatham* 12, no. 6 (April 1991): 180–185.

Nongyao Kanchanachari. *Dara Rasami, Phra prawati Phra Rachaya Chao Dara Rasami phrom phra niphan kham phrarop doi Somdet Phrachao Phee Nang Thoe Chaofa Kalayani Wattana*. Bangkok: Khanae Kamkan, jat nangsue, 1990.

Omrot Runarak, Nang. *Wang Luang*. Bangkok: Khurutsapha, Lad Phrao, 1983.

Phaothong Thongchua. *Chalong Phraong Fai Nai Samai Ratanakosin*. Bangkok: Borisat Amarin, jamkat (Mahachon), 1999.

Prayut Sittiphan. *Rak Nai Rachasamnak Rachakan Tee 5*. Bangkok: Saradee, 2000.

Phunphit Amatyakun. *Ueng Ngern. Anuson Nai Phra Rachthan Plerngsop Chao Suntorn Na Chiang Mai*. Bangkok: Borisat Rak Silp, 1987.

Phunphitsamai Diskul, *Mom Chao Ying. Phrachum Phra Niphan*. Bangkok: Bamrung Banthit, 1986.

———. *Phra Prawati Somdet Phrachao Boromawongtoe Phra Ong Chao Ditsaworakuman Krom Phraya Damrong Rachanubhab, P. S. 2405-2486*. Bangkok: Phrakhru Khana Nam Soman Ajaan, 1943.

Phra Racha Phongsawadan Krung Ratanakosin Rachakan tee 4. [Bangkok: n.p., n.d.].

Pon Atsanjinda. *Anuban ramleuk phim pen bannakan nai ngan Phra Racha phloengsop Amdey Ek, Phraya Anuban Payapakit*. Department of Social Sciences, Chiang Mai University, Chiang Mai, Thailand: 1969.

Prachum Phrakatsa Rachakan tee 4. Bangkok: [n.p., n.d.].

Prani Sirithorn na Phattalung. *Petch Lanna*. Chiang Mai, Thailand: Soon Phak Nuea jat phim, 1995.

——. *Chao Thipawaan (na Lampang) na Chiang Tung*. Chiang Mai, Thailand: [n.p.], 1989.

Ratana Pakdeekul. "Botbat khong Phra Rachaya Chao Dara Rasami Nai Khansang Phaplak 'Phuying Nuea'." In *Khattiyani Sri Lanna*, edited by Wongsak na Chiang Mai. Chiang Mai, Thailand: Within Design, 2004.

Rataphatri Chandavij. *Pha Phim Lai Boran Nai Phiphitaphan Sathan Haeng Chaat*. Bangkok: Krom Silpakorn, 2002.

Ruang Mahatlek khong Krom Sinlapakorn. Cremation volume for Phon Ek Nai Worakhan Buncha (Kanbuncha Sutuntanon), Wat Thepsirin, 8 November 1974. [N.p.]

Saengdao na Chiang Mai. *Phra Prawathi Phra Rachaya Chao Dara Rasami 26 Singhakhom 2416–9 Thanwakhom 2476*. Chiang Mai, Thailand: Rongphim Klang Wieng, 1974.

Sakda Siriphan. *Kasatri lae Klong: Wiwathanakan thay phap nai prathet Thai P.S. 2388–2535*. Bangkok: Dan Sutha Kanphim, 1995.

Sakdee Ratanasay lae Khana Thamngan Suksa Khon Khwa 2537–2539. *Suea phanung mueang: Watthanatham taeng kay mueang Lampang*. Sathawathanatham jangwat Lampang ruam kap Sun Wathanatham Jangwat Lampang. Lampang, Muang Thai: 1996.

Samnak Phra Rachawang. *Phra Rachawang Dusit, Moo Phra Thamnak*. Bangkok: Samnak Phra Rachawang, 2002.

——. *Jodmaihet kan kosang lae som saem phra thee nang Wimanmek Phuttasakarat 2443–2517*. Bangkok: Samnak Phra Rachawang, 1990.

Samnak Ngan Serm Sang Ekalak Khong Chat. *Sathaphatyakam nai sathabun Phranakasatri [jat tham doi Khana Anukammakan chepoh kit jat tham nangsue sathaphatyakam nai sathaban Phramahakasatri Khana Kamakan Ekalak khong chat samnak Nayok Rathamontri.] kan jat ngan chalong sirirat, sombathi krop 50 phii*. Bangkok: Khana Kamakan Omnuay, 1996.

Samnao Phraracha Hata Lekha jak Phrabat Somdet Phra Phuttha Chao Luang Phra Rachathan Krom Phra Narathip Phra Phanphong. Bangkok: Sophon Phiphithaphan Thanakon, 1931.

Sanguan Chotisukkarat. *Khon dee mueang Nuea*. Bangkok: Odeon Store, 1962.

Sansani Wirasingchai. *Luk kaew, Mia khwan*. Bangkok: Matichon, 1997.

Santi Leksukhum, Dr. S. *Sinlapa Phak Nuea Haripunchai-Lanna*. Bangkok: Muang Boran, 1994.

Sengiam Khumphawat. *Racha Pradiphat*. Bangkok: Serm Wit Banakhan, 1969.

Sitthiphon Nethraniyom. *Phra Rachaya Chao Dara Rasami kap Ngan Sangkhet Sin*. Chiang Mai, Thailand: Chulalongkorn Mahawittyalai, 2006.

Sommai Premchit. *Thamnan sipha rachawang chabap sop chamra*. Chiang Mai, Thailand: Mahawittyalai Chiang Mai, 1997.

Songsak Prangwatthanakun and Patricia Cheesman. *Pha Lan Na: Yuan, Lue, Lao.* Phim khrang thi 1 ed. Chiang Mai, Thailand: Mahawittyalai Chiang Mai, Khrongkan Sun Songsmoe, Sinlapawatthanatham, 1987.

Sulak Sivaraksa. *Samphat M. C. Jongjitrathanom Diskul.* Bangkok: Khlet Thai, 1986.

S. Phlainoi. *Rueang lao jak khao khong khrueang thaeng kai.* Bangkok: Phim kham Samnakphim, 2003.

———. *Phra Boromma Rachinee lae Chao Chom Manda.* Bangkok: Borisat Ruamsan, 1998.

Thanet Charoenmuang. *Kanbokkrong mueang nai sangkhom Thai. Koranee Chiang Mai jet sutawat.* Chiang Mai, Thailand: Khrongkan Suksa kanbokkhrong thongthin, khana sangkhomsat, Mahawittyalai Chiang Mai, 1997.

———. *100 Phii sai samphan Siam Lanna 2443–2542.* Chiang Mai, Thailand: Khrongkan Suksa kanpokkhrong thongthin, Khana Sangkhomsat, Mahawittyalai Chiang Mai, 1999.

———. *Khon Muang.* Chiang Mai, Thailand: Soon Suksa Panha Muang Chiang Mai, 2001.

Thawee Sawang Punnyagun. *Tamnan Mueang Chieng Tung: Phreewat jak samut khoi phasa lae tua akson Thai Khoen khong Wat Phrathat Sai Mang, A. Thakhilek, J. Chieng Tung, Sahaphap Phama.* Khrongkan Tamra, Mahawittyalai Hong Jamnay nangsue samnak hoh samut Mahawittyalai Chiang Mai, 1984.

———. *Tamnan Mueang Yong.* Chiang Mai, Thailand: Social Research Institute, Chiang Mai University, 1984.

Thipakorawong, *Chao Phraya. Phra Racha Phong Sawadan Ratanakosin Rachagan thi 3.* Bangkok: Ongkhan Khurutsapha, 2010.

Thipawaan Wongtongsri. "Chao Dara Rasami nai Thamnaeng Phra Rachaya." *Jam Juree* (the Alumni Journal of Chulalongkorn University) vol. 2, no. 2 (1998): 69–80.

———. "Phra Rachaya: Phra Sri Ming Mueang nakhon Chiang Mai." *Jam Juree* (the Alumni Journal of Chulalongkorn University) 2, no. 3 (1999): 49–56.

Wannaphon Bunyasathit. *Chom Nang Haeng Siam. Nai Rachakhan tee 4 tueng Rachakhan tee 6 kap krasae wathantham tawantok.* Bangkok: Sangsan, 2006.

Wichitwong na Phomphet. *Sethakit Siam: Bot wikroh nai Phra Ong Chao Dilok Noparat, Krommuen sankawisay rop dee dutsadee banthit thang srethasat jak Yermanee Ong raek khong Siam.* Bangkok: Matichon, 2001.

Wongsak na Chiang Mai. *Khattiyani Sri Lanna.* Chiang Mai: Within Design, 2004.

Unpublished Thai-Language Sources

Aroonrut Wichienkieow. "Kan wikhroh sangkhom Chiang Mai samay Ratanakosin on ton chabap bai lan nai phak Nuea." Master's thesis, Chulalongkorn University, 1977.

Chatraphon Chindadet. "Kanborihan Rachasamnak Fai Nai, Racha Samay Prabat Somdet Phra Chulajomklao Yu Hua." Master's thesis, Chulalongkorn University, 1999.

Daruni Somsri. "Kan Sang Phap Lak Kwam Naam Kong Chiang Mai, 1921–1957." Master's thesis, Chulalongkorn University, 2007.

Nidhi Aieusiwong. "Kan Phrap Haw lae kansiya dindaen P.S. 2481." Master's thesis, Chulalongkorn University, 1966.

Nuachanok Withet Witanusaat. "Botbat dan kanmuang lae sangkhom khong Phra Rachaya Chao Dara Rasami tii mee phon doh kanblien blaeng Chiang Mai." Master's thesis, Chiang Mai University, 2007.

Phonpan Jongwathana. "Korani Phiphat rawang chao nakhon Chiang Mai kap khon nai bangkap Angkrit, an pen het hai rataban Siam jadkanphokkhrong Monthon Payap (P.S. 2401–2445)." Master's thesis, Chulalongkorn University, 1974.

Phonsiri Bunranakhet. "Nang Nai: Chiwit thang sangkhom lae botbat nai sangkhom Thai samay Rachakan tee 5." Master's thesis, Thammasat University, 1997.

Plai-Auw Chonanan. "Botbat nay toon pho tee mee dokankoh lae khayay thua khong toon niyom phak Nuea khong Prathet Thai P.S. 2464–2523." Master's thesis, Chulalongkorn University, 1986.

Ratana Pakdeekul. "Phaplak 'Phuying Nuea' thang thae play phuttasathawat 25 tueng don phutthasathawat tee 26." Master's thesis, Chiang Mai University, 2000.

Ratanaporn Sethakul. "The International Court in the Northern Part of Thailand (1874–1937)." Master's thesis, Chulalongkorn University, 1981.

Rujaporn Prachadejsuwat. *Nattasin Lanna. Khorani Suksa Samay Phra Rachaya Chao Dara Rasami (P.S. 2416) tueng Bachuban*. Research funded by a grant from the [Thai] Office of National Cultural Commission, Ministry of Education, 2000.

Sara Miphonkit. "Satri nai rachasamnak Siam tangtae Rachakan Phrabat Somdet Phra Chula Chom Klao Chao Yoo Hua tueng Rachakan Phrabat Somdet Phra Mongkut Klao Chao Yoo Hua, P.S. 2394–2468." Master's thesis, Silpakorn University, 1999.

Saysuwan Khayanying. "Phra Rachaya Chao Dara Rasami kap nattasin Lanna." Master's thesis, Chulalongkorn University, 2000.

Suwadee Phanphanit. "Kansueasaan nai wang luang Krung Ratanakosin khong Phra Rachaya Chao Dara Rasami." Master's thesis, Chulalongkorn University, 2003.

Tuenjai Chaisin. "Lanna nai kanraproo chonchan Phokkhrong Siam, P.S. 2437–2476." PhD diss., Thammasat University, 1993.

Websites Accessed

Chao Intawichayanon, Dara Rasami's father: http://en.wikipedia.org/wiki/Inthawichayanon

Chao Gaew Nowarat, Last Lan Na governor of Chiang Mai: http://en.wikipedia.org/wiki/Chao_Keo_Naovarat

Chao Thipkraisorn, Dara Rasami's mother: https://en.wikipedia.org/wiki/Thip_Keson

Dara Rasami: https://en.wikipedia.org/wiki/Dara_Rasmi

Kamthieng House, Siam Society, Bangkok, Thailand: http://www.siam-society.org/facilities/kamthieng.html

Lanna-Thai: http://en.wikipedia.org/wiki/Lanna

Mae Ying Lanna [Noble Women of Lanna] ~ Social Research Institute, Chiang Mai University: http://www.sri.cmu.ac.th/~maeyinglanna/

McKean Senior Center, Chiang Mai, Thailand (formerly McKean Rehabilitation Center and Hospital): https://mckean.or.th/history/

Sao Khrua Fa: http://th.wikipedia.org/wiki/สาวเครือฟ้า

Sitthiporn Kridakara: http://www.siamese-heritage.org/jsspdf/1971/JSS_060_1r_ObituaryPrinceSithipornKridakara.pdf

U.S. Consulate Building in Chiang Mai, Thailand, https://th.usembassy.gov/wp-content/uploads/sites/90/2016/07/consul-general-residence.pdf

Page numbers followed by *f* refer to figures.

CPSIA information can be obtained
at www.ICGtesting.com
Printed in the USA
LVHW031820050421
683485LV00006B/316